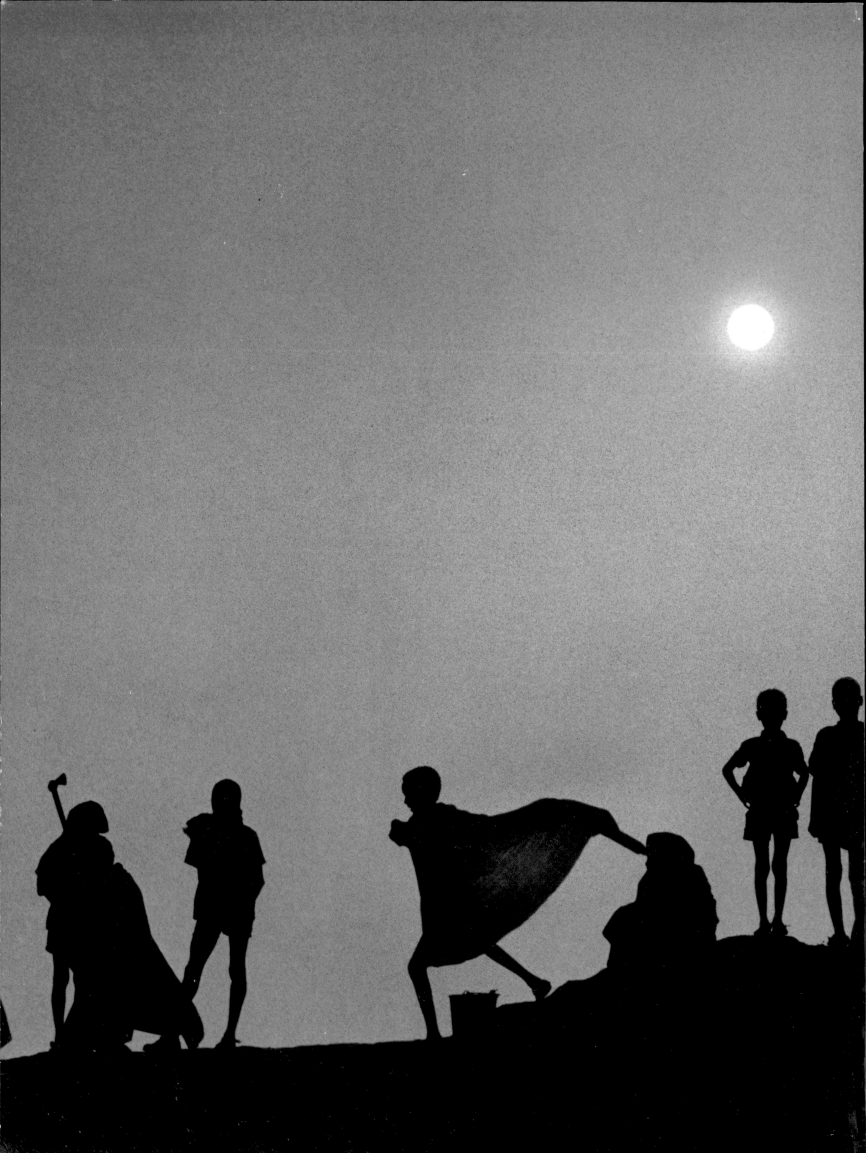

LOST FUTURES
OUR FORGOTTEN CHILDREN

STAN GROSSFELD

FOREWORD BY
MUHAMMAD ALI

WITH A MESSAGE FROM
MOTHER TERESA

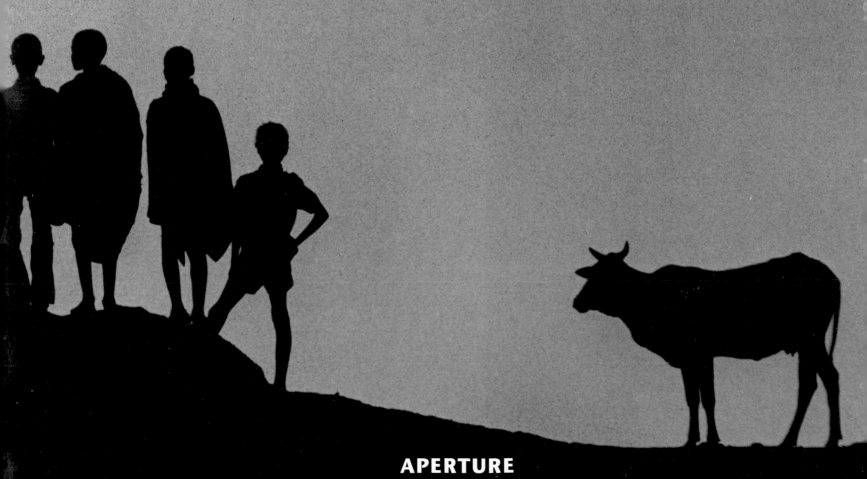

APERTURE

FOR IQBAL

FOREWORD
MUHAMMAD ALI

TRACING THROUGH THE PAGES OF *LOST FUTURES: OUR FORGOTTEN CHILDREN* I BECAME ABSORBED IN THE FACES OF THE CHILDREN THAT FILLED EACH PAGE. DARK EYES, LIKE REFLECTIVE POOLS, CLEARLY MADE VISIBLE THE LACK OF HOPE THESE CHILDREN HAVE IN THEIR FUTURES ON THIS EARTH. THE DEGRADATION AND HUMAN MISERY WE HAVE *ALLOWED* CHILDREN OF THE WORLD TO LIVE IN IS INEXCUSABLE.

TOO MANY OF THE FACES I SAW ON THESE PAGES REMINDED ME OF THE CHILDREN I HAVE SEEN THROUGHOUT MY TRAVELS IN INDIA, SUDAN, EGYPT, CHINA, THE PHILIPPINES, AND THE UNITED STATES. I HAVE GREETED THESE CHILDREN MANY TIMES WITH NOTHING MORE TO OFFER THAN A FEW WORDS OF ENCOURAGEMENT, A KISS, A GENTLE HUG, AND SOMETIMES A SCARCE MEAL FROM A SPONSORING CHARITY GROUP. I CANNOT UNDERSTAND HOW WE AS HUMANS ALLOW OUR LACK OF HUMANITY TO BLIND OUR EYES, HARDEN OUR HEARTS, AND ERASE ANY SENSE OF MORAL RESPONSIBILITY AND CONSCIOUSNESS TOWARD THE PLIGHT OF OUR MOST INNOCENT BEINGS.

CAN IT BE OUR WEALTH MEANS SO MUCH TO US THAT WE HAVE LOST SIGHT OF THOSE WHO HAVE NOTHING? CAN IT BE THAT WE DO NOT FEEL FOR THE CHILD IN SOMALIA WHO HAS NOT EATEN IN SEVERAL DAYS, OR THE CHILD IN THE STREETS OF BANGLADESH WHO HAS BEEN LYING ON THE SIDEWALKS DAY AND NIGHT WITH NOWHERE TO GO, AND NO ONE TO CARE IF HE OR SHE LIVES OR DIES? OR THE BABIES WHO ARE CAST OUT IN THE STREETS SIMPLY BECAUSE THEY WERE UNLUCKY ENOUGH TO BE BORN FEMALE? IT IS NO ACCIDENT THAT THERE ARE MORE AND MORE HOMELESS WOMEN AND CHILDREN FILLING OUR AMERICAN SIDEWALKS AND DOOR STOOPS EVERY DAY. THEY ARE OUR REMINDERS. THEY ARE OUR CONSCIENCE. THEY ARE OUR SALVATION.

EVERY DAY OF OUR LIVES WE HAVE AN OPPORTUNITY TO MAKE A DIFFERENCE IN THIS WORLD. EVERY DAY OF OUR LIVES GOD GIVES US AN OPPORTUNITY TO SAVE OUR SOULS BY THE KINDNESS AND CHARITY WE SHOW TO OTHERS. EVERY DAY OF OUR LIVES WE CAN CHOOSE EITHER TO TURN OUR BACKS TO THESE INNOCENT ONES IN NEED OR TO EXTEND A HAND OF HOPE. OUR HOPE FOR HUMANITY DEPENDS ON THEM.

IF WE LEAVE OUR HEARTS OPEN FOR LOVE, MIRACLES CAN HAPPEN; FOR LOVE IS THE NET WHERE HEARTS ARE CAUGHT LIKE FISH.

Muhammad Ali

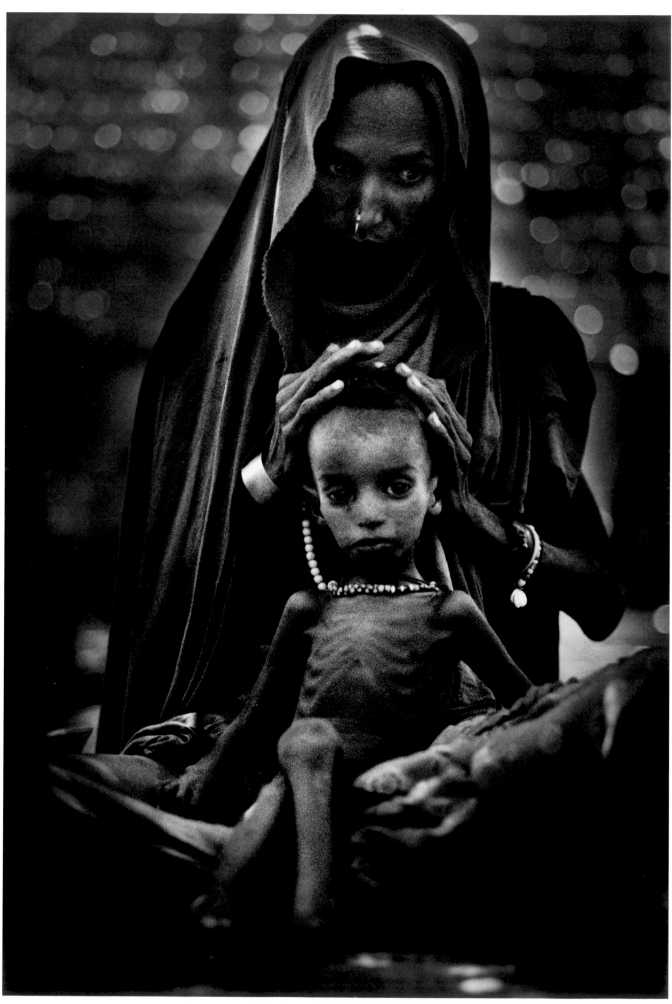

An Ethiopian mother and child wait for food in
a refugee camp. The child died later that day.

"WHATEVER YOU DO TO THE LEAST OF MY BRETHREN, YOU DO IT TO ME."

Dear Mr. Grossfeld,

Thank you for your kind letters and the pictures to be used for the book, *Lost Futures: Our Forgotten Children*. The pictures speak for themselves.

Every child is a gift of God, loved into being, infinitely precious to God, created for greater things: to love and be loved.

Yet so many are forgotten, abandoned, abused, made to suffer the most unimaginable pain in their souls and bodies. I have looked into the eyes of children—some shining with hunger, some dull and vacant with pain. I have held countless babies in my arms—dying for lack of a little milk, some medicine. And why does this all happen? Why?

These children are my brother, my sister, my child. If there is such terrible suffering for children in the world today, it is because men and women have forgotten to pray, to thank God who is the Author of Life for the precious gift of life.

Men and women today are afraid of the little child. Will there be enough food? Will there be enough water for all? Will there be enough space? Let us begin by loving the little child. And love to be true must cost us. God has made a world big enough for all his children. If the rich were more willing to share with the poor, to give up a little bit of luxury, some little pleasure—that new TV set, latest car, vacation—need the child be exploited, abused, or die of hunger?

The children in these pictures speak to us. They urge us to pray.

I assure you of my prayer that your work for the children of the world, with God's blessing, may bear fruit in a happier and more hopeful future for children everywhere.

Let us pray.

God bless you,

M Teresa mc

PREFACE
STAN GROSSFELD

When I was growing up in the Bronx, I used to go fishing with my dad just offshore of Hart Island. I never knew what was out there.

What's out there is a company of prisoners stacking dead babies in shoe-box-sized coffins into mass graves. Dead babies. Stacked seven deep virtually in the shadow of the Empire State Building. On the sides of the coffins are small pink tags. One of them reads "Bronx Lebanon Hospital." I was born in that hospital. But unlike me, these tiny people—mostly AIDS and crack babies—never had a chance.

Take a tour of the planet with me, and think about what you could do to make a difference. One thing I learned is this: everyone can do something. The first stop is home.

In the 1950s, there was an elderly gentleman who used to sit outside his Bronx apartment listening to the Yankees' game on his transistor radio. He listened, but he also watched. He had an unwritten contract with the neighborhood. If a kid did anything wrong, he'd tell their parents, which meant big trouble. Guaranteed.

That old-timer didn't hit as well as Mantle, but he was every bit as valuable. He helped to raise the 150 kids who lived in the six-story apartment building that was my home. He kept us away from the temptations of trouble, and, more important, he wasn't afraid to confront wrong and do something about it.

I tried his technique in a Los Angeles emergency room last year when a gang member who had been shot was visited by his homeboys. I overheard them talking about instant revenge. Soon, it seemed, more blood would flow. Soon another mother would be clutching her rosary beads, sobbing in the waiting room. In this country, fifteen kids are killed every day by handguns, a fact not listed in National Rifle Association brochures.

"I'm gonna tell your mother," I said, flashing back to that old Bronx Bomber. To my surprise, it worked. Macho men turned into choirboys. Cooler minds prevailed. End of problem.

Richard Serino, head of Boston's Emergency Medical Services, likes to visit Boston public schools to tell students what it is like to get shot. "Tough kids always say the same things when the ambulance doors shut: 'Am I gonna die?' and 'I want my mommy.'" Oddly enough, the biggest response comes when Serino describes how EMTs cut a shooting victim's clothing off in the street to look for wounds. The kids don't like the thought of that, so maybe some of them won't get shot. What Serino is doing is what he knows best. Whatever works. Everybody can do something.

Take a tour of the planet with me, and look and listen to these children.

The screams of civilians were occasionally drowned out by the thumps and whistles of Katyusha rockets slamming into Tripoli, Lebanon. A group of Palestinians spotted me, and, speaking rapidly in Arabic, they hustled me to a door with a wooden bolt across it. I could smell death. The doors were flung open, and I saw dozens of bodies piled on ice in a makeshift morgue. For a moment, I thought they were going to keep me there as a prisoner. But instead, they wanted me to photograph the innocent victims caught between warring factions. To do so, I had to climb over the dead to show both the victims in the foreground and, in the background, the villagers covering their noses from the stench. Amid the drably clothed dead was the body of a pretty young girl lying face up, dressed in pink. I remember thinking that maybe it was her birthday.

Take a tour of the planet, and see what we do to children in the name of God.

Meet Fida Sherafi, who, at nine months old, lost her eyeball to an Israeli rubber bullet in the Gaza Strip. Talk to Ireland's Catholic and Protestant families who have lost loved ones in "The Troubles," and one thing becomes clear: the religious views are different, but the tears and nightmares are exactly the same.

But amidst the nightmares are dreams of what could be. Who could be racist after meeting the starving children of Ethiopia waiting patiently for a ration of food? Children under a starless sky on a pitch-black night simply wanting a hand to hold.

We have no control over where on this planet we are born. The Ethiopian mother and child pictured in the front of this book were victims of a deadly combination of politics and drought. They had walked through the rebel-held desert, drunk from polluted water holes, and avoided Ethiopian MIGs that bombed villages and food convoys. Now they were in a dark straw tent, but the relentless sun was streaming through in pinholes, and the child was dying.

The only sound was the awful moaning of dying children. Later, I went to check on the child's condition. The doctor said he had died that day.

Some scenes were too horrible to photograph, like the "tail of hunger" where the intestines are forced out several inches from the anus as the body feeds on itself.

Take a tour of the planet, and instead of thinking, "There's nothing I can do," ask, "What can I do to change this?"

In a Mexico City sewer, sixteen-year-old Veronica sits in her own blood because she can't afford a tampon. She has a doll, some marbles, a poster of Jesus, and scars on her wrists from when she tried to commit suicide. Veronica lives in the sewer because the local shelter doesn't take girls, and she sniffs glue to forget the father who abused her. The police, she says, only visit the sewer to force her to have sex with them.

Take a tour of the planet, and know the boundless horrors to which innocent children are subjected.

Stop in Rio de Janeiro and visit the ward of inhumanity at the local hospital. A baby, deliberately scalded by an iron on her buttocks, is abandoned, yet has the courage to try to stand.

Visit the House for Abandoned Children in Semipalitinsk, downwind from the Soviet nuclear test site in Kazakhstan, and watch Dr. Natalya Borisovna Averbach cuddle a child with no forehead. The baby writhes like an insect.

During the Cold War, the United States bombed its own people with radiation, poisoned its own water, and lied about it for decades. The USSR did the same, and the effects on our children are apparent even today. In Vietnam, officials report that the herbicide Agent Orange is still causing birth defects in its country's children.

But always, somehow, hope emerges from horror. In Kazakhstan, Berik, a boy born with flaps for eyes, asks if he can smile to have his picture taken. Halfway around the world, two children born with Down's syndrome near a nuclear testing site in Utah, grow up and get married. Eight thousand miles away in a Vietnamese hospital, a boy with no arms balances himself on one leg and writes with his toes stretched up on the blackboard.

Take a tour of the planet but instead of entering the Magic Kingdom in Orlando, Florida, stop and see the children of migrant workers living nearby.

On a relentlessly hot day, a mother hanging her tattered wash outside a third-world trailer is asked if she has enough food for her children. "Oh yes," she says. But open her refrigerator and all that's inside is a cool breeze.

Take a tour of the planet, and see how the spotlight of world attention shines brightly and then passes into shadow.

In Romania, after the fall of Ceausescu, the media exposed the filth and horror of the orphanages and they were cleaned up. But five years later, there are abandoned children who enter them healthy and wind up handicapped. "We have time to feed them, but no time to hold them," said one nurse. On a visit to a local kindergarten full of children with AIDS, I carried a young boy in my arms. When I tried to put him down, he planted his feet on my chest and walked back up. As I left, I turned around. The little boy still had his arms out while another boy bit the chainlink fence next to him.

How can we allow this?

How can Madagascar allow wildlife agents in new four-wheel drives with purring air conditioners to cruise through villages visiting the lemurs while the state remains blind to the bloated babies catching and eating insects?

How can villagers be allowed to sell their children to the brothels of Bangkok so that the rich nations of the world can have sex tours?

How can we allow powerful American companies to build hazardous-waste sites in minority neighborhoods? Or allow women and children to be beaten in their own homes?

How can we avoid becoming numb to the many problems affecting our children?

Everybody can do something. If you are a photographer, you can expose injustice. If you have fifteen cents to give to UNICEF, you can buy an oral rehydration pack that will keep a child alive. You could adopt a child, become a Big Brother, volunteer at a Boys and Girls Club. The possibilities are endless. It depends on your passion.

Don't know where to start? Try matching up your interests with various support groups. For starters, check out the "Hope for the Future" section in the back of this book. Or browse the listings in the Encyclopedia of Associations, a three-volume book in the reference section of your library.

There is hope for the future in the energy of the young. Consider the case of Iqbal Masih. A Pakistani human-rights activist who was sold into slavery at the age of four, Iqbal escaped six years later to spearhead an international battle against child slavery on behalf of Pakistan's 7.5 million child laborers.

In December 1994, Iqbal visited a school in Quincy, Massachusetts, while he was in Boston to receive the Reebok Youth In Action Award. He told students at the Broad Meadows Middle School how he was beaten and chained to a loom by carpet owners. He also expressed his desire to someday study law and become "the Abraham Lincoln of Pakistan." The sight of the growth-stunted yet energetic Iqbal left a lasting impression on the students.

On Easter Sunday last year, Iqbal was killed by a shotgun blast while riding his bicycle near his home in Muridke, Pakistan. Pakistani police and government officials maintain that Iqbal and his cousin, who was wounded, got into an argument with a man on drugs, who opened fire. His cousin believes that Iqbal was assassinated by carpet makers who had vowed to kill him.

Halfway around the world, the students have not forgotten the little boy with the big heart. They vowed to raise $5,000 to build a one-room, mud-brick school in Pakistan. Using the Internet, they appealed to children around the world. Because Iqbal was sold into slavery by his parents for twelve dollars, they asked each class to send that amount. They also wrote letters, washed cars, gave up their baby-sitting money, and asked their parents for contributions.

"I thought if Iqbal could make a difference, so could I," said one of the students, Amanda Loos. In the end, they raised over $100,000—more than twenty times their goal. "If the adult wants to change things he should go to the child," she said.

I met Iqbal during his visit to Boston, and when I think of him I remember his smile. As he left that triumphant night, he high-fived the crowd. When I saw him last, he turned around just before disappearing amongst the big bodies. He thrust his fist in the air.

"Keep fighting," he said.

Nantucket, Massachusetts
September 6, 1996

12 DESPAIR IN THE LAND OF HOPE

Over fifteen million kids live in poverty in the U.S. Each night, twelve million children go to bed hungry, and 850,000 are victims of abuse or neglect. Why can't the leader of the free world care for its children?

36 VULNERABLE AND ABUSED

Child abuse knows no economic boundaries. In 1993, 1,299 children died of abuse and an estimated 2.9 million suffered neglect in the U.S.

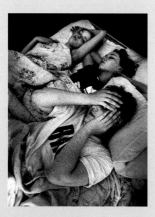

42 RUNNING TO NOWHERE

Meet Baby, a fourteen-year-old prostitute, one of 2,000 youths who call the streets of Seattle their home and one of the 1.3 million teenage runaways nationwide.

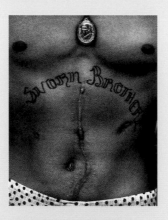

44 GANG WARFARE

Gangs are a deadly attraction for millions of kids in the U.S. Between 1979 and 1991, nearly 50,000 children were killed by firearms—a total equivalent to the number of American casualties in the Vietnam War.

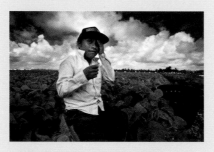

52 CHILDREN OF THE HARVEST

Agriculture is one of the three most dangerous occupations in the U.S., yet nearly one million children work on farms in America, over 100,000 illegally, but most under special child labor law exemptions.

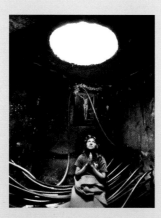

60 MEAN STREETS

In Latin America, the problem of homeless children is rampant. There are seven million street children in Brazil and forty million in all of Latin America. For these kids, some of whom are hunted by death squads, stealing is the only way to survive, and sniffing glue the only way to escape.

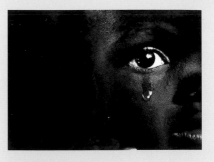

68 DIRT POOR

Haiti and Madagascar, once lush paradises, share the same enemy—man. Overpopulation and overuse of resources have led to their economic declines. Deforestation is so severe that the land bleeds into the sea, while thousands starve or die from curable diseases.

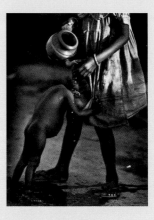

82 THE LARGEST DEMOCRACY

India, the world's largest democracy, is a place of stark contrasts in wealth. Overcrowding, lack of basic sanitary conditions, and political corruption have led to a state where four million children under age five die unnoticed each year.

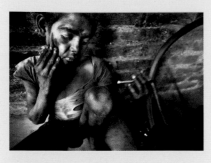

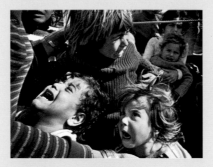

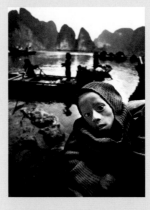

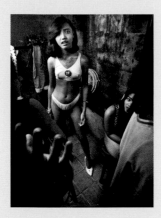
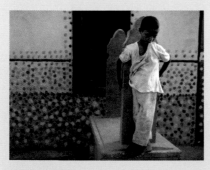
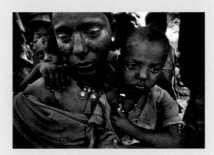
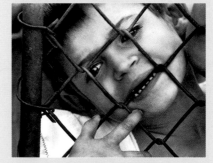
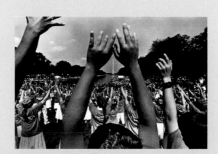

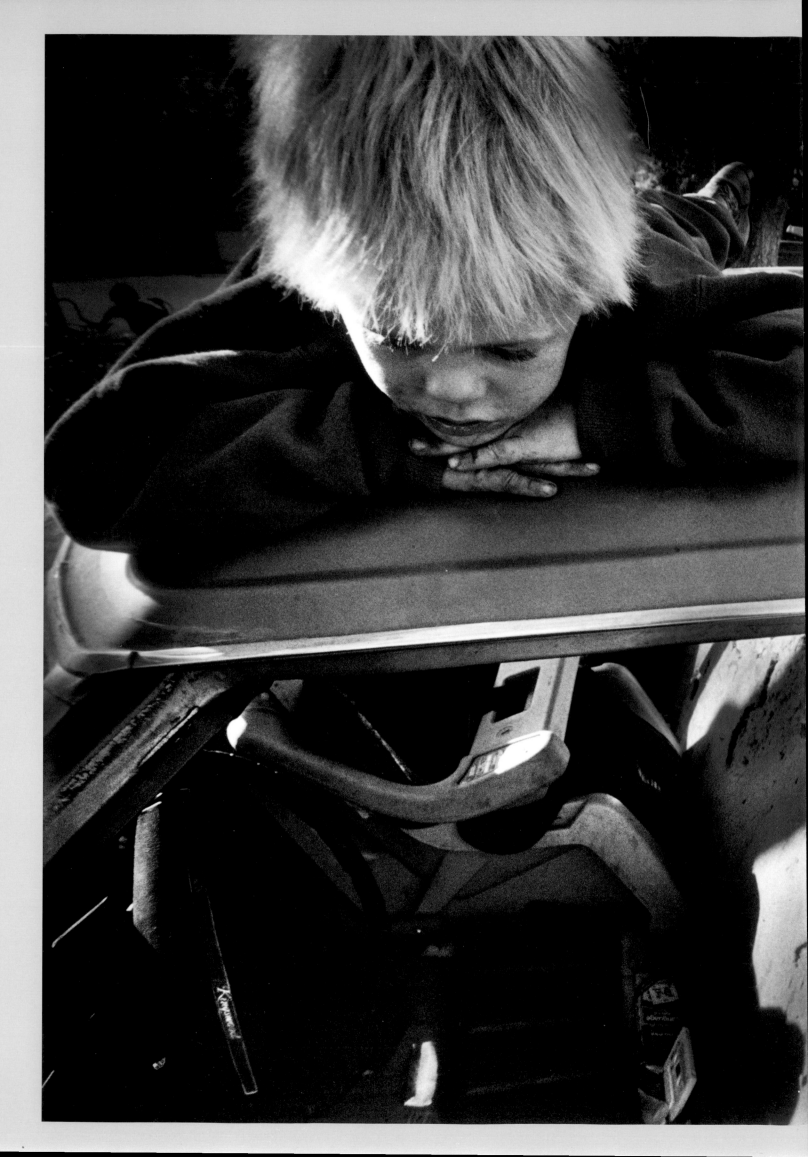

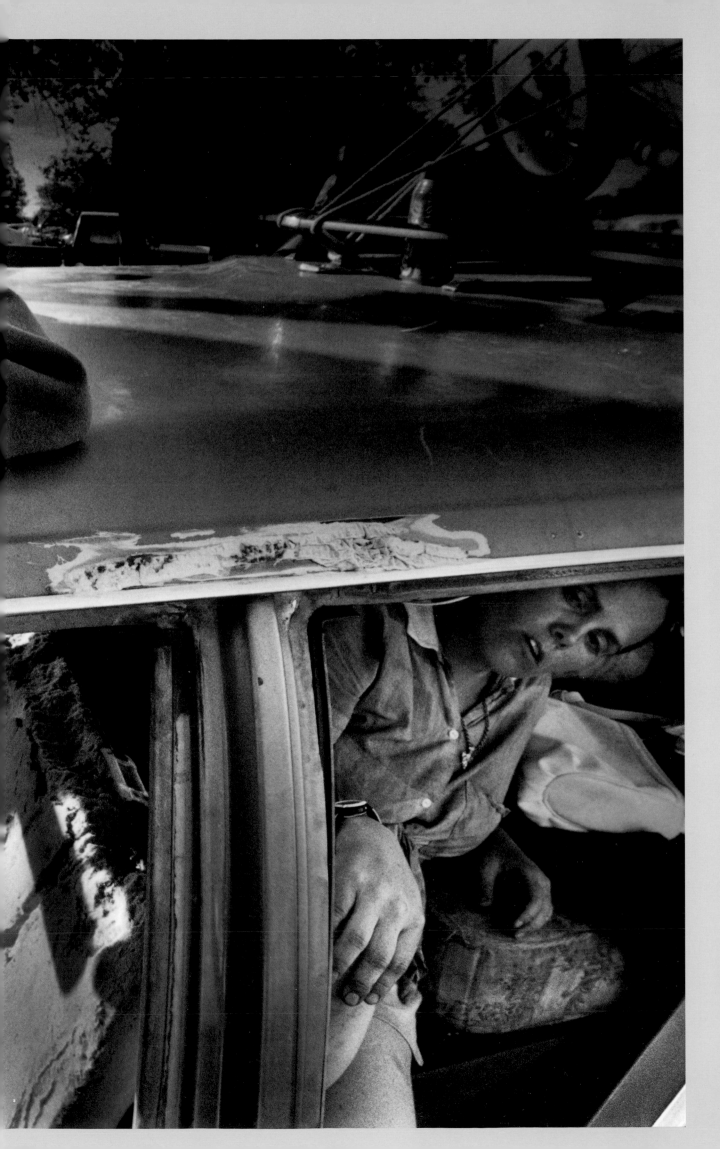

Previous spread: "Most of America is ninety days from where I am," says Brian Brunner, who is out of work and lives with his wife Debra, son Thomas, six, and their five other children and a dog in a 1971 station wagon. Brunner lost his $66,000-a-year job as a computer operator.
Right: Newark has lost over 22,439 housing units through demolition permits since 1970, according to HUD. Over half of the 90,878 households in Newark have very low incomes according to the 1990 Census.

Vicky Feltner Moore protects her turf in the hollows of Kentucky's Appalachia. *Opposite*: In the *colonias* of Brownsville, Texas, a young child screams. The Census Bureau reports that over 15.7 million children live in poverty in the United States.

The United States, a world leader in just about everything, is certainly a world loser in taking care of its most precious resource—its children.

In 1990, the United Nations Convention on the Rights of the Child passed a measure recognizing a child's basic right to education, health care, and special protection for children exposed to economic and sexual exploitation, drug trafficking, and drug abuse. One hundred seventy-six countries signed it before the United States did in 1995. But the United States still has not ratified it. George Bush did not sign the document because it deals with adoption, child welfare, and education, which, in the United States, are mandated by state law. One group of conservative senators, led by Senator Jesse Helms, called it "incompatible with the God-given right and responsibility of parents to raise their children."

The United States is the first nation in history in which the poorest age group in the population is the children, according to Senator Daniel Patrick Moynihan.

A record 15.7 million children live in poverty, according to the Census Bureau. That's 22 percent of the nation's kids—the highest poverty rate of any age group. It is also a substantially higher poverty rate than that of any other Western industrialized nation. And the problem is getting worse.

"In less than a generation there has been a three-quarter increase in poverty of our most vulnerable children—those under six," said Julian Palmer, director of communication for the National Center for Children in Poverty.

The United States has lower birth-weight rates than thirty other nations, has a smaller proportion of babies immunized against polio than sixteen other nations, and has the worst adolescent pregnancy rate in the developed world.

The family is in shambles. Divorce rates have doubled since the fifties, and one in four children now live in a single-parent home. In 1992, there were 850,000 substantiated cases of child abuse or neglect. That's more than the combined populations of Albany, New York, and San Francisco, California.

(continued on page 23)

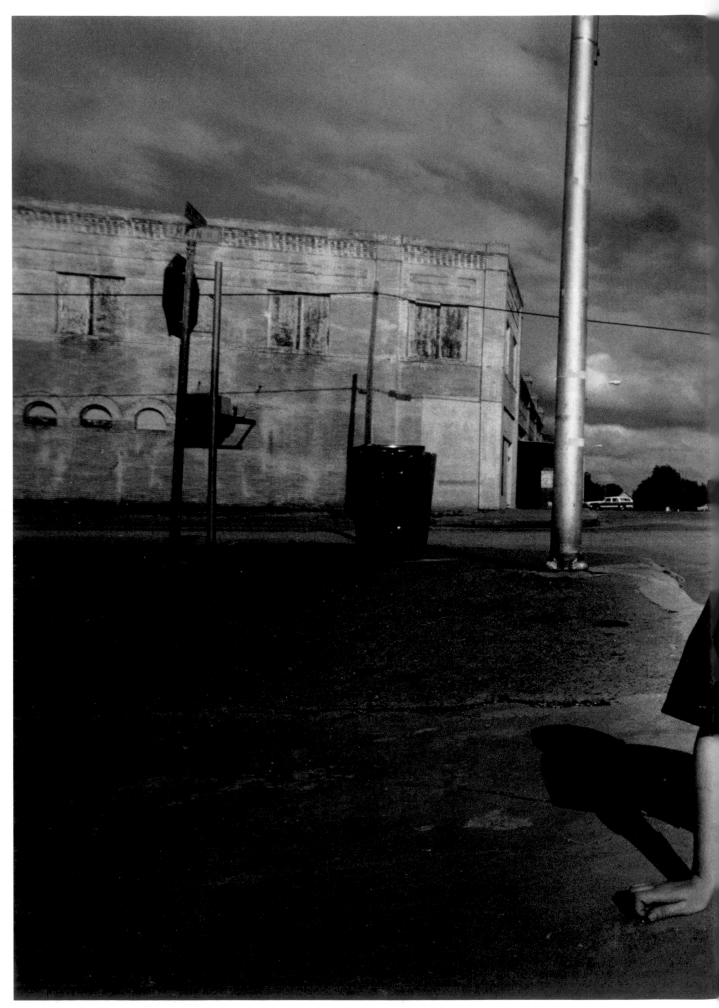

Dewrell Bryan, seven, sits on Main Street in Grandfield, Oklahoma. The majority of poor children in the United States live in rural or suburban areas rather than metropolitan centers.

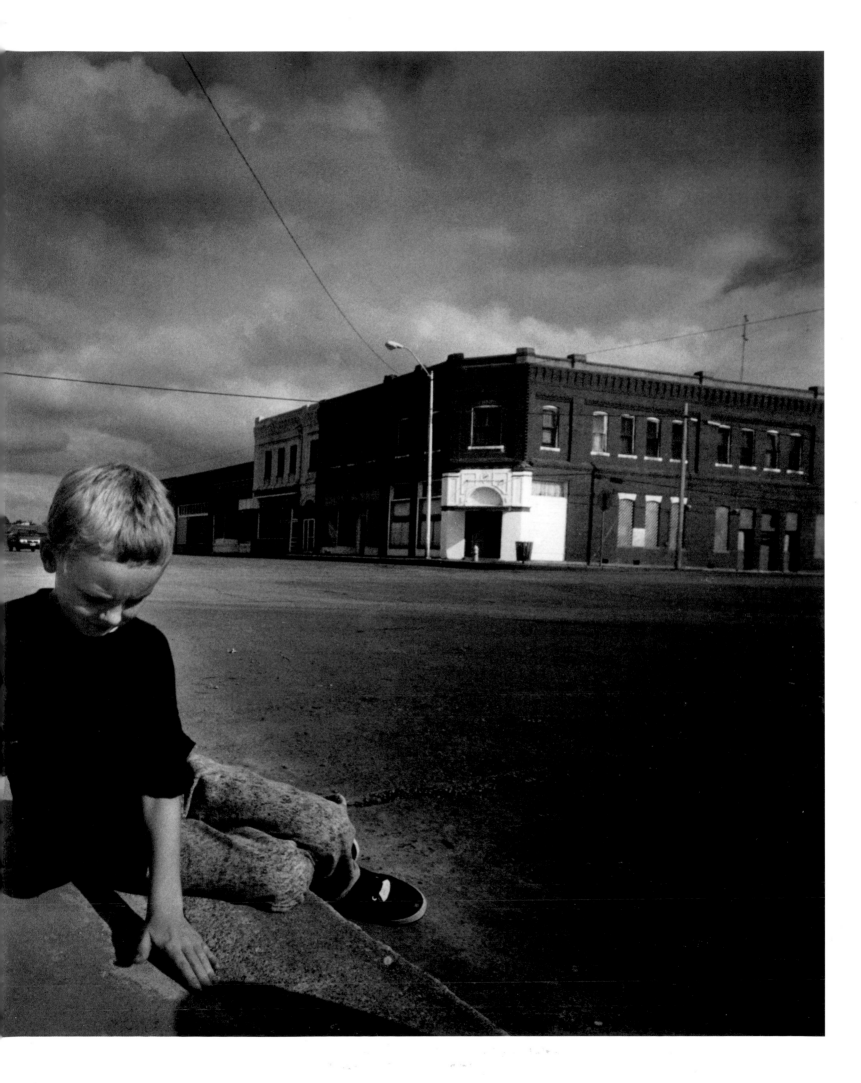

A student navigates the hallways of a Boston high school. The most obvious symptom of an underfunded school may be poor physical conditions, but other inequities do greater harm. The National Governors' Association states in a 1995 report that, "many poor and minority students are taught throughout their entire school careers by a steady stream of the least qualified and experienced teachers."

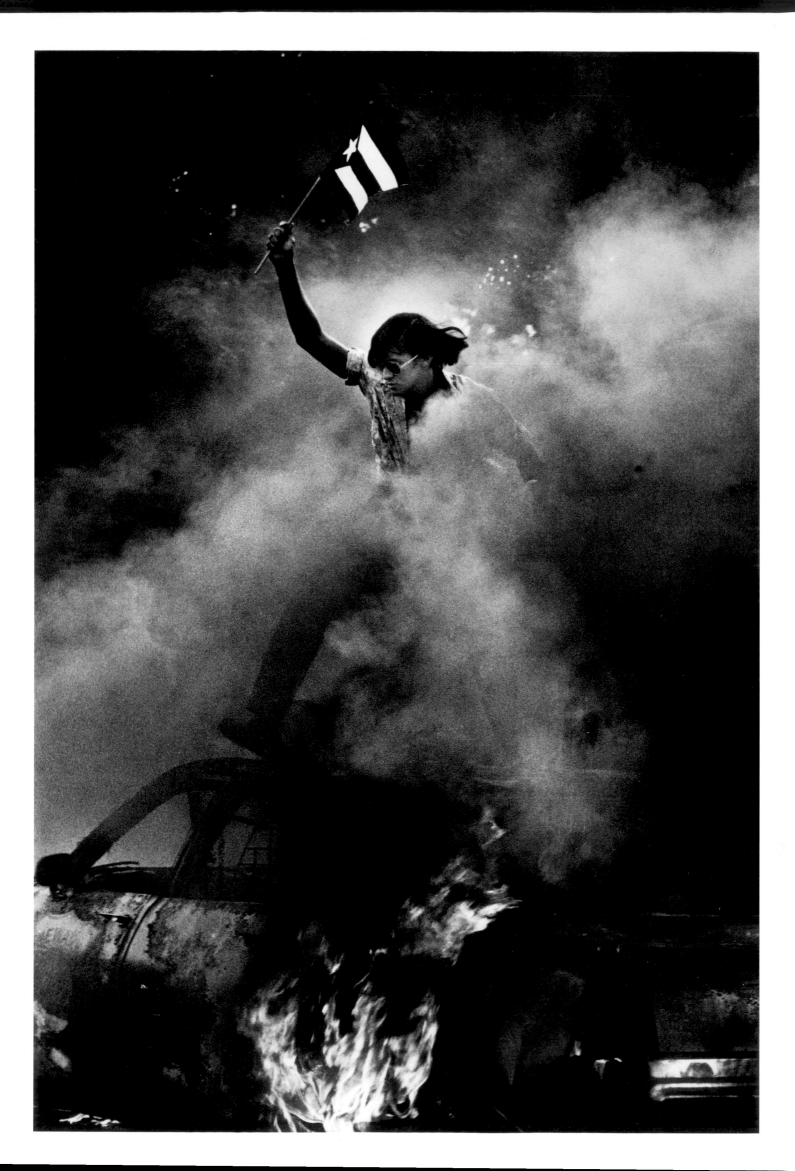

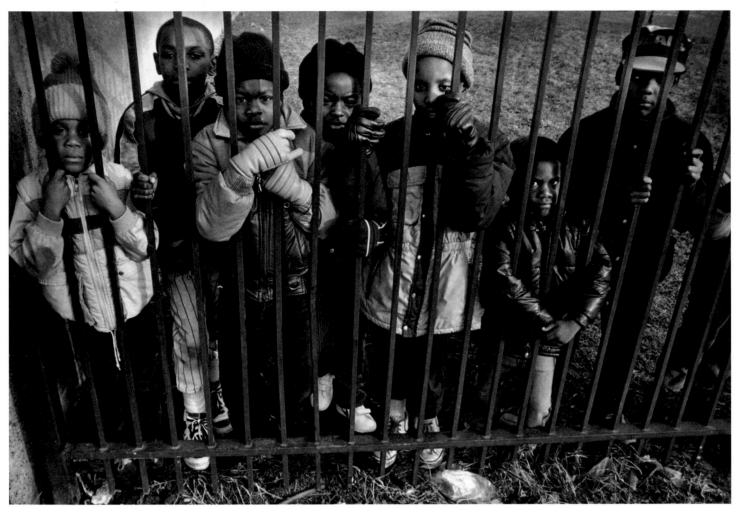

Above: Youngsters in a Chicago housing project. Among industrialized nations, the U.S. is first in GNP, but eighteenth in the gap between rich and poor children. *Opposite*: A youth holds a Puerto Rican flag atop a burning Newark police cruiser. A riot erupted when a mounted Newark police unit attempted to break up a dice game and a horse stepped on a baby's hand.

(continued from page 17)

Every day in America three children die from abuse and neglect, six youths commit suicide, fifteen children are killed by guns, and 2,217 students drop out of school according to the Children's Defense Fund.

One hundred seventeen countries offer paid maternity leave ranging from six months to three years. The United States is not one of them. It offers no paid maternity leave. The United States also lags behind countries like France and Belgium which cover nearly 100 percent of their preschool costs. Ten million American children have no health insurance.

In 1996, the welfare reform bill became law, ending the sixty-year federal guarantee of minimal support for needy parents and children. The welfare bill could toss an additional one million children into poverty—a majority of them from working-class families—according to a 1996 Urban Institute study.

"It takes no political courage to stand up to two-month-old babies," said Children's Defense Fund president, Marian Wright Edelman.

"America"—the song, not the country—boasts of "amber waves of grain." Yet today in the United States things are decidedly off-key. America has record harvests of wheat in the heartland, yet 21 percent of the requests for emergency food assistance go unmet in our nation's cities. There are still places in this rich country—like the *colonias* of Texas—where children do not have access to clean drinking water. Every night, twelve million children go to bed hungry. Recent cuts in food stamps mean roughly eight billion fewer meals for hungry children.

"Statistics are simply numbers with the tears washed off," said Senator Patrick Leahy at the Hunger Forum in 1993. "They stop being names, and they start being numbers."

Hunger is the faces of the third graders in Wyoming County, West Virginia, who wrote in a thank-you note to the local food bank: "The taste of the toothpaste was great."

Food stamps are a necessity for many families, like Charlyne Thomas and her children. "I am hittin' rock bottom," she says from a tiny slum apartment in Los Angeles that costs her $325 a month. "The food stamps have run out. We've got no milk, no juice," she says. "How am I gonna get out of this?"
Opposite: Kashmiere Perkins, two, is weighed and measured at Boston City Hospital's Failure to Thrive Clinic. At twenty pounds, his weight is equivalent to that of a healthy nine month old. "In general, severe malnutrition in early childhood greatly increases the risk of later school failure and behavioral problems," says the clinic director, Dr. Deborah Frank. "Now we are seeing more kids, and we have less resources. We are desperate for donations."

It's a sad-eyed boy ripping open a cereal box at a supermarket in the Dorchester section of Boston while a girl sitting in a cart opposite him licks the side of a frozen-beef-patty box.

It's the child in any school, anywhere in the United States, who loses a pound or two every weekend without the school breakfast or lunch program.

"Most of America is ninety days from where I am," says Brian Brunner, out of work and living with his wife, six kids, and a dog in a 1971 station wagon in Albuquerque, New Mexico. "To go from a $66,000 computer operator to this is a surprise. We spent one month pretty skinny. We spent the last of the savings, and now my sense of confidence is shattered."

While the United States sends food and troops to places like Somalia, it is unable to battle hunger at home. American hunger is different from Somalian starvation. Hunger here is the absence of nutrients necessary to lead a productive life. There are no dramatic photos of brittle-boned American children too weak to shoo away flies. No photos of ragged refugees fleeing civil war or clouds of topsoil swirling off our land. But the situation is quietly getting worse. The bottom line is: we don't end hunger, we sustain misery.

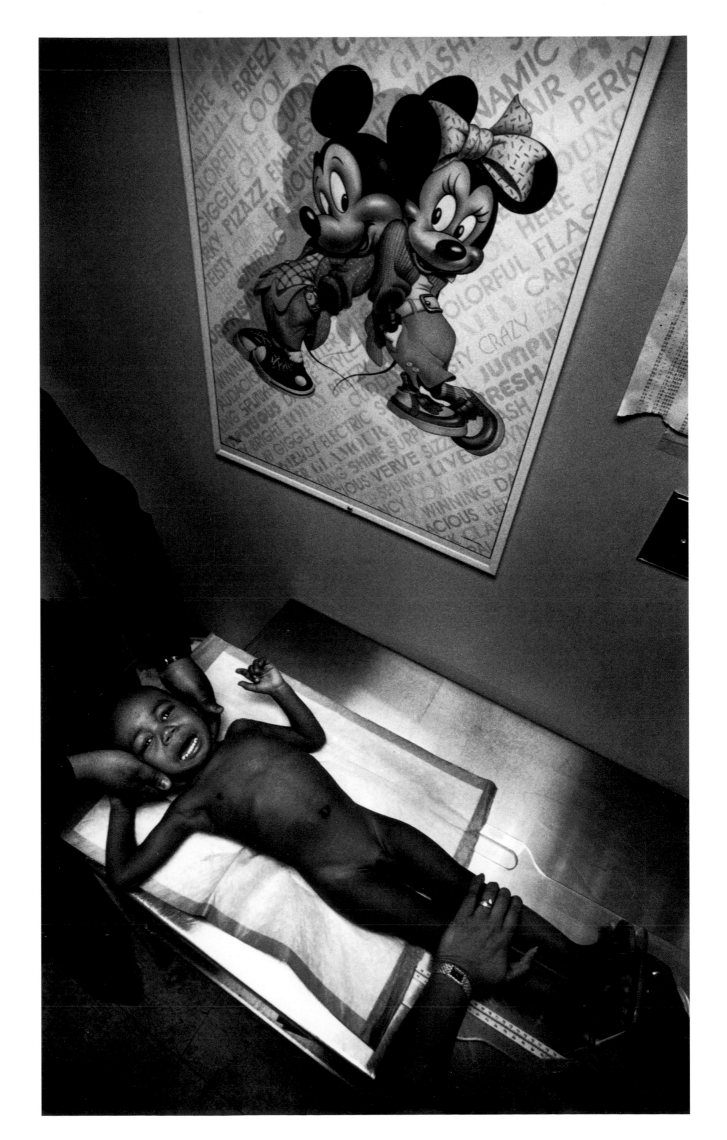

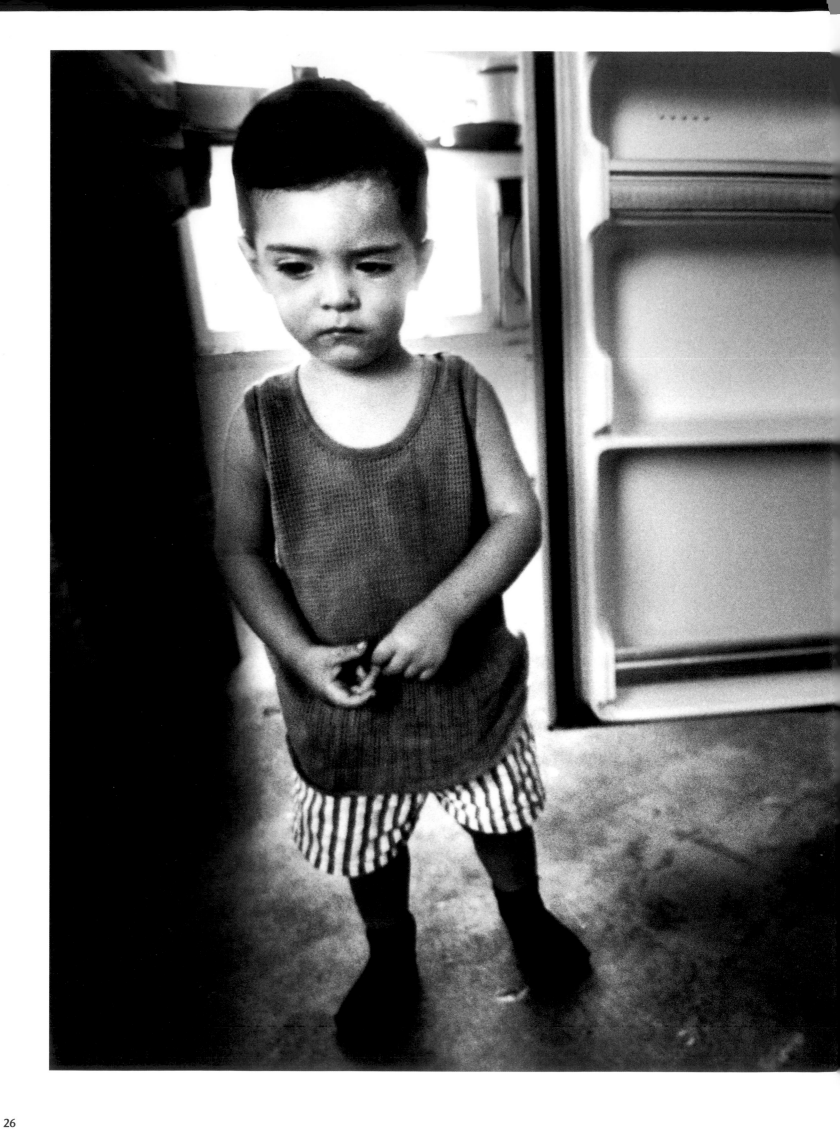

Francisco Bautista, two, stands next to a nearly empty refrigerator in central Florida. His mother says that pride keeps her from accepting welfare. Twelve million children go hungry in the United States.

A child collects food aid at a St. Louis pantry.

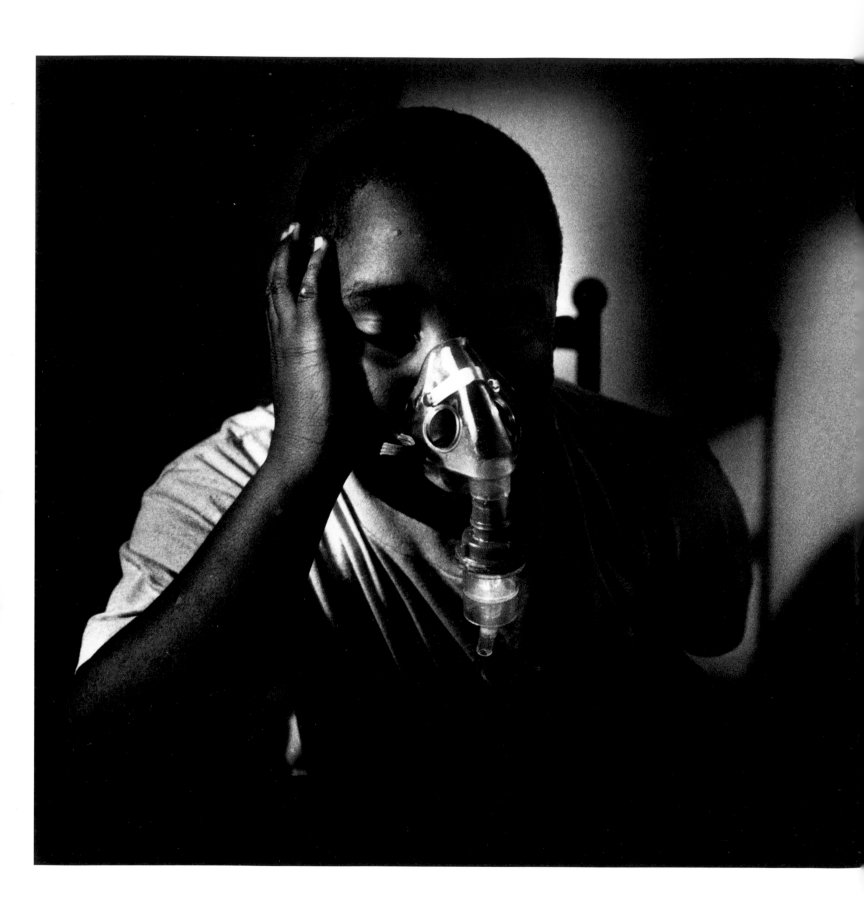

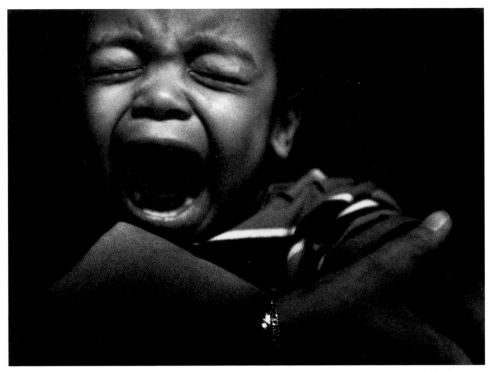

In the United States, minority communities have been called "poison zones" by those who point out inequalities in the location of toxic wastes and polluting industries. "Race is the single most accurate predictor of the location of hazardous-waste sites," noted Vice President Al Gore.

Above: DiAndre Nixon, nineteen months old, is tested for lead at the Roxbury Comprehensive Community Health Center in Boston. The EPA reports that lead poisoning is significantly higher among black children than white children. *Left:* Darnell McCarter, eight, is an asthma sufferer. He lives in Chicago's South Side, an area ringed by fifty landfills and toxic-waste sites and referred to as a "toxic doughnut."

Environmental racism—discrimination in the placing of toxic wastes in communities where minorities live—is now being recognized as a human-rights violation.

"South Central Los Angeles is in a zip code that is the single most polluted zip code in the state of California," said Vice President Al Gore, who co-sponsored a bill to stop environmental racism. "That is not an accident."

The *National Law Journal* has charged that the Environmental Protection Agency enforces its cleanup laws unfairly. It stated that "white communities see faster action, better results and stiffer penalties than where . . . minorities live."

Hazel Johnson lives in a housing project on Chicago's far South Side that was built on top of a garbage dump and is surrounded by at least fifty landfills and toxic-waste sites. Johnson, founder of People for Community Recovery, has discovered that more than 95 percent of her neighbors suffer from respiratory problems, skin rashes, or burning and watery eyes. The community also has been plagued with high cancer rates, kidney problems, and birth defects.

"We have a sewer-treatment plant where they put sludge out to dry that is horrible because it smells like hundreds of decomposed bodies," she said. "We have babies that were born with tumors on the brain, that died at two to three years old. We had one little baby [born] with the brain protruding from the head. Many people in my community have died. It's a form of genocide."

A premature baby touches her mother at Children's Hospital in Boston. The baby later died. The United States ranks eighteenth among industrialized nations in infant mortality rates.

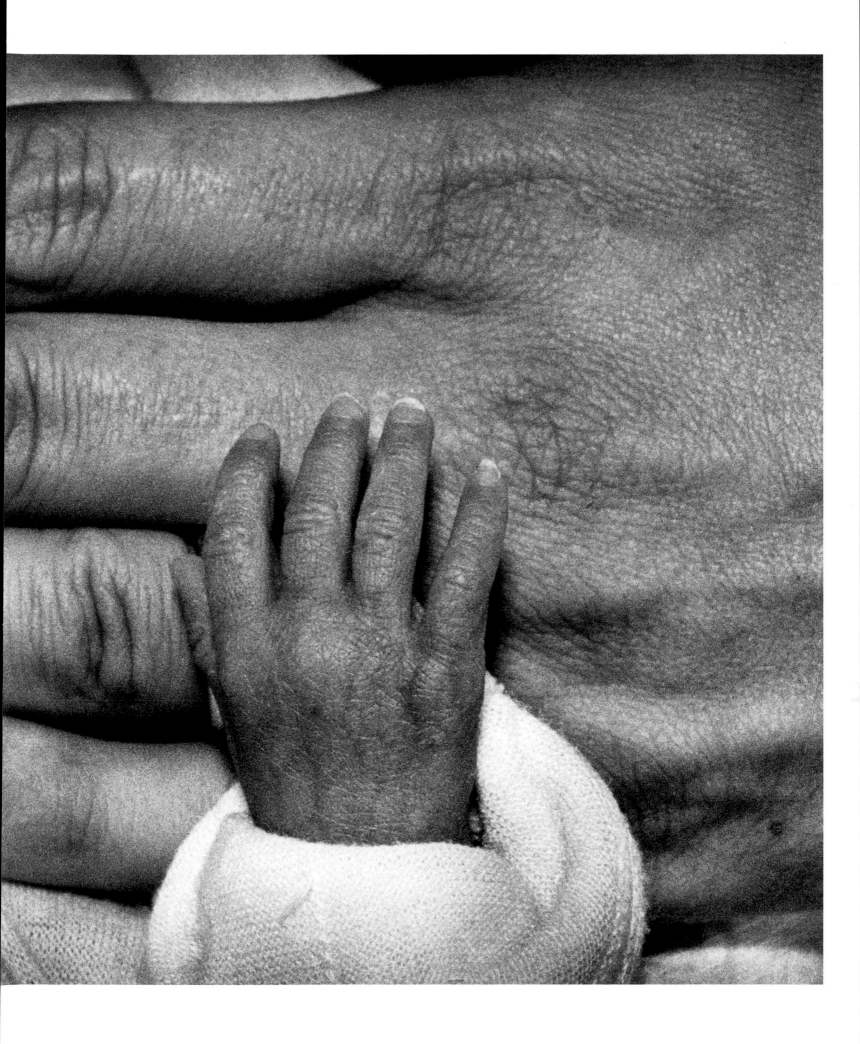

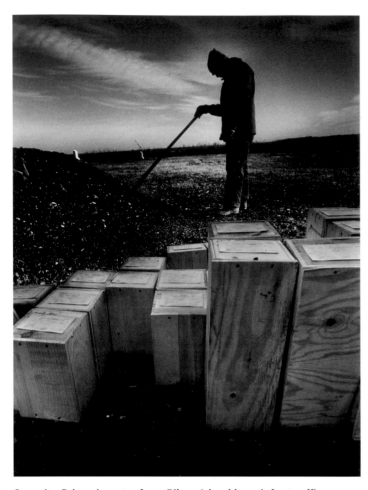

Opposite: Prison inmates from Rikers Island bury infant coffins on Hart Island, New York City. The caskets are stacked seven deep, a thousand to a grave. *Above*: Another prisoner reflects on his task.

The baby is passed from one person to another in a rocking motion, but this is not a child in a cradle—it's a dead infant in a simple pine box being lowered into a mass grave. This could be Rwanda, except for the New York City skyline sitting eerily in the distance.

The men, prisoners from Rikers Island making thirty-five cents an hour, work quietly and respectfully. The infants' coffins are stacked seven deep in a pit, looking like so many wooden shoe boxes. When they number a thousand, or about a year's worth, the diggers cover the pit with carbon and dirt, place a simple white concrete tablet on the site, and move on. During the burial, the prison guard speaks only once: "Don't throw the dirt on the coffin, place it."

The coffins are collected at New York hospitals and shipped over on a car ferry. "The first time I saw those baby boxes I got upset," says Michael Pastorino, a driver for the Department of Health and Hospitals. "Most of them are stillborn. Most of their lives are minutes and hours. It hurts. I have a sixteen-month-old son, and when I get home, I give him a big hug."

The potter's field on the 102-acre Hart Island has been used by the city to bury its poor since 1869. There are more than 750,000 bodies buried here, roughly half of those are children. Confederate soldiers were detained on Hart Island during the Civil War, and Union soldiers were buried here and later moved. Germans caught spying off the coast of Long Island were imprisoned here during World War II. Later, Nike missiles were installed, and the rusty silo remains. This is where they dumped the stands from Ebbets Field after the Brooklyn Dodgers deserted the city.

For the prisoners, the burial detail is coveted. "It beats sitting in a cell, plus you're doing something good," says one. Near the burial site a monument reads, "Blessed are the poor, cry not for us for we are with the Father."

But at least one prisoner is upset. "It's sad to see so many kids before they even get a chance at life," says Curtis Iaison. "Man, we're burying crack babies and we should be burying drug dealers."

Why do we have mass graves of infants in the United States? "Unofficially," says one Department of Corrections official, "you say two words—crack and AIDS, and you got most of them."

Statistics bear him out. In 1988, an estimated 375,000 fetuses were exposed to illegal drugs in the United States, according to Congress. New York City currently has the highest rate of AIDS in the nation, and for children aged one through four, AIDS is the leading cause of death.

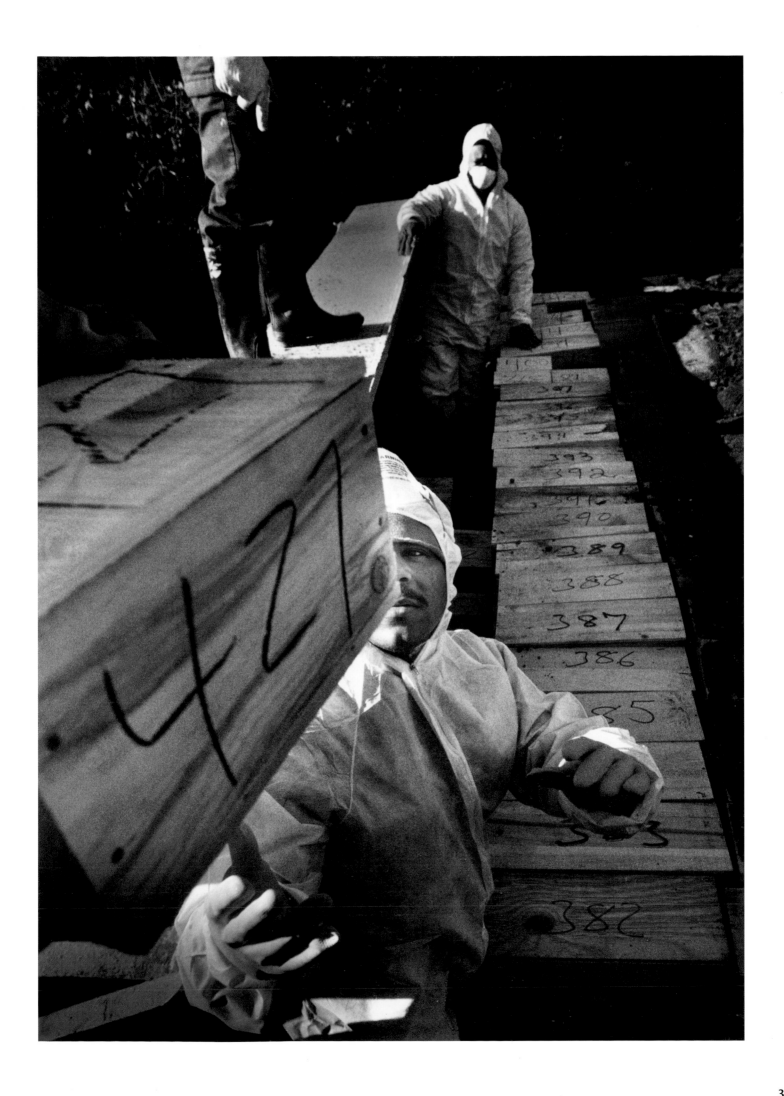

The baby is legally drunk.

Inglewood police and paramedics rush Jules Stewart into the emergency room. The sixteen-month-old boy's blood-alcohol-level is .35, more than four times the legal limit for intoxication in California.

"He wasn't breathing when they got to the house," says Cynthia Garreth, a neighbor. "They said just a little bit, just a little more, and he'd be dead." After treatment at two Los Angeles hospitals for respiratory depression, lack of oxygen, and hypoglycemia, the infant is sent to intensive care.

The mother says it's all a mistake, that the baby grabbed a glass of gin and orange juice at a house party. The social worker doesn't believe her and places the baby in protective custody.

In 1993, there were 1,299 child-abuse deaths nationwide and an estimated 2.9 million reported cases of abuse and neglect, according to the National Committee to Prevent Child Abuse. Reports of child abuse have increased 50 percent between 1985 and 1993.

"It's not just the disproportionate poor, socially marginal, and minorities," says Dr. Eli Newberger of Children's Hospital in Boston. "There's a tremendous underreporting of white kids.

"If a fractured-femur case goes into Boston City Hospital, the doctors would quickly recognize it as possible child abuse. But if it's referred by a private pediatrician to [an affluent suburban hospital], it never gets reported to DSS. Kids get different treatment if they are poor or rich. The DSS perspective is to punish the mother. . . . The system is a nightmare."

Norman Lowe, an investigator for the state's Department of Social Services, disagrees. "A lot of people have the misconception that we take children, but if it's not beneficial to the child, we don't."

Ride with Lowe and the frustration seeps in. "People tend to clean up the drugs if they know I'm coming. The older kids will lie for their parents, but the young kids will tell us everything," he says.

In Roxbury, one suspected drug abuser with two kids talks a good game. Her home is spotless and she insists that she, too, is clean. On his way out, Lowe asks if he can look in her refrigerator. It's empty.

Another investigation is for child abuse: Lowe asks a woman for directions. She answers in perfect English. It turns out that this is the woman he is looking for; she is suspected of beating her daughter. When he starts to ask her about the abuse, she no longer speaks English, but turns to her daughter and says in Spanish, "Don't answer any questions."

Next case: a charge of dirty and neglected children. "Who called?" asks the mother. "Was it the Vietnamese? I want to know. I'm gonna beat their heads in." Her son comes into the room. He's clean, except for his mouth.

"Maybe it's because I was in a fight," he says. "This 220-pound girl, she called me a white honky. I called her a nigger." Lowe, an African-American, sighs deeply when he returns to his car.

In Los Angeles, child-abuse reports jumped 24 percent in 1993. "We see nine hundred cases a year," says Dr. Nancy Schonfeld, director of the emergency room at Children's Hospital Los Angeles. "One-third of them are custody battles."

"In this emergency room, the majority are sexual abuse," says Dr. Bonnie Goldstein. "A doctor's exam on a frightened ten year old takes one hour and you're re-enacting in subtle ways what happened. As a feminist and an American woman, it drives me crazy."

Sometimes the wrong person is asking the questions.

An eleven-year-old girl, allegedly raped by a twenty-year-old man, is interviewed by a male police officer while his female partner wanders the halls. He asks the same questions over and over. His tone is unsympathetic. The girl feels violated. "He made me feel like a whore," she says. "Like a criminal."

But on another day, two LAPD officers are heroes. They rescue a young boy from an abusive home, buy him food, play with him. When they get up to leave, the boy holds out his arms to them. "Uh-oh," says one officer. "I'm gonna cry."

In Boston, a quiet afternoon is pierced by screams and sirens. Police find a three-month-old baby and his mother sitting on the floor, weeping. Between sobs, the mother says her boyfriend —the baby's father—kicked her, tried to strangle her, and beat the infant. Paramedics check the baby. They discover marks on his temple, cheek, chest, abdomen, both shoulders and buttocks. They rush the infant to the hospital. Police arrest the suspect, but he makes bail. The probate court allows supervised visitation of the child.

The assistant district attorney is not happy. "If the victim is a stranger, they wouldn't have allowed visitation. But because the baby has the misfortune of being related to the alleged batterer, they allow it. It's ridiculous. What is the purpose?"

Richard Serino, director of field operations of Boston's Emergency Medical Services, is mad and frustrated. "The alleged attacker is five-feet-ten and 250 pounds. The baby is two feet tall and 20 pounds. You're three months old. Your bones are still being formed. What do you have to protect you?"

Before the case comes to court, a member of the family tries to cover up what happened. "The babies were playing on the bed. He probably fell off."

"The victims tell the truth initially," says Serino. "But then they recant in court for their own safety."

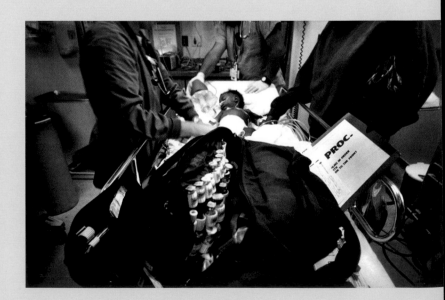

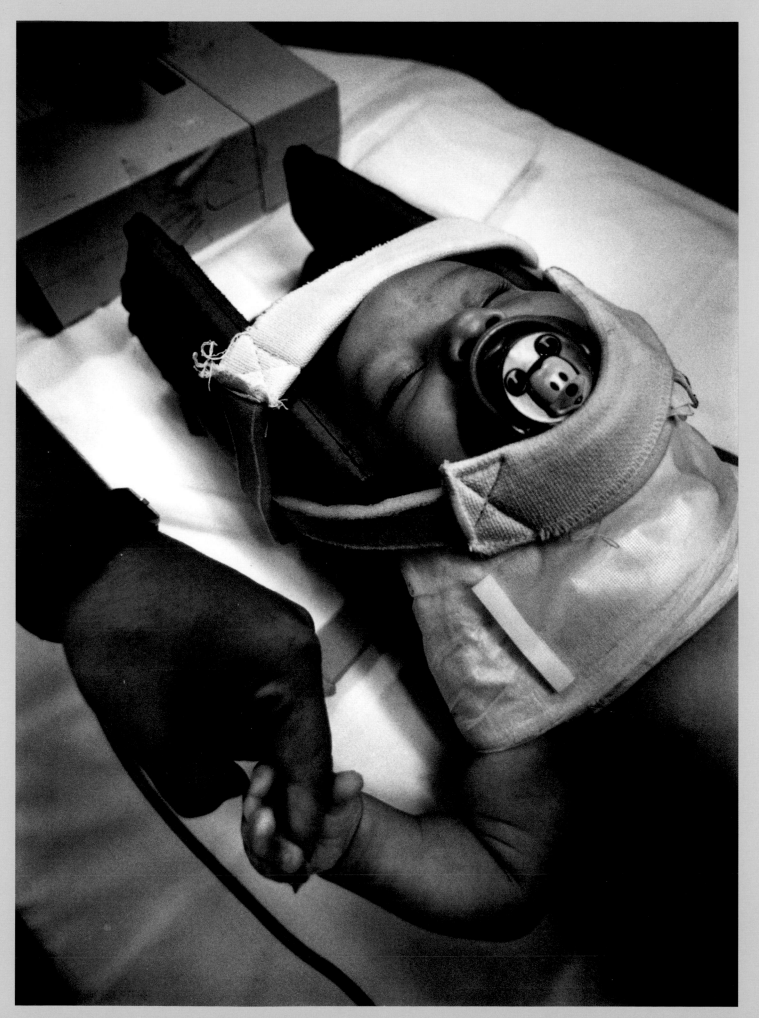

Police report on this abused child in Boston: bruises from head to buttocks. *Opposite,* he is rushed into Boston City Hospital.

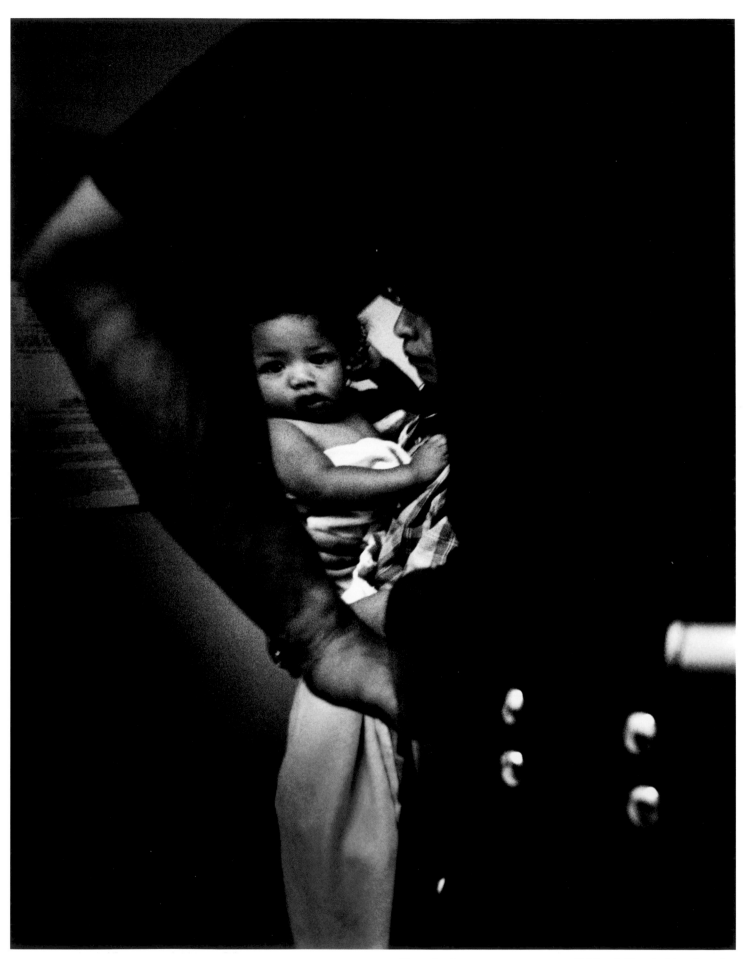

Above: In the emergency room at Children's Hospital Los Angeles,
a police officer questions the mother of an abused child.
Opposite: A CAT-scan of a severly abused child.

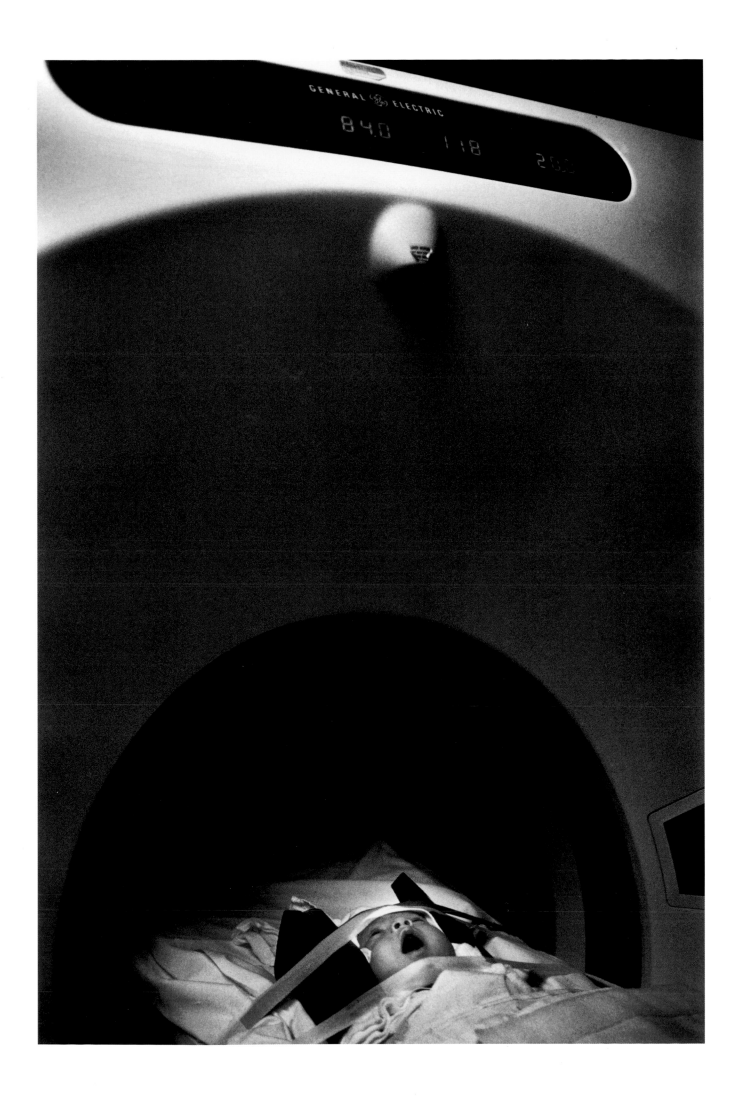

An abused Los Angeles
boy reaches out
to the police officers
who rescued him.

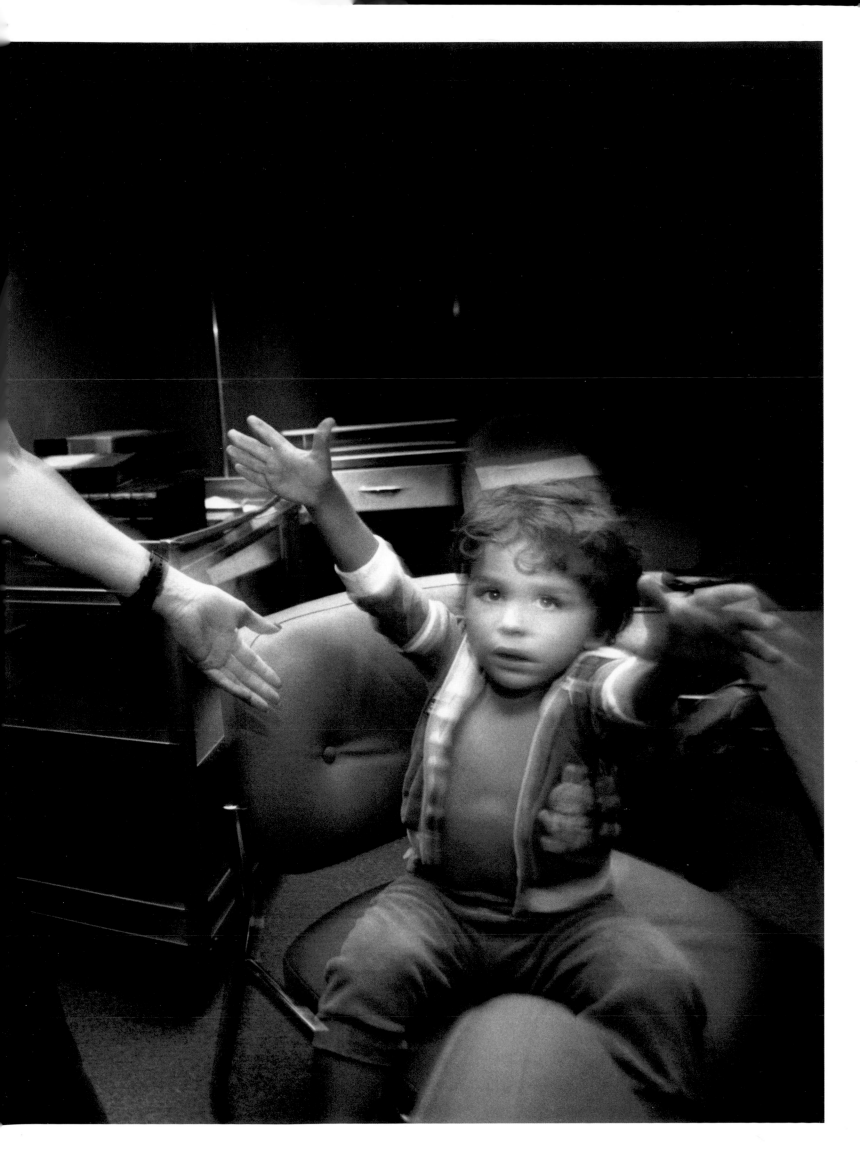

"Baby" puts down the *Flintstone's Fun Book* and lets a visitor into the bathroom while she puts on her nylons, the ones with the *x*'s scrawled up the legs in ballpoint pen. She doesn't want her name used, but she likes having her picture taken. Baby wants a ride to work, she says, and Baby wants it now. The fourteen-year-old prostitute doesn't understand why a journalist won't transport her to her next trick.

The next afternoon, Baby's asleep in a queen-sized bed at the City Centre Hotel in Seattle. It's the kind of place where the front desk is behind bars, and the scent is a mix of Lysol and stale cigarettes. She looks like a girl at a pajama party with her junior-high friends. On one side of her is a freckle-faced six-teen-year-old hooker, fast asleep except for a hacking cough. On the other side is what both teenagers call their friend. A twenty-something madame who calls herself "Brown Eyes."

Brown Eyes pays $39.56 a night for the room, a sum she deducts from the earnings of the two teenage prostitutes. She says her father was a pimp and her mother a heroin addict.

"It's better they're with me than with some pimp who'll beat 'em, not feed 'em," Brown Eyes says, glancing at her two sleeping bedmates.

"It's better than these girls livin' in abandoned buildings screwin' every boy and gettin' every disease. They're young and impressionable.

Above: Baby, a fourteen-year-old prostitute, in a Seattle hotel.
Opposite: Three teenage prostitutes share a bed.

"If they were twelve or thirteen I wouldn't be workin' 'em," says Brown Eyes. "Fourteen's OK, because that's when I first started having sex. But because my mother was a heroin addict . . . I can't have children. This is my family."

As many as two thousand youths call the streets of Seattle home, according to the Seattle Youth and Community Services Agency. Nationally, 1.3 million teenagers run away from home each year, according to government figures. These kids don't have to look for trouble, trouble looks for them.

"Within forty-eight hours of running away most kids will be approached for prostitution, and 10 to 15 percent of these teens end up as prostitutes," says Dyana Flanigan, marketing manager of the National Runaway Switchboard, a youth and family-crisis help group. She said the runaway problem is getting worse as families endure more stress. Calls to their hotline increased a record 50 percent in 1996.

Back at the hotel, it's getting dark and both teenagers are just getting up. Brown Eyes is out, but the teenage hookers refuse to admit she is a wrong number. After all, they have everything they need, including cable TV.

The sixteen year old admits to shooting drugs. She doesn't want to work, and says she's got bleeding ulcers. She won't talk about herself. "I'm not the one," she says in between imitating the poop-a-choo background sounds of rap records.

The fourteen year old says sometimes she hates being a prostitute but "I need to make a hundred dollars." Of her parents she says, "I didn't run away from them, they ran away from me." But other times she dreams aloud of having dates in a big Cadillac with gold trim.

Talk to these girls about sexual exploitation, and they don't know what the phrase means. Tell them that shooting drugs means death; sex without condoms means AIDS; and that Brown Eyes should be turned over to the police, and they say no way. Offer to drive them home to their parents, and the conversation is over.

Finally, Brown Eyes arrives with the evening's game plan. She has convinced a pregnant teenage runaway named Sky into pimping one of the girls on Aurora Boulevard, while the other one uses the hotel room for "dates."

For the time being "the family" watches television, but everyone is bored. There are eight people in the room watching the tube; outside, a hooker argues with a man in a pickup truck. The family votes and the television is turned down. Street fights are better entertainment than Monty Python.

At Denny's, the two teenage hookers devour supper. They each weigh ninety-eight pounds. Baby picks up another *Flintstone's Fun Book* at the cash register, goes back to the hotel, and puts on her makeup. Everyone fusses over her and tells her how pretty she looks. Everyone but Sky, who just chain-smokes her cigarettes. "I'm scared," she says softly.

A year later the phone rings. It is a police detective calling from the West Coast. "Brown Eyes" is under arrest. "Baby" has finally grown up.

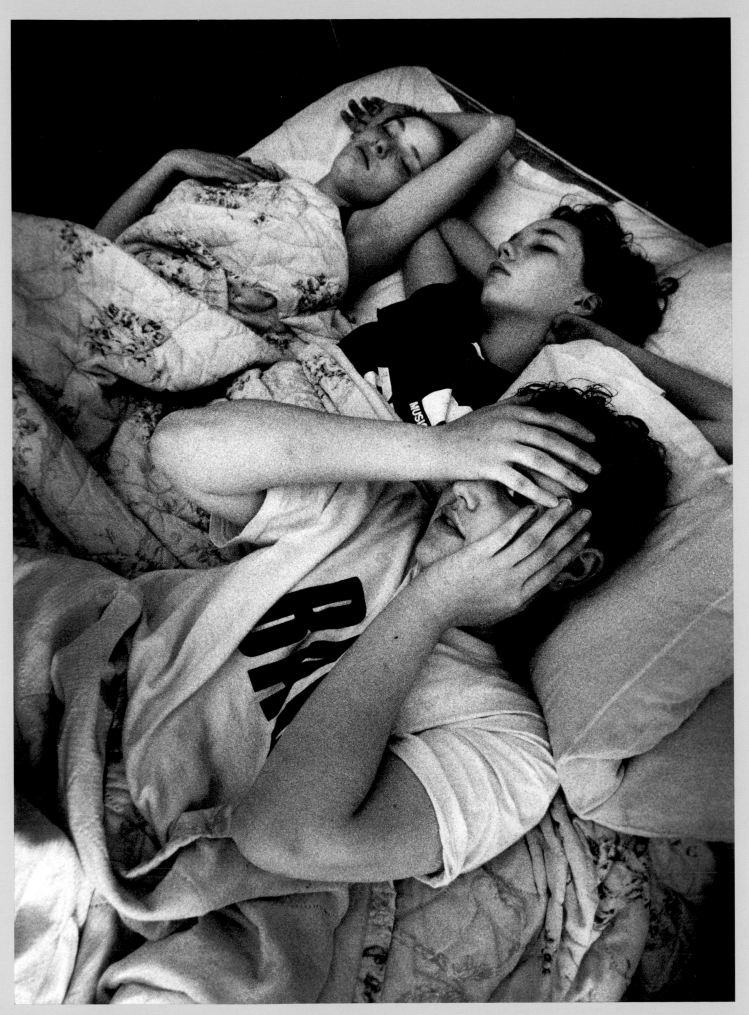

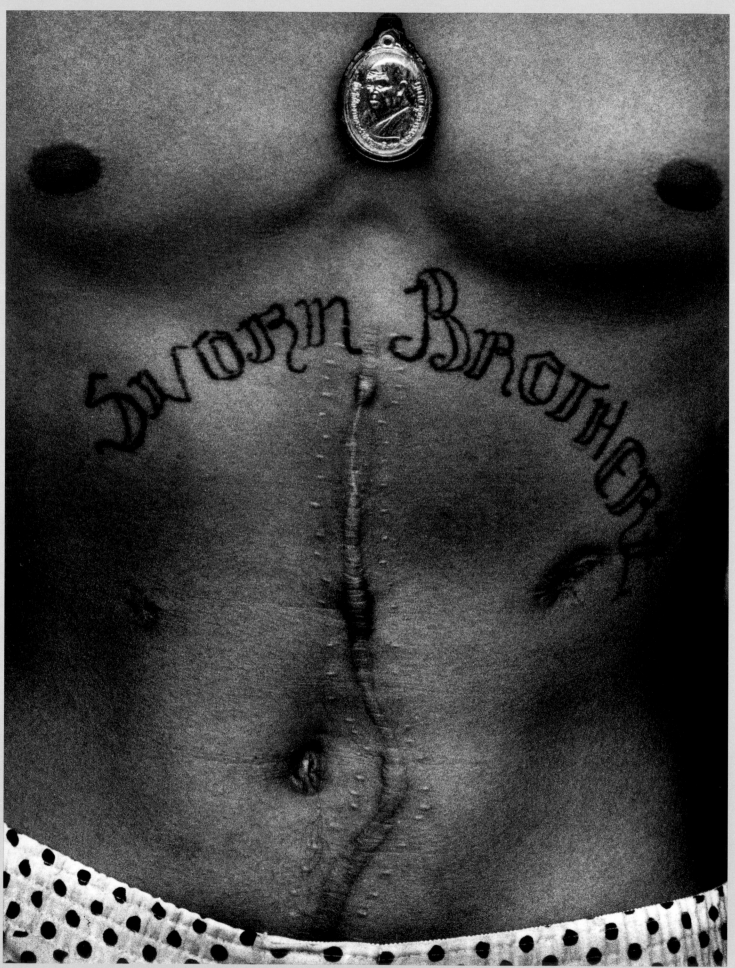

Kitt Philaphandeth, nineteen, of Lowell, Massachusetts, a member of the Sworn Brotherz gang:
"If I was never in it, I'd be the coolest kid . . . if I leave, I'd get jumped out."

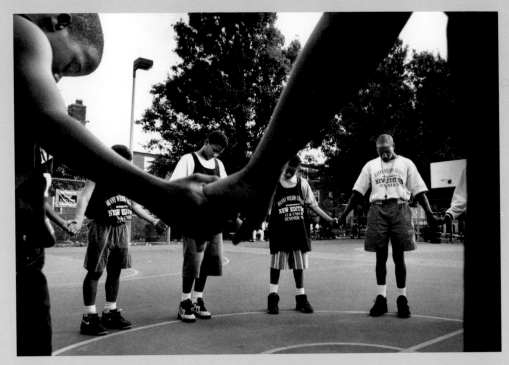

Jeff Bynoe, thirty-three (far right), leads a pregame prayer in Orchard Park, where he was born and raised. "We hit bottom in '87, '88 when they let the gym deteriorate, then closed it, and the kids went nuts and the gang stuff started."

When the FBI performs ballistics tests, the specialists fire into a substance that simulates the human body—Jell-O. We are all Jell-O versus a speeding bullet.

One child is killed by a gun every two hours in the United States. Between 1979 and 1991, nearly fifty thousand children were killed by firearms—a total equivalent to the number of American battle casualties in the Vietnam War, according to the Children's Defense Fund.

We used to have basketball wars in Los Angeles and Boston. Magic vs. Larry for the world championship. Now the basketball wars are in our playgrounds, and the losers leave on stretchers.

In Los Angeles, Gilbert Guytan, thirteen, was playing basketball when a bullet pierced his chest. In the emergency room, doctors didn't have to ask him his name; it was written on the elastic band of his underwear.

"Life here used to be paradise," says his father as his mother crumples into a chair at Children's Hospital Los Angeles. "Now, it isn't worth a plug nickel." The doctors say the father can enter the trauma room. His son is conscious. "Make me smile," he tells him. "I'm never going to leave my room again. I just want to move," says the wounded basketball player.

"He's lucky," says Officer Dominique Fuentes of the LAPD's Southwest Division. "An inch lower and they would have shot him in the heart. We can't really referee it. We're undermanned. We can't be everywhere at once. We just get to clean up the mess."

The cops and his father leave, and friends enter forming a huddle around the bed. "I went back and got the gun," whispers one kid. "Fuck the Mexicans. Let's rumble."

But I overhear them and threaten to tell their parents. In a heartbeat, they stop being gangsters and resume being kids who wear their names on their underwear.

In Dorchester, Massachusetts, Emir Quintana, an honor stu-dent, was playing one-on-one basketball at the Winthrop Playground when a .25-caliber bullet traveling, according to FBI estimates, 555 miles per hour, ripped into his chest. Police arrived less than two minutes later, but Quintana was already dead, face down between the foul line and the three-point line. Into his casket, his family and teammates placed his South Boston High School jersey, nine pictures of Michael Jordan—his idol—and a letter from the athletic department of Rutgers University.

"I hate guns," says Father William Francis of St. Paul's Catholic Church before the Quintana funeral service. "This may sound trite, but we have to get back to family values. These kids see nothing but violence."

In Springfield, Massachusetts, on a steamy summer night, Julio Orenga, sixteen, is in handcuffs, and his mother in tears. "I'm scared," says thirty-two-year-old Maria Arenas. "He threatened me three times. His father is in jail. He wants to be like his father, beat me and take drugs. The gang is trying to control the area. I gotta get out of here. Look at this. He smashed my high-school-equivalency diploma."

At Springfield police headquarters, Lieutenant Anthony Pioggia of the Springfield Youth Aid Bureau tries to explain why his city has a higher murder rate than Boston does.

Orenga, bare-chested and defiant, glares at him.

"I have a family," says the sixteen-year-old gang member. "Los Solidos is my family. I won't deny that."

Pioggia shakes his head. "You pushed your mother, punched a few walls, and broke a frame. You even said you were gonna kill your mother in the presence of an officer."

"I didn't say shit. She promised to wait till my father got out of jail. But she went on a date. She's a whore."

"The bottom line is respect, and they don't have it. Some kids are not fit for society. They need to get their asses kicked."

(continued on page 48)

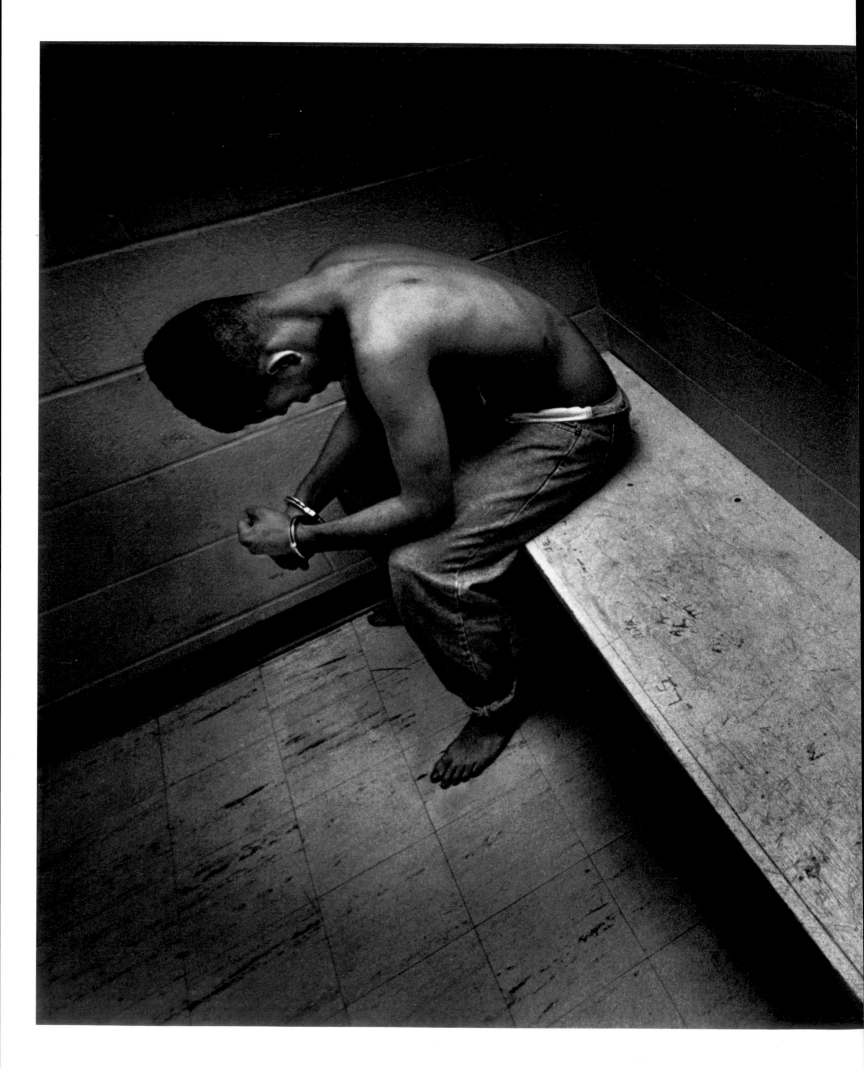

Julio Orenga, sixteen, in jail in Springfield, Massachusetts. The charge: assault and battery of his mother.

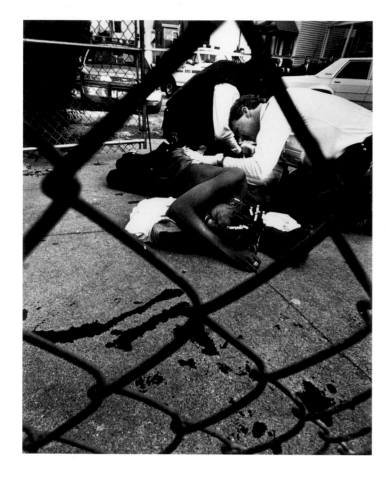

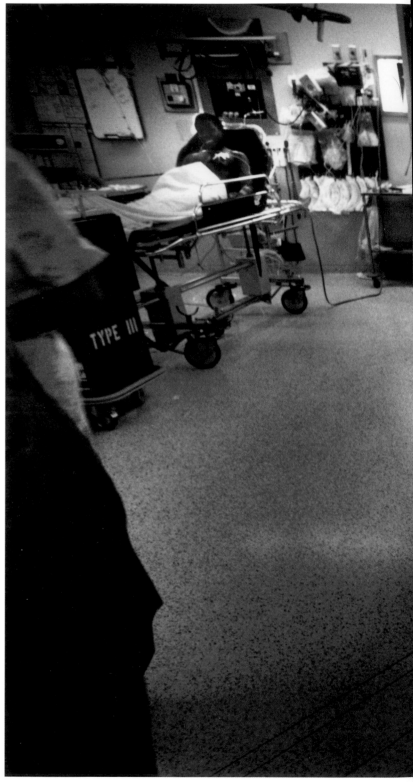

(continued from page 45)

"You ought to show some respect. You'd show me respect if I didn't have these handcuffs on."

"Well, you're gonna be in jail and I'm free. Julio, you've gotta grow up. You're not gonna like jail."

"You some comedian. Bet if we was in the streets, you wouldn't be talkin' this way to me."

The next day is Saturday, so there is no chance for bail, but plenty of time for second thoughts. "It's cold and there's no mattress down there," says a subdued Orenga. "Time goes slow." Julio never makes eye contact. "I was wrong. . . . She is my mother, but I'm a Los Solidos. I love those people; they treat you with respect. I never got that at home."

There are close to one million youths in gangs across the United States, according to Laurence Jones of the National Gang Network, which tracks gang activity.

In Lowell, Massachusetts, a Sworn Brotherz gang member named Kitt Philaphandeth sports a huge scar and a medal showing a Laotian monk on his chest.

"TRG [Tiny Rascals Gang] was at the party and they shot me. Gangs? It's like a trap. I joined early because of racism, but now the racism isn't as bad. There's no reason to join a gang. If I was never in it, I'd be the coolest kid. But, like now, if I leave I'd get jumped out [beat up]."

What's the worst thing you've done? Murder?

"Close to it. I don't know. I never stayed. But after the hospital, the surgery, and all that torture, I'm gonna make somebody pay. I'll shoot him several times in several places. I'm gonna make him slowly feel the pain. I took some LSD and I'm tripping. I can see trails. But you know what I really want? I want to live on Cape Cod with a wife and kid."

Above: **The bullet that pierced Gilbert Guytan's chest in a Los Angeles drive-by missed his heart by an inch and stunned his mother.**
Top left: **Richard Serino, head of Boston's Emergency Medical Services, treats a shooting victim near Dorchester High.**

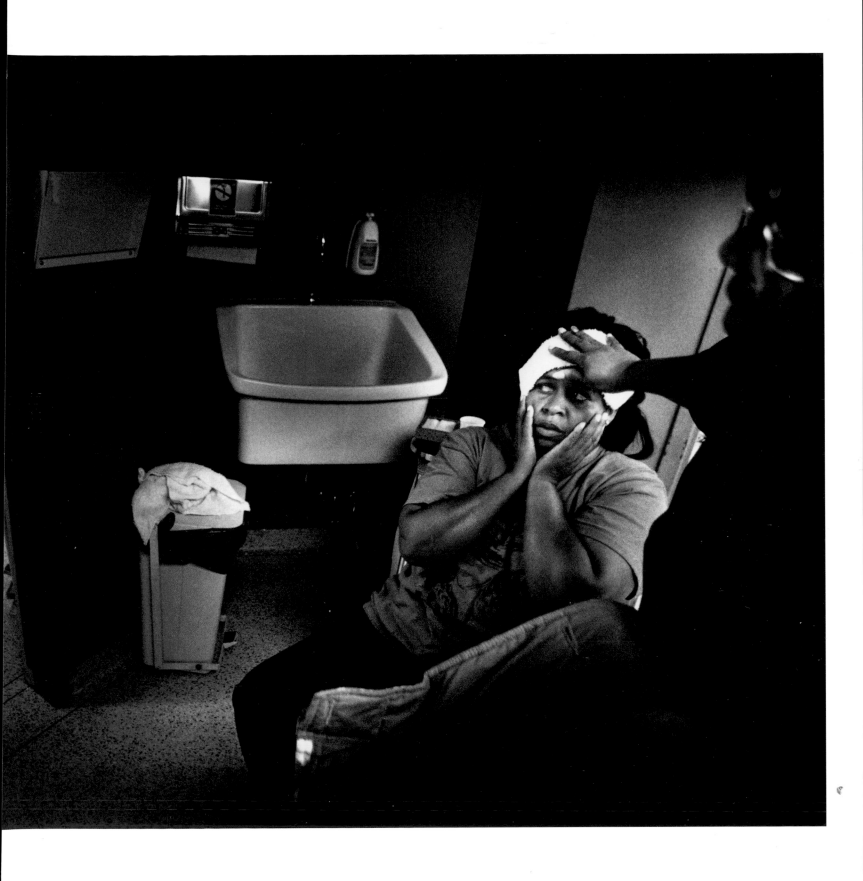

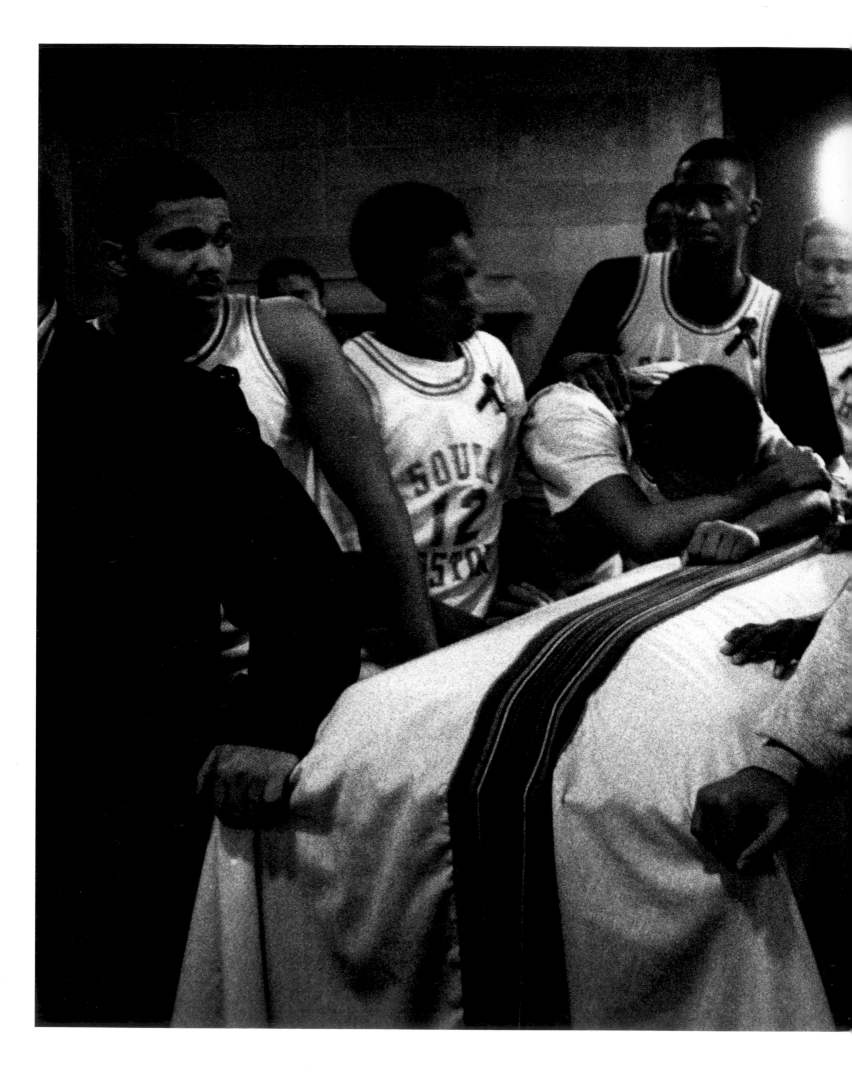

Emir Quintana was gunned
down while playing basketball
in a Dorchester playground.
Mementos of his short
life were placed in his casket
by family and friends.

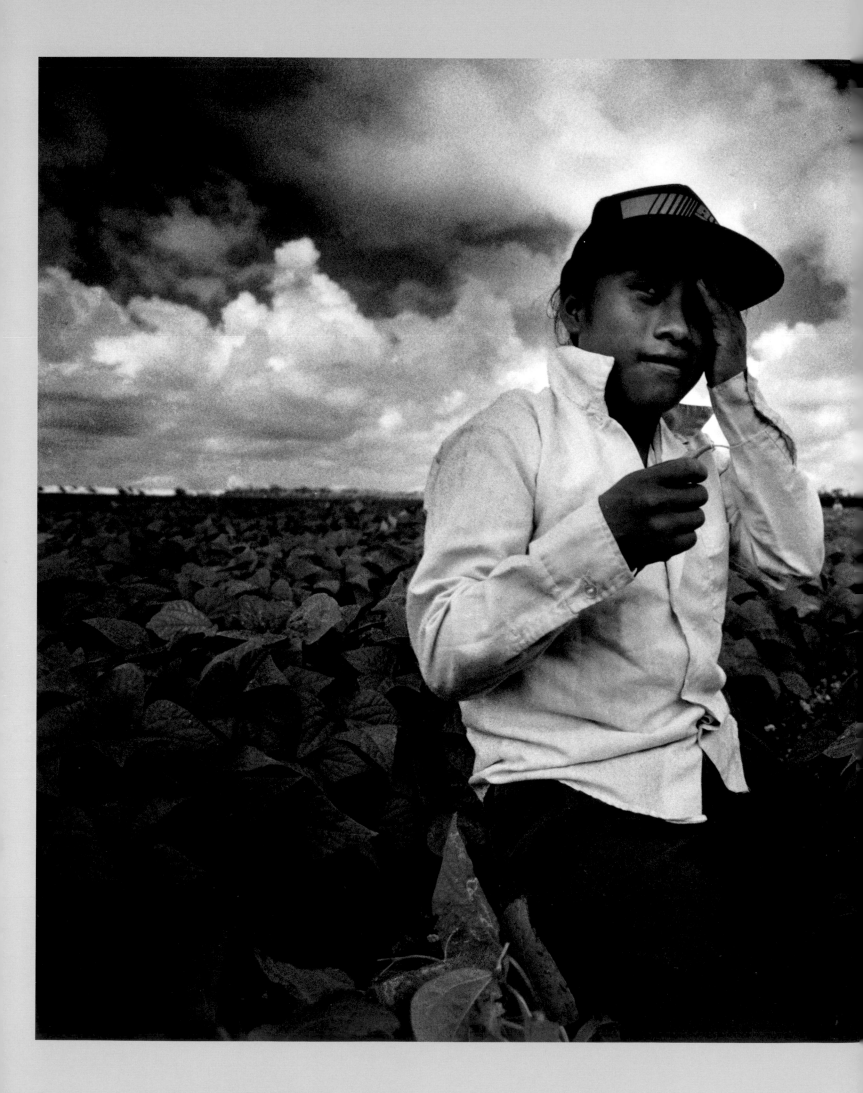

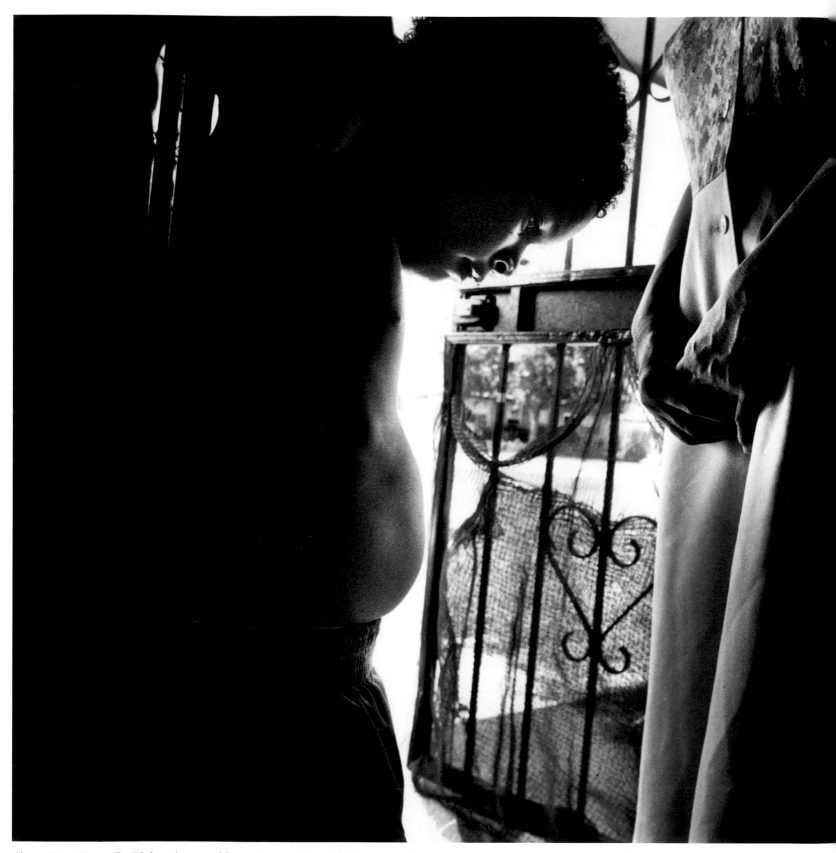

Above: Mary Maxwell with her six-year-old son Tiawan. "The child is malnourished, probably from eating only cookies. He's not getting proper food," says Lynne Delvich, a registered nurse at the Family Health Center's Migrant Child Outreach Program in Apopka, Florida.
Opposite page: Juan Carlos Gonzales, eight, ponders his family's fate in their trailer home in Glenville, Georgia. His father, now deceased, never got a medical checkup until his body was riddled with cancer. Juan's mother, Maria, is pregnant and cannot work. His twelve-year-old brother, who works in the field picking flowers off tobacco plants, is asked what he does for fun. "Nothing," he replies.
Previous spread: A child works illegally in a Florida field.

The sun beats down and the children are on their knees, heads lowered, picking green beans, helping to make sure America continues to pay less for food than any country in the world. But when a man enters the field, the children scatter.

These migrant farmworkers, most of whom are here legally, hide because they are violating child labor laws.

There are more than one hundred thousand children working illegally on U.S. farms, according to the National Child Labor Committee, a New York-based group working to prevent child exploitation. The United Farmworkers Union estimates that there are eight hundred thousand children working in agriculture, many of them legally, under special exemptions to labor laws.

But agriculture ranks with mining and construction as one of the three most dangerous occupations in the United States, according to a 1992 report by the General Accounting Office, the investigative arm of Congress. Approximately 23,800 children and adolescents were injured on farms, and three hundred died, between 1979 and 1983, the last time national statistics were compiled. The GAO report cited a 1990 study of migrant children working in western New York that found that 40 percent had been sprayed with pesticides.

Labor laws originally passed to allow children to help on small family farms are now being exploited by huge farm conglomerates that worry more about crop damage than damage to children, activists say.

"Why are these kids working in the fields?" asks Diane Mull, executive director of the Association of Farmworker Opportunity Programs, a national federation of farmworker employment, training, and support organizations. "For just about every labor standard in the book, agriculture is exempt. They

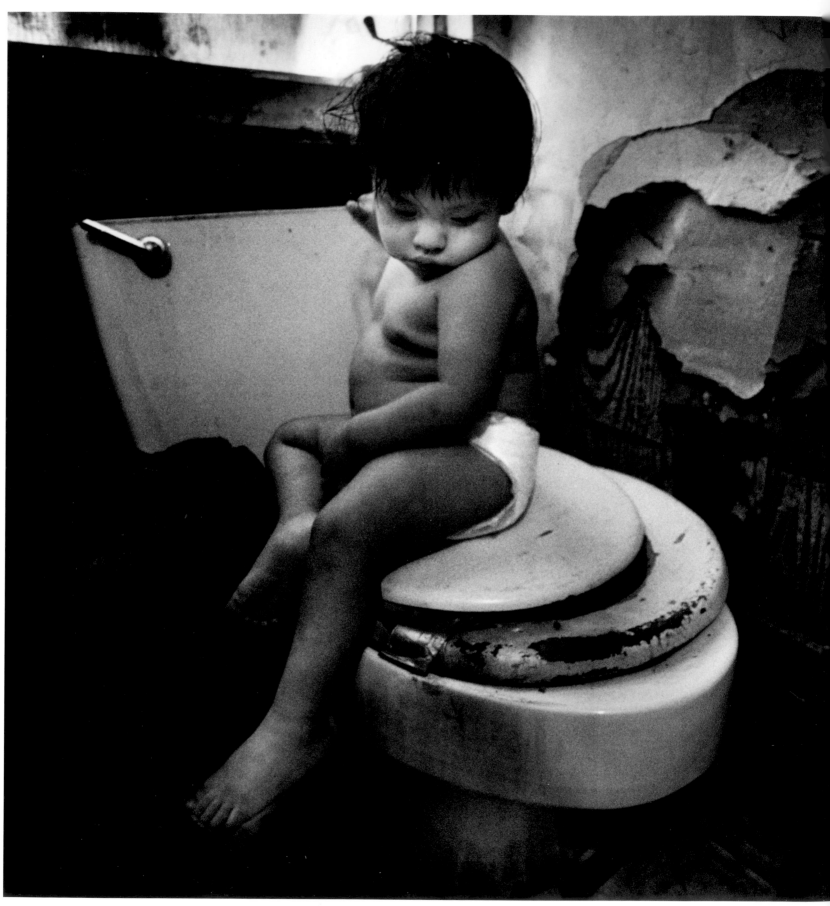

Roberto Flores sits in an Apopka, Florida, apartment that the landlord refuses to fix. "The sewage leaks into the kitchen when it rains," says his mother, Maria Santana. "And the baby gets rashes all over his body." They have since moved.

work, so they can't go to school, and they don't make much money, so they stay poor."

But higher wages are not the answer, according to farmers.

"If we say, 'OK, let's pay them more,' then there is no way to pass it on [to consumers] and come in cheaper than Mexico, Chile, and Brazil," says Scottie Butler, general counsel for the American Farm Bureau. "Housewives in Boston may not understand it, but there's nothing wrong with fourteen year olds getting their hands dirty and learning some discipline. Would you rather they stay in a city slum?"

Migrant families lead a third-world life. Paid piecemeal by crew leaders, they are sprayed with pesticides in the fields, and the children receive more education in discrimination and racism than in reading, writing, and arithmetic. Even though two-thirds of them now struggle below the federal poverty line, the worst may be yet to come.

"Here they all know about Proposition 187 in California and they think they're going to be deported," says Sister Ann Kendrick of the Office for Farmworker Ministry, a Florida migrant-aid group. "They used to come here and work hard; the adults suffered, but there was hope for the kids. Now the dream is getting dimmer and dimmer. They want to deny school and health services, even to the legal immigrant."

Proposition 187, which sharply limits benefits to undocumented immigrants, was approved by California voters in 1994, 59 percent to 41 percent. It is now under court challenge.

Such measures, coupled with recent Republican proposals to restrict services to legal immigrants, have people who work with migrant families worried.

"They are the bottom of the barrel," says Diana Riggs, head nurse for a Georgia assistance program. "But if they don't work, the food would rot in the fields."

In 1994, only two hundred children nationwide were caught illegally working in the fields, according to the U.S. Department of Labor, which says it conducted four thousand investigations. Food producers "know they are being targeted," says a spokeswoman, "so they're being good."

But on a recent Saturday morning, at least a dozen children were working in a Homestead, Florida, field.

"The only people that can stop it are the growers," says Sauveur Pierre, a 1991 Reebok Human Rights Award winner for his work with migrant farmworkers. "If the farmer knows the Department of Labor will fine them, that'll stop that."

According to various public and private organizations, the rate of school enrollment for farmworker children is lower than that for any other group of children in the United States, and the dropout rate is 45 percent. The infant mortality rate for migrant farmworkers in California is almost double that of Bosnia-Herzegovina. The life expectancy of a migrant worker in the United States was forty-nine years in the 1970s, the most recent period for which statistics are available. "The research isn't there," says Mull. "No one's putting the money into studying the problem."

But finding the problem is all too easy.

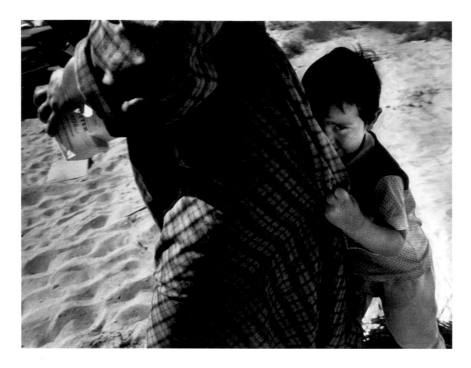

Rosa Rubio of Lyons, Georgia, was happy picking Vidalia onions for seventy-five cents a bushel to support her family of five. But last June, when the onions were all harvested, she packed her family into her '89 Chevy Blazer with 120,000 miles on it.

"I was desperate," Rubio says. Forty miles away she met a crew leader at a convenience store who told her about a job paying five dollars an hour grading and packing watermelons. "I tried to get the kids into day care, but there was a long waiting list."

Angelica Santos of the Kitty Kastle Head Start Center for Migrant Children in Lyons, Georgia, confirmed Rubio's story. "Her children were on the waiting list. Unfortunately, we don't have room, so some wind up in the fields. They shouldn't be out there. Fire ants and unattended kids in hot cars, pesticides—it's so sad."

So Rubio took her children to work. Inside a huge shed she saw youngsters putting stickers on watermelons as they passed by on conveyor belts. She and her husband began to work.

The next thing she remembers is hearing the screams. Her son Jacob's hand was caught in a conveyor belt. "I saw his arm wasn't there, and his hand was stuck in there, and I went crazy." His father helped free him and they rushed Jacob to Tifton Hospital, where he was then airlifted to Atlanta.

"They gave me a box," Rubio says. "I didn't know what it was. They told me, 'Take the hand. We got it out.' They said it was all shriveled up—all white and all dead—and they put it on ice. In Atlanta they couldn't reattach it, and I never saw it again."

The boy needed surgery, so Rubio went to the factory for help. "They said they were gonna help me and then they backed off and I never heard from them since."

Jacob sits at the kitchen table and cries. Every day he cries. One day, Rubio recalls, he asked, "Ma, are you still gonna love me with one hand?"

Above: Jacob Rubio, five, of Tifton, Georgia, lost his hand when it was caught in a conveyor belt. "Now he's desperate," says his mother, Rosa. "He doesn't want to go out. He asked me, 'Ma, are you still gonna love me with one hand?' "

Opposite page: A woman and her son get food assistance in El Paso. Although two-thirds of migrant farmworkers live below the poverty line, three-quarters of them don't receive any government assistance.

Mineirinho says he's nine, then he says he's twelve. One thing's for sure: he's high.

He's wearing an old sweater that smells of glue and urine. He has long fingernails caked with grime. His eyes are slits and his nose and mouth are immersed in a plastic bag smeared with glue, so that all you can see are the skull and crossbones on a piece of tape wrapped around his forehead.

"I've had a couple of friends die because of glue," says this victim of Rio de Janeiro's streets.

"We were robbing a tape deck, but this family saw us and one of them had a gun. We tried to run, but my friend got hit with two shots in the back. He said, 'Call my mother and say I'm dying,' but I didn't know who was his mother. He died."

Mineirinho goes back into the glue. Try to pull it away from him and he makes a fist. Then he comes up for air.

Where are your parents?

"They're dead."

Would you like to go to a shelter for street kids?

"I went there, but there's always a fight."

Do you know that glue causes brain damage?

The skull and crossbones head toward the toxic bag. "I like the smell," he says. "The police do nothing 'cause you're here. If you're not here, they'd take our money. Sometimes the police hit us and kick us when we are asleep."

He buries his nose back into the plastic and the bag inflates and deflates, the antithesis of life support. The Rio cops laugh as they drive by.

"If we want rain, we get rain," he says, head out of the bag. "If we want a rainbow, we get a rainbow." His eyes start to water, and the nose goes back into the bag.

He is hungry, and the glue cuts the hunger. "Someday, I'd like to work in a supermarket. Yeah, I wanna work in a supermarket, but for now I prefer the streets."

Mineirinho again raises his head from the bag. "When the glue stops, we get more." His face is beaded with sweat and he goes right back to the glue.

His friend, Marlelo Gomes da Costa, sixteen, agrees to go to a shelter. "I'm stopping." The glue has destroyed his brain, but he lives to sniff the stuff.

Without it, he gets angry and has to rob somebody. "Robbing gringos is a piece of cake. Gringos and old people.

"All of us are afraid to die, except when we're smelling glue. It gives us courage. We're afraid of the exterminating—some of the police do that. They think if they kill a street kid, that's the end of the problem," says Gomes da Costa.

According to a joint study by Human Rights Watch/Americas and the University of São Paulo, 5,644 teenagers aged fifteen to seventeen were murdered by death squads in Brazil between 1988 and 1991.

"It's a human-rights violation. They are not the cause of the problem, they are the consequence," says Roberto José dos Sāntos, director of the Sao Martinho Center, a children's shelter.

Sāntos and I try one more time to get help for Mineirinho, who is sitting sniffing and sweating in an empty lot. He begs for food, gobbles half a sandwich, then wraps the other half in his filthy sweater. With his fate on his forehead, he heads back into his plastic bag.

The next time we search for him, we are besieged by a half-dozen street kids who are high on glue and try to smash the car windows with scissors. They jump on the car and their palm prints smear the windshield.

There are seven million street children in Brazil, and forty million in all of Latin America, according to the World Health Organization. Without roots or security, they have no place to call home.

In a Mexico City sewer, Veronica, sixteen, has a poster of Jesus Christ over her shoulder and a puddle of blood in her lap. She sits on packing material full of cigarette burns and stains. The ground is slimy, and her home is decorated with electric cables, marbles, a yo-yo, a soiled doll, and an empty Christmas stocking hung on the wall. Her pants are unzipped and bloodied, she says, because she is having her period but has no tampons.

Veronica says she was raped four times by the police and sniffs glue because "it's the only way to forget this." She misses her two sons, but can't go home to see them because she is afraid of her abusive father.

"He hit me. My father hit me for nothing. He hit my mother and left her with bloodstains daily. I left my sons and I ran.

"I lived in the streets, begging. Yesterday, I tried to kill myself. I took twenty-eight tablets. Now I feel like my blood is very heavy. I was on a glue trip and very crazy."

She says of her life on the street, "The police beat me with a belt. Sometimes they come here and make me have oral sex. I was raped. Some men came into the sewer while we were sleeping.

"I want to see my sons, but I don't want to see my father. I would like to live with my sons." She is asked about a scar on her wrist. "I used a piece of glass.

"One time I read in the Bible that there was an Antichrist. Do you think it's going to happen?"

Veronica, sixteen, in her Mexico City sewer home. She seeks relief by inhaling glue because "it's the only way to forget this."

"I like to live in the sewer," says Juan José Mivboron, of Mexico City. "I like the rats. When they are dead, I pick them up and I pet them and I bury them with a cross because they have souls. I pray for our God to take this rat to heaven."

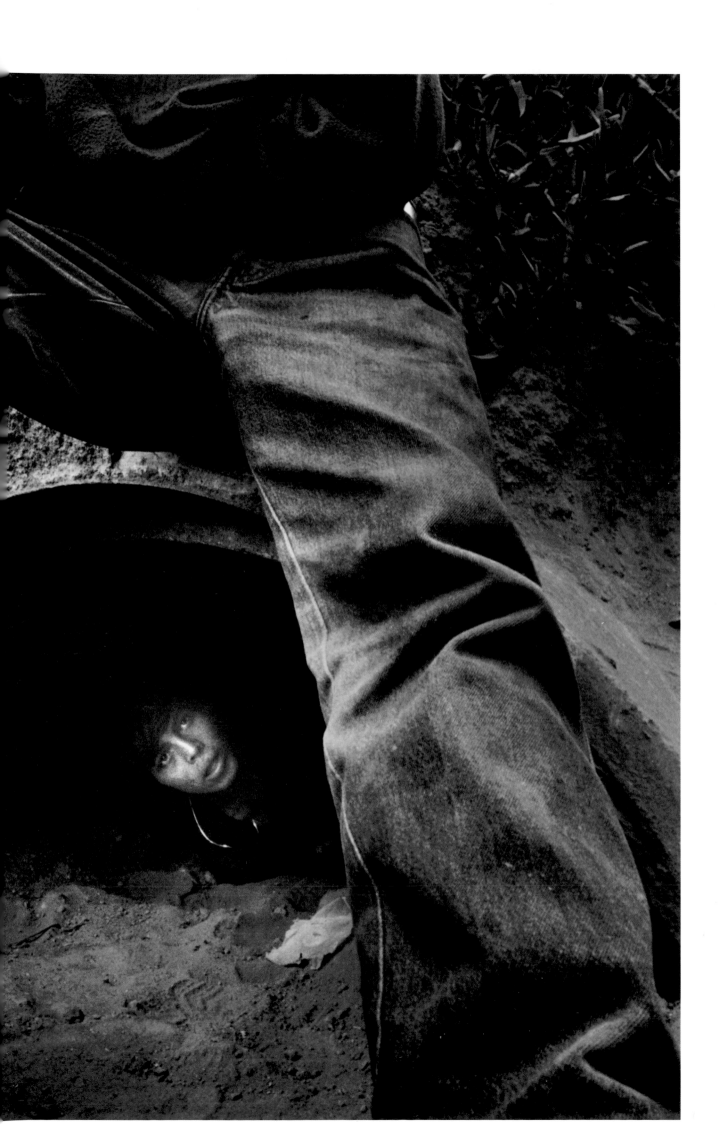

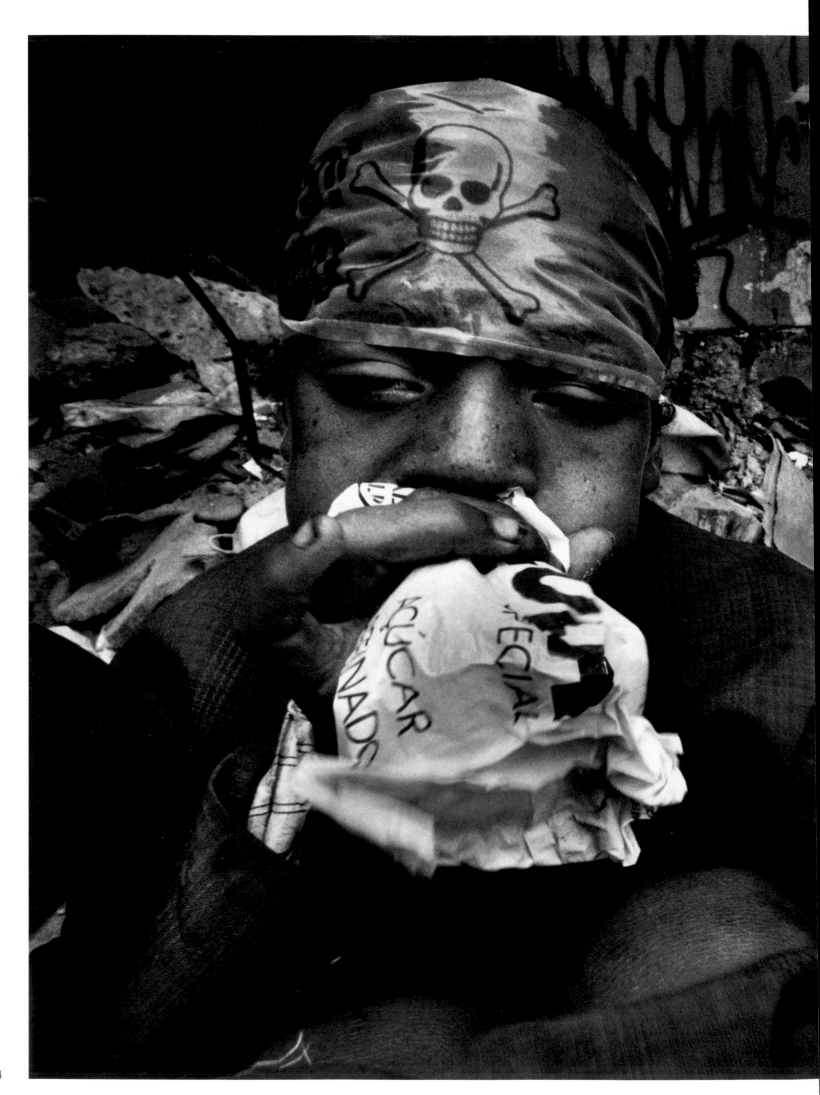

Mineirinho, a Rio street kid, inhales glue to quell his hunger and to escape reality. "If we want rain, we get rain. If we want a rainbow, we get a rainbow," he says.

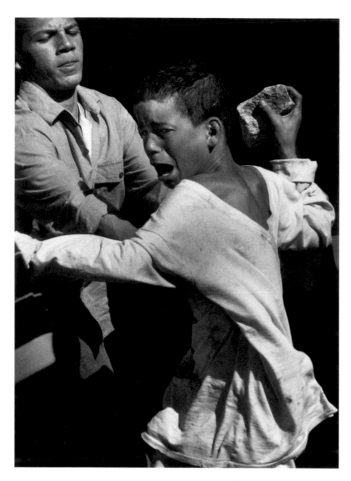

Above: In Rio de Janeiro, death squads of off-duty police aren't the only ones looking for kids; rights workers are out there too. "We give them shelter, food, and love," says Roberto José dos Santos. "Sometimes we're better than a home, because there's so much violence in their homes."

Right: An abused child being treated in Rio de Janeiro's Souza Aguiar Hospital. She has cigarette burns on her leg and is missing a piece of a toe, a nipple, and part of a buttock that was seared by an iron. Says Maria da Gloria Cunlia, the mother of another child in the hospital who has unofficially adopted this youngster: "She's alone. Whoever did that does not have a heart."

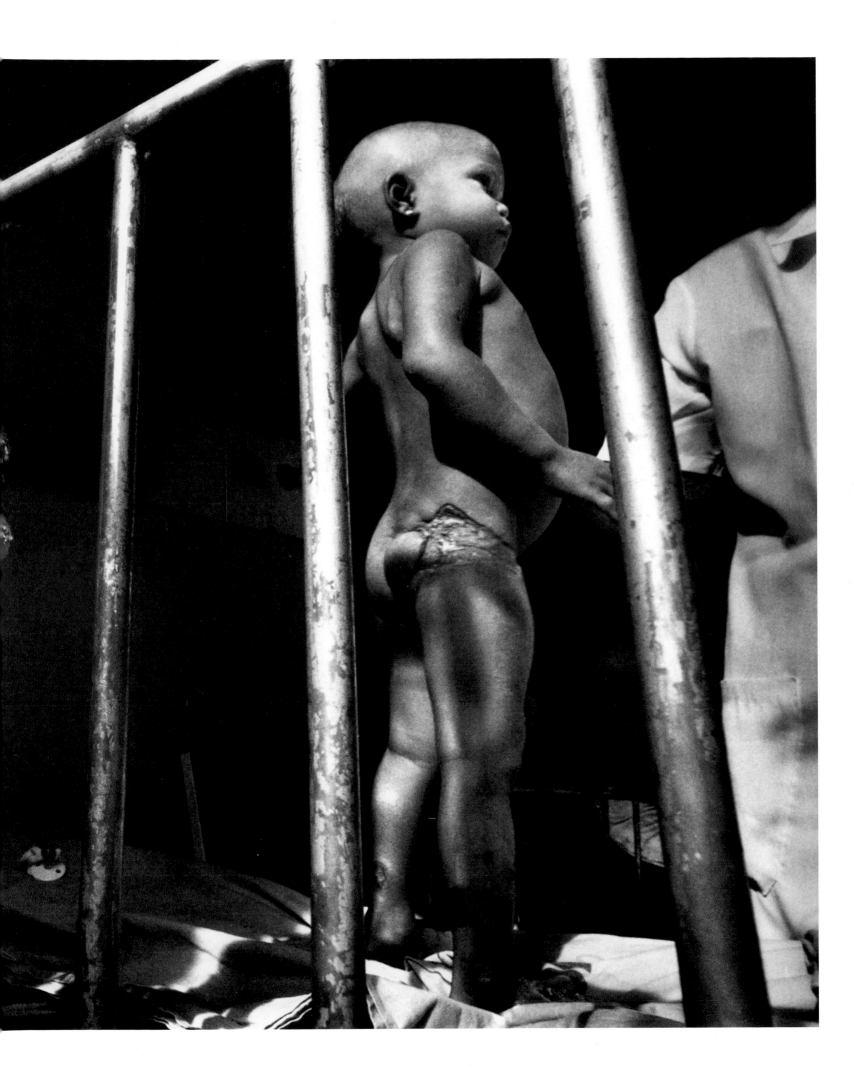

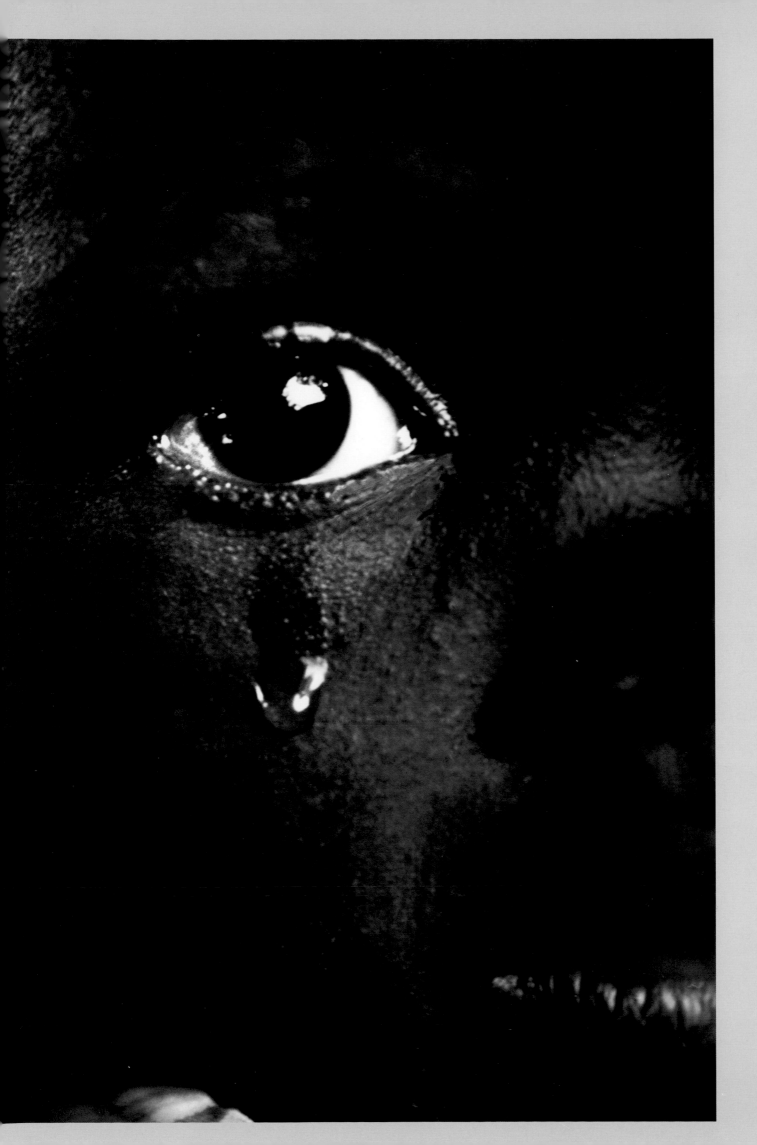

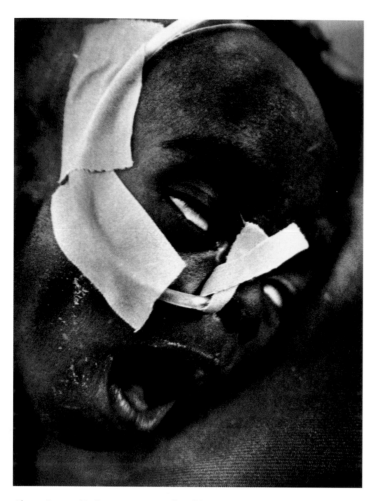

Above: James DuJour, two months old, gasps for air in St. Catherine's Hospital. Every year, 19,200 of the country's children die before reaching their first birthday. Forty percent of those deaths are from diarrhea caused by poor sanitation and a lack of clean water. "This child has chronic diarrhea from bad water . . . very preventable," says an exhausted physician.
Opposite: A child sits in his own urine.
Previous spread: An infant cries as he waits for food at St. Catherine's Hospital in Cité Soleil, Haiti.

Trapped between the here and hereafter, two-month-old James Dujour gasps for air in a Port-au-Prince hospital in Haiti. He wheezes as his eyes roll back into his tiny skull. Someone softly murmurs a prayer that is punctuated by the rasping breath of the struggling baby.

The room is dark and cool but far from quiet; Dujour's gasping is drowned out by the cries of other malnourished children. A doctor hurries over to the boy and checks the feeding tube in his tiny nostrils. In a country with one doctor for every 7,140 people, he is always rushed.

"This child has chronic diarrhea from bad water," says the exhausted physician at St. Catherine's Hospital, shaking his head and moving onward. "Very preventable. The prognosis is very, very bad."

On another island a similar scene is repeated. A child is dying in Madagascar, 250 miles off the eastern coast of Africa. But this time there is no hospital, only the flesh-on-flesh of a limp child in his mother's arms in a rusty metal shack. In rural areas of Madagascar, only 10 percent of the population has access to safe drinking water, according to UNICEF figures.

Both Madagascar, famous for having more plant and animal species than anywhere else in the world, and Haiti, once known as the "Pearl of Antilles," are dying. The cause of death is the same—poverty.

Haiti is now the poorest country in the Western Hemisphere, with its rich, fertile topsoil washed into the sea, its forests bare, its mountains bald, and only 11 percent of its land arable. In Madagascar, the erosion is so pronounced that United States astronauts have noted the rivers bleeding red stains into the sky-blue waters of the Indian Ocean.

Both Madagascar and Haiti's forests are vanishing, destroyed by their people who burn them for fuel or to clear land for crops. Madagascar is already 85 percent deforested, and conservationists warn that it could lose its remaining forests within thirty-five years.

"People are cutting the forests for food. If you don't have food to feed your kids, conservation is not a priority," says Muriel Glasgow, Madagascar program administrator for UNICEF.

Environmentalists consider Madagascar one of the world's most threatened "hot spots," because four out of five of the island's plant and animal species are found nowhere else on Earth. Centuries of deforestation have caused massive cave-ins on the island. The craters, called *lavakas*, make the bright green hills look as if a giant has trudged over them, leaving behind huge footprints of blood-red soil.

In the past, missionaries came to this thousand-mile-long island to preach salvation. Now environmentalists preach conservation, but some believe they have chosen the wrong primate. "They want to save the lemurs, they want to save the rain forest," says Reine Raoelina, a member of Madagascar's mission to the United Nations. "I would like them to save the homo sapiens."

(continued on page 79)

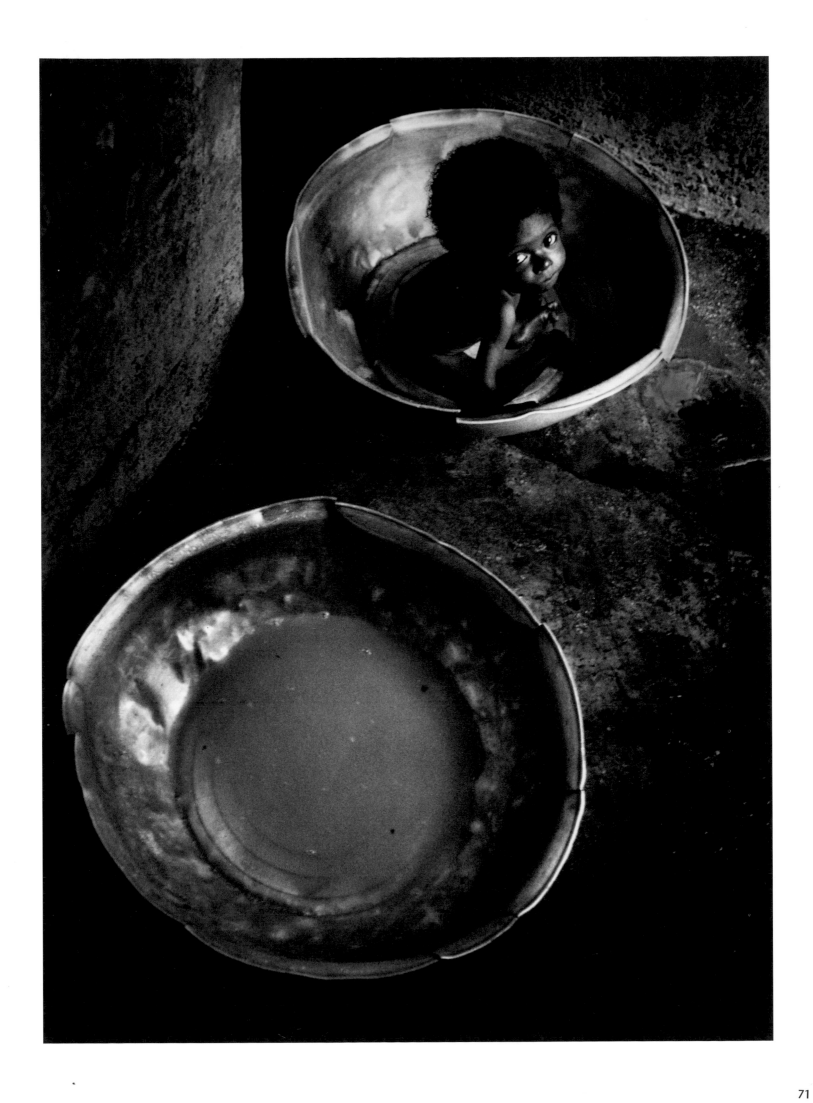

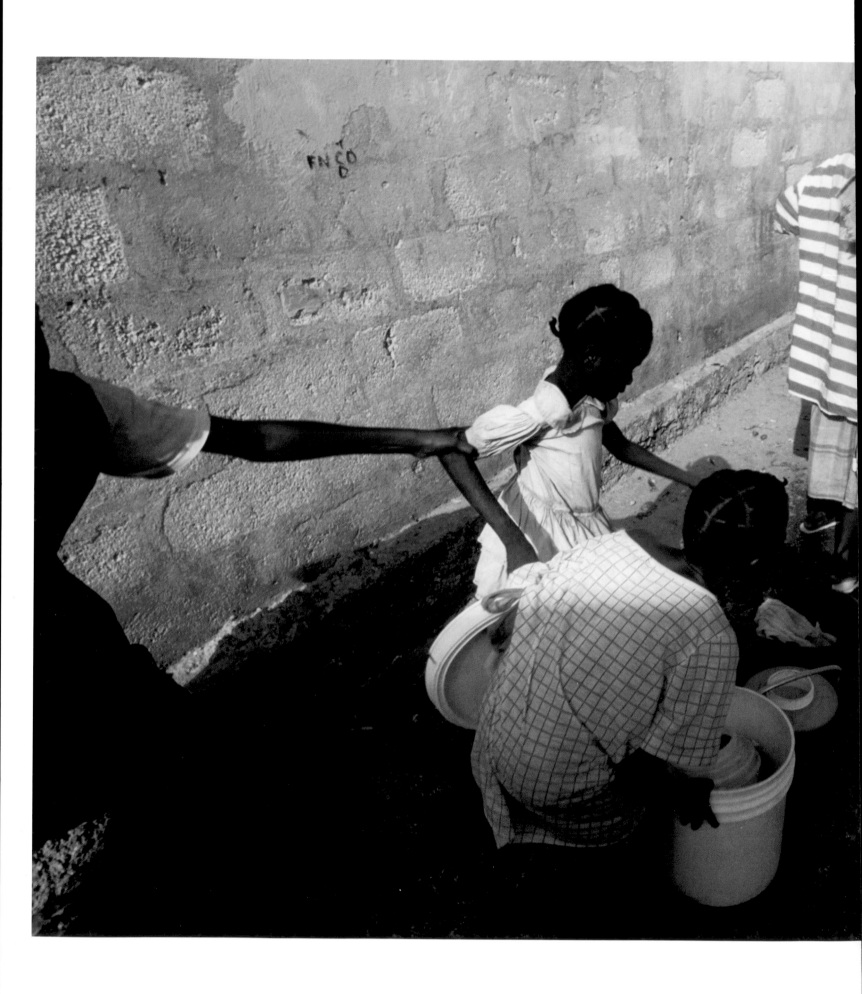

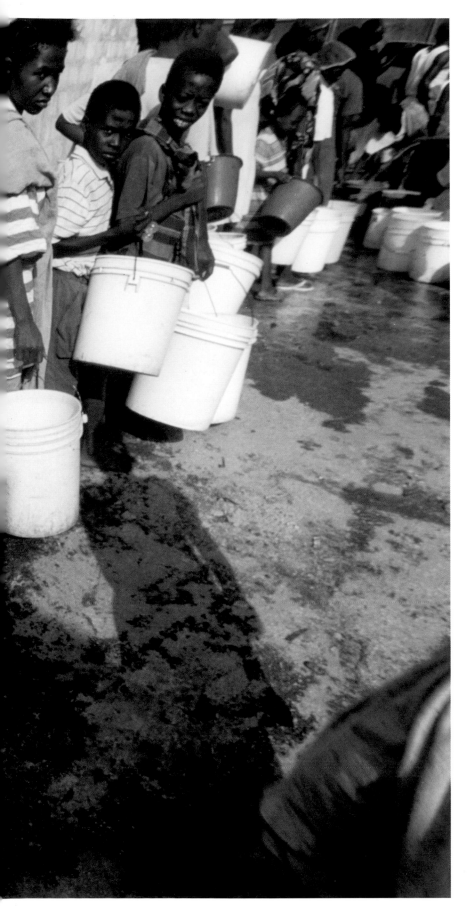

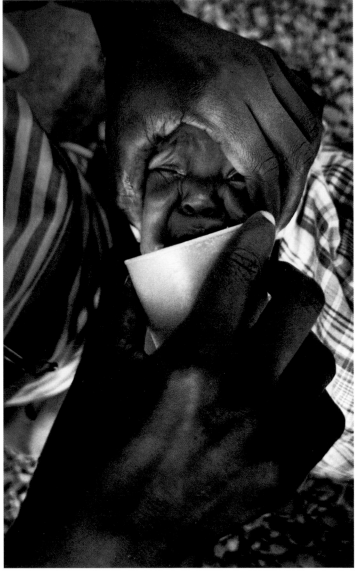

Left: A Port-au-Prince girl tries to sneak into a line for water. Fifty-eight percent of Haitians do not have access to safe drinking water.

Above: A malnourished baby is force-fed liquids at a hospital. In Haiti, four hundred thousand children under age five are underfed.

The distended abdomen of a child in Fort Dauphin, Madagascar, shows the effects of chronic malnutrition. "In Haiti there is poverty," says one human-rights worker. "Here, there is misery."

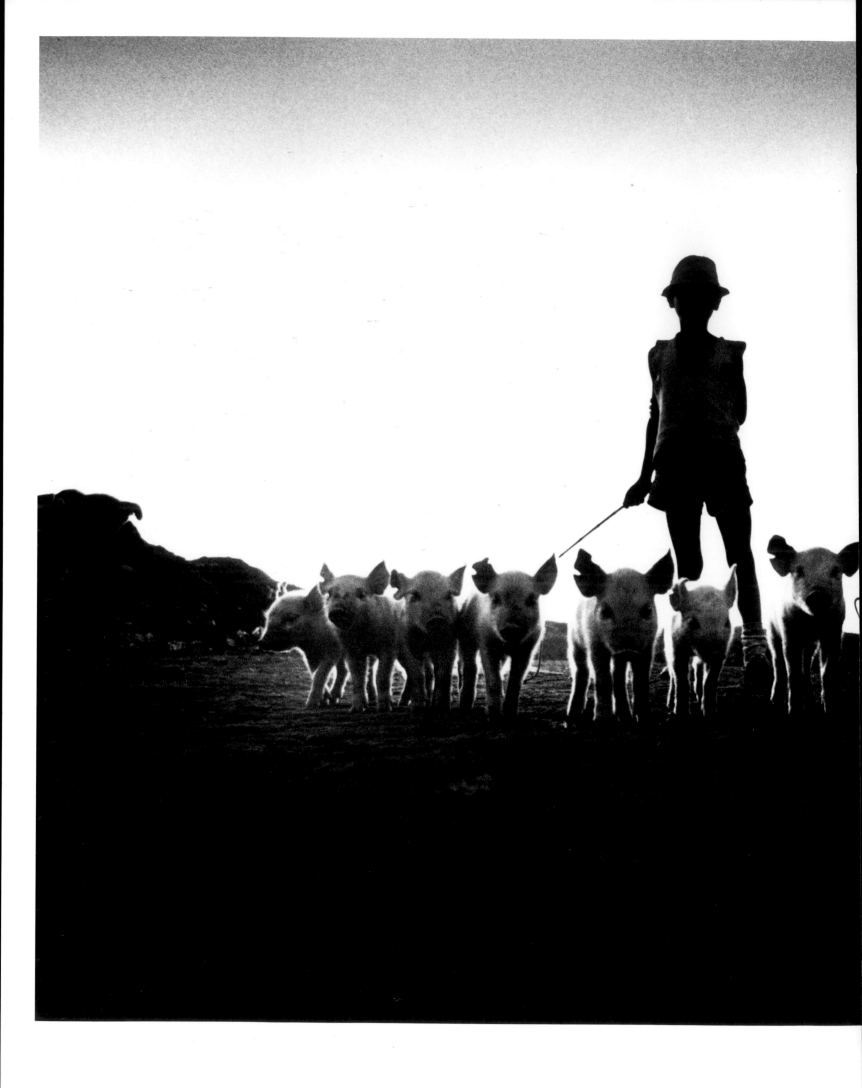

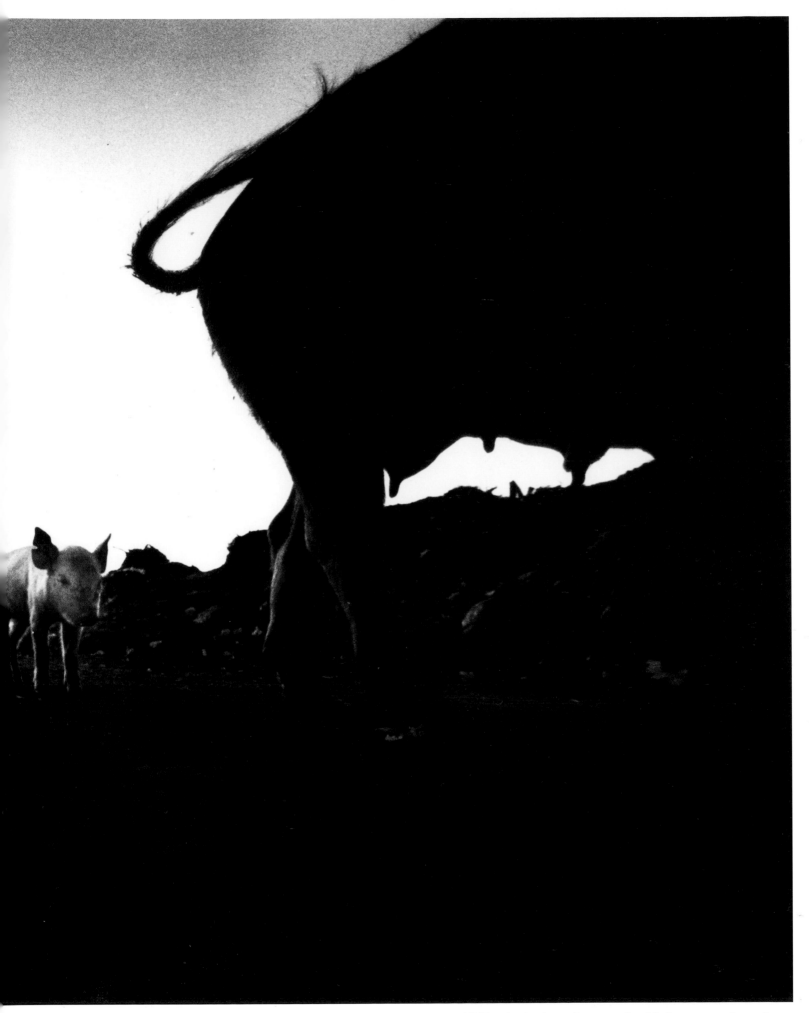

A child herds pigs in an Antananarivo, Madagascar, garbage dump.

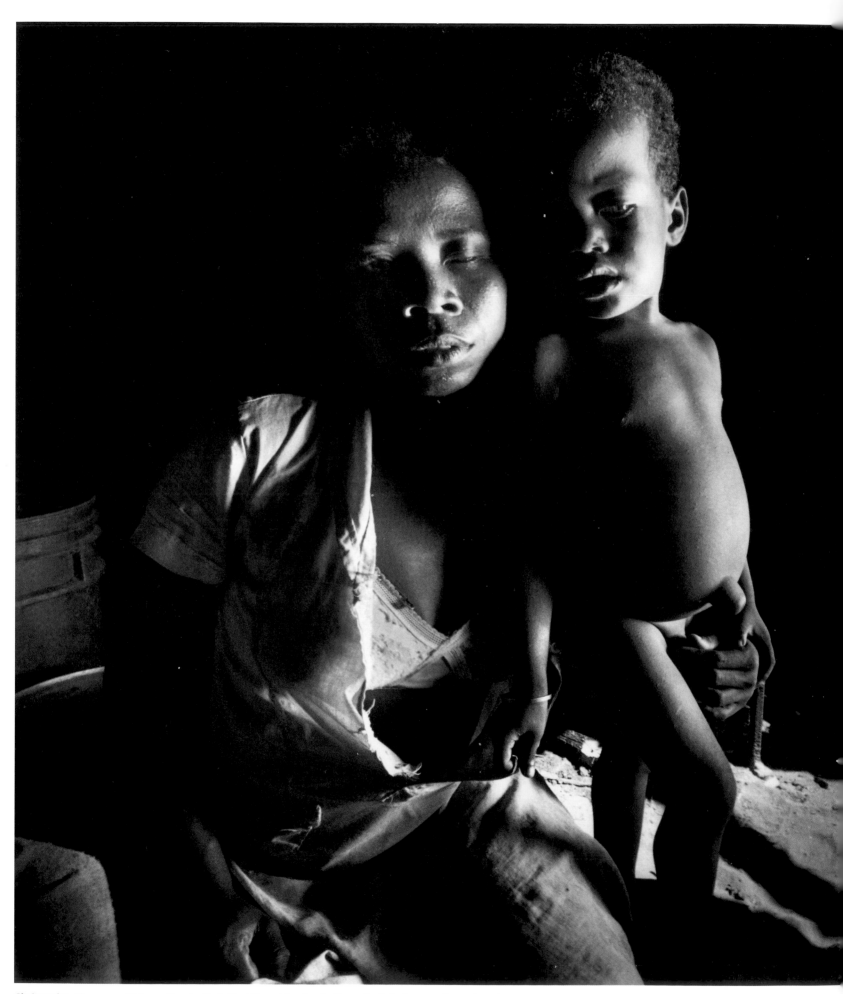

Christophe, three, and his mother in their Fort Dauphin shack. Drought left thousands to die of starvation, while aid agencies took care of the lemur and other exotic species. Eventually, the international community donated food.

(continued from page 70)

Already among the ten poorest countries in the world, Madagascar is getting poorer. One in ten children dies before reaching their first birthday.

When people talk about human rights in Haiti, they talk about political problems, not the environmental consequences of poverty and lack of infrastructure. The bigger picture is that the entire country is dying. "It is the end of the line," says oceanographer and environmentalist Jacques Cousteau. "Almost."

"Haiti is a worst-case scenario," says Peter Burtchell, a Cousteau Society lecturer. "Our planet in microcosm. Resources overused. Its treees are lost, cut down for charcoal. The mountains—that's what catches the rainwater—are deforested, so the water washes off in flash floods. The topsoil is burying the reefs alive. The ecosystem is on the verge of total collapse, and the society on the verge of total chaos."

St. Catherine's Hospital's development and health director, Dr. Reginald Boulos, estimates that 19,200 children die every year before their first birthday in Haiti. Forty percent of those deaths are from diarrhea. "This is the greatest human-rights violation going on in this country," he says. "You don't have 19,200 dying from repression."

He pulls out a pencil and does some quick math. "For example," Boulos says, "six hundred forty newly born children under the age of one die in Haiti each month because of dehydration caused by diarrhea caused by unsanitary water. We need to end the political violence, but let's not ignore the fact that our children are dying in far greater numbers."

There are few places on earth worse than Cité Soleil, a ramshackle section of Port-au-Prince. No water. No electricity. No sanitation. Two hundred thousand human beings in a seaside slum surrounded by raw sewage bubbling in the noonday Caribbean sun. It is an assault on the senses. A fly on the feces first goes to the food, then to the face, seeking moisture. "It's awful," a United Nations adviser says. "In Cité Soleil, they are drinking sewage."

People who live here don't pursue happiness. They pursue enough water to get through the day. "Water. Water. All we worry about all day is getting water," says Wilson Pierre, a resident of Cité Soleil. "Then we drink the water and get sick. My two kids are sick all the time. Tell Clinton we need help."

"Children in Cité Soleil have one episode of diarrhea every month," Boulos says. His hospital has a shortage of antibiotics and intravenous fluids. There is no shortage of death.

"Lack of sanitation is probably the biggest killer," Boulos says. "Kids suffer from viral skin diseases and parasites. Sixty percent have some kind of worm infection. They are treated and then reinfected." With potable water and immunization, he says, ten thousand infants could be saved each year from death by diseases."

Fritz Ohler, a United Nations Food and Agriculture Organization technical adviser, agrees. "I've seen kids so dehydrated the doctors couldn't find a vein."

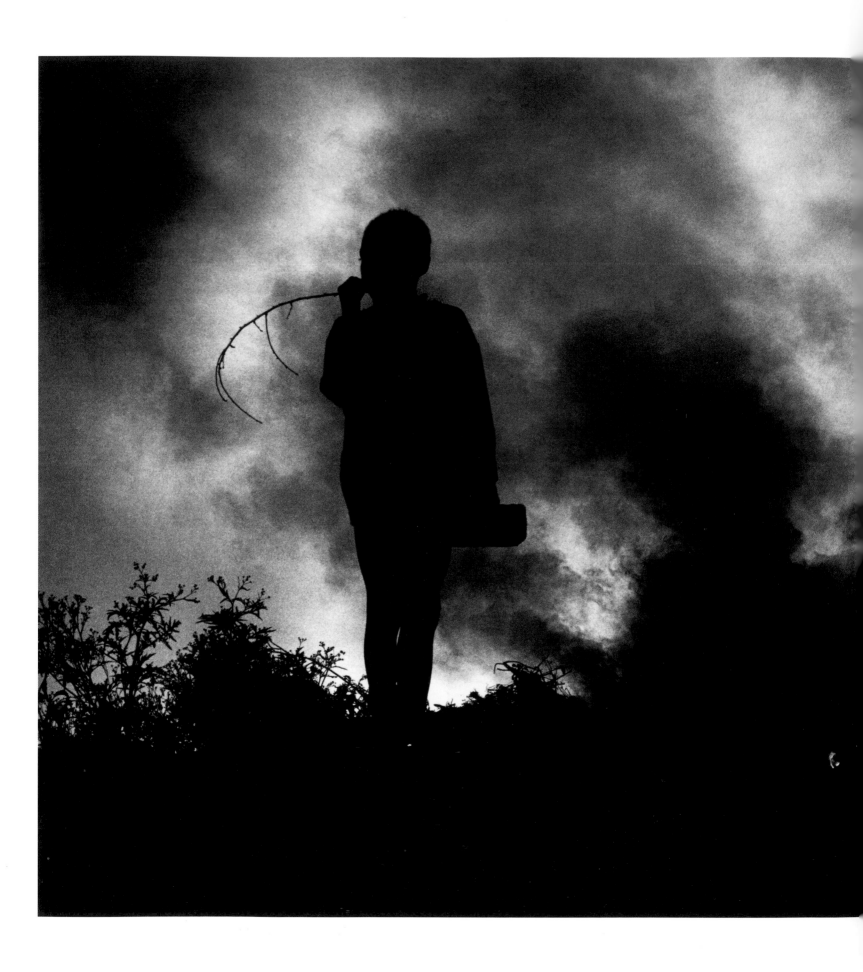

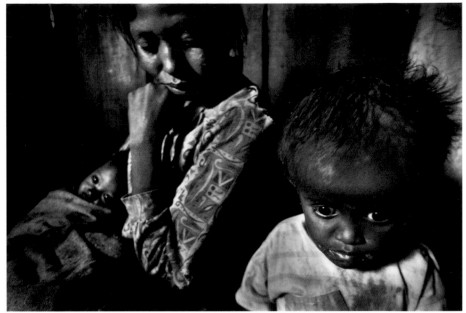

Above: In Madagascar, Perline Soarimalala, twenty-eight, walked eighty kilometers to Antananarivo to seek aid for her sick children, Fidel, one, and Solonirina, four, who has hydrocephalus, only to be refused treatment because she had no money.
Left: A youngster is framed by smoke from burning vegetation. Madagascar's central highlands have been almost denuded to make way for subsistence farming and livestock raising.

UNICEF estimates that 90 percent of the deaths from diarrhea are preventable at low cost, and that worldwide, three million children under the age of five die from diarrheal diseases every year.

Rehydration is easy, according to Aboubacar Saibou, UNICEF's Haitian program coordinator. "It's a very simple solution: one liter of water, six cubes of sugar, and one teaspoon of salt to stop a child from dying of dehydration."

In Madagascar, they are working on solutions, but not for children. Conservationists talk of lemurs first, people second. For some of Madagascar's eighteen tribes, the lemur is sacred, believed to embody the spirits of their ancestors. For others, it is dinner, charcoal-browned and served with rice.

Eco-tourism guides talk of how many species of lemurs can be seen in the Berenty private nature reserve, but they won't mention the drought that afflicted southern villages, where nearly one hundred people died each day in 1992, according to Jean-Michel Jordan, a relief worker for the United Nations World Food Program. "We couldn't get anyone to listen," said Jordan. "It wasn't as spectacular as Somalia." Finally, he said, the United States and the European community responded with aid, averting many deaths.

The drought was eased, but tourists still drive from the southern city of Fort Dauphin to Berenty through areas as steeped in poverty as any in the world. Kids with hunger bellies stand barefoot on the side of the road, selling charcoal for a dollar a bag. In one village, a young girl dressed in tattered cloth walks on handmade stilts trying to get the tourists in minivans to stop and buy bananas to feed the lemurs. A mother sits in the shade, picking lice from her daughter's head. The tourists proceed to Berenty to stuff by-now tame lemurs with so many bananas that the animals sometimes throw up. The dull-eyed child leaves her mother and curls up hungry.

In Haiti, there's a commotion on the street as night falls. What now? A fight over water? No, everyone is looking down on the sidewalk. Another execution? No. A woman spins around with a gleam in her eye.

"She's having a baby."

At dawn, the streets look like morgues, with lifeless forms curled up in every nook and cranny. But those who arise early are not interested in the little children sleeping in burlap bags. Even the rats ignore them. They know these children have nothing.

Last year, nearly four million children under age five died in India. That's more than the entire population of Los Angeles.

Each day, the equivalent of "twenty faulty jumbo jets filled with little children crashes in India alone, which is exactly how many children die in that country every day," according to UNICEF goodwill ambassador Liv Ullmann.

Yet their deaths don't make the news. The bellies may be bloated by malnutrition, but bones aren't sticking out as in Ethiopia. They don't die in massive refugee camps but scattered on the filthy streets and in makeshift huts, far from the glare of television cameras. In Bhopal, 3,400 people died in 1984 when gas leaked from a Union Carbide chemical plant. It was a world-class tragedy with a major villain to blame. But who is responsible when the largest democracy in the world accepts malnutrition and unsanitary conditions as a way of life?

"India has one foot in the twentieth century, another in the eighteenth," says Reverend Vincent Concessao, who works with the ragpickers of New Dehli. Because of corruption, ancient customs, neglect, and horrendous sanitary conditions, India has become the epicenter of misery. Here, the bizarre is commonplace.

A monkey chained to a sleeping boy awakes first and pries open the boy's eyes. Youngsters bathe in a tributary of the holy Ganges River, even though lepers and thousands of animal carcasses have been dumped into its waters.

In a Calcutta park, children entertain themselves by feeding rats out of their hands. Outside the Indian Museum, a seven-year-old boy wraps his head in burlap, burrows a hole in the ground, and becomes a human ostrich. "I want to feed myself, my father is sick, and it's the only way I can get money," he says. Someone hands him a two-rupee note, and he stares briefly at the satellite that is on its back. "What do you dream about?" he is asked. He crumbles the bill and stuffs it in his pocket. "I want to work someday in a hotel," he says, "because I know they have food there."

A nine-year-old lies on his back, chanting "please help me." He claims he had his hands blown off when he was paid to transport a bomb. But there are whispers that some children are deliberately mutilated. "The stories are true," says Francesco Toso of UNICEF. "Their limbs are crushed, all for begging."

Some businessmen are trying to eliminate begging in their city streets. On Sunday morning, they give out fistful-sized bags of rice to the poor who live under the Howrah Bridge, over which a million people cross each day.

"Approximately 40 percent of all the young children who die in the world each year, 45 percent of all the children who are malnourished, 35 percent of those who are not in school, and over 50 percent of those who live in absolute poverty are to be found in just three countries—India, Pakistan, and Bangladesh," according to the UNICEF State of the World's Children Report for 1990. Malnutrition in South Asia is the worst in the world, even surpassing that of sub-Sahara Africa, according to the latest UNICEF figures.

In New Delhi, in 1989 there was a demonstration for the rights of the cow, sacred in the Hindu religion. At nearly the same time, the United Nations was unanimously adopting the motions from the first Convention on the Rights of the Child. Sister Smith, a New Delhi nun, cautioned a journalist against painting a portrait of doom. "The children are poor, but they are happy in a way, since they are ignorant of the consequences of their lifestyle."

Near the train station in Calcutta, a well-dressed man wants to fight an Indian photographer taking pictures of malnourished, naked children. "Why don't you give them your shirt instead of taking pictures?" the man angrily asks as he rips off the photographer's shirt. "Why don't you give them yours?" replies the photographer. "We're trying to bring the problem to light. You just want to ignore it."

In the cities, a new untouchable class has emerged. Ragpickers —those who scavenge through garbage for things to recycle— are up before dawn scrambling up and down the streets. Barefoot and bravely risking noxious fumes and jagged glass, they often sleep in the burlap bags they use to collect the garbage.

Government figures say there are eighteen million child workers, but nongovernmental agencies have estimated forty-four million. The problem is that there is social acceptance of child labor in India.

"There are laws against it, but it's easy to buy off factory inspectors," says Gurinder Kaur, Oxfam America's South Asia bureau chief. "Poverty is increasing, and women and children are getting hit the worst. In the carpet factories, I was really moved. The crassness with which children are hired and dismissed—it's terrible that you use a six-year-old child because he has nimble fingers, and then, at puberty, that certain dexterity is gone. They're through at fourteen."

In Jahanirpuri, outside New Dehli, two hundred thousand people live in a filthy twelve-block area. Ellis, a twelve-year-old ragpicker, doesn't go to school, nor does he ever look up. His livelihood is what people discard on the ground. "I feel sick, and sometimes I go hungry," he says. "The police harass us— they think we're thieves. Mad dogs come and bite us. But I'll remain here and take care of my parents." He turns his head

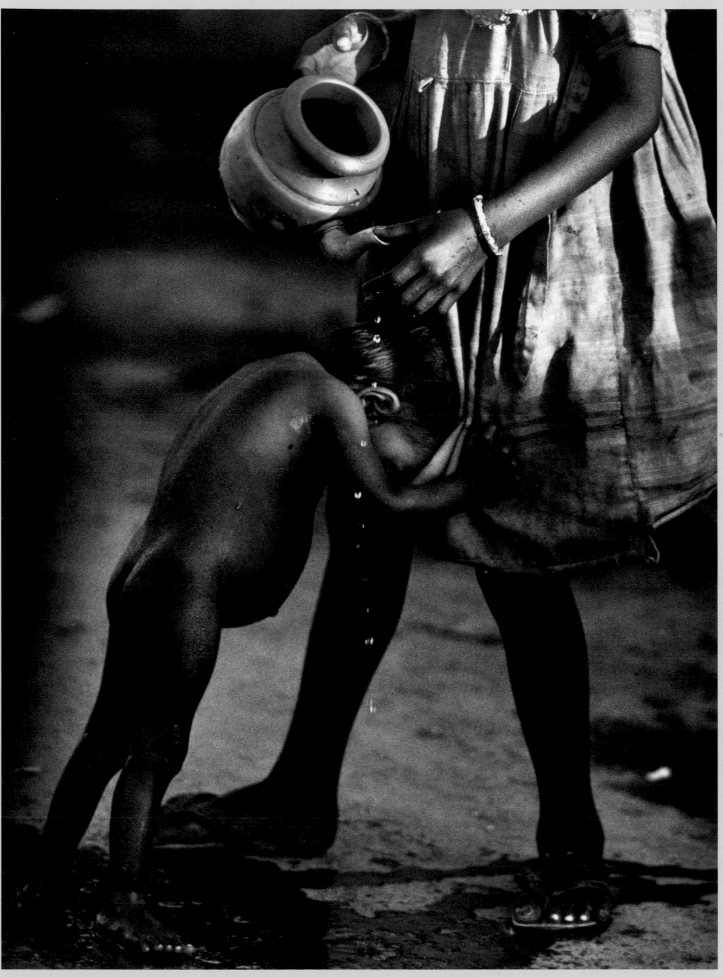

A child takes a sewer-water bath in New Delhi, India.
Nearly four million children under the age of five die in India each year.

away from another child squatting in a field that serves as a community bathroom. A pig follows, and when it stops to eat the excrement, a crow lands on its back.

Nearby, in a small windowless room, fourteen young girls spread glue across envelopes. A group called Development, Justice and Peace tries to tutor them because they have dropped out of school. Half their parents don't work; some are ill with tuberculosis, some just feel the work is beneath their dignity. When asked what they want to be when they grow up, not one of the girls could expand their horizons. All said they wanted to be like their mothers. Being a girl in India means being what UNICEF calls "the lesser child."

India is "a culture that idolizes sons and dreads the birth of a daughter," states a report issued by UNICEF'S Ministry of Human Resource Development. Amniocentesis, a prenatal test designed to discover congenital deformities, also determines the sex of the fetus. If it's a girl, the fetus is aborted. The report states, "In a study of 8,000 abortions after amniocentesis in Bombay, it was reported 7,999 of the aborted fetuses were female." Girls will grow up with less education and less nutrition than their male counterparts.

Despite being outlawed, child marriages and dowry-giving are still often a part of the female lifestyle.

"My father died last month, so, to save money, we had the marriage ceremony for my daughter the same day as the funeral," says Lalu Laduri, twenty-five, sitting outside her home, which she shares with twelve other people in the small village of Nathra, three hundred miles south of New Delhi. There is no electricity here, and the blue moonlight is stronger than the flickering candlelight. Lalu's daughter, Hanja, is cradled in her mother's arms, sucking on her thumb. At six months old, she's a Mrs. before she's even a child. Her destiny is sealed.

The future looks even dimmer for Kato, four, crying in a Calcutta gutter.

"He was born on this street," says his mother, picking the lice from his hair. "He is malnourished, his father left me, and I must beg for food." Born on the street, died on the street—the black hole of Calcutta still exists.

At Mother Teresa's Misssionaries of Charity, a simple stone building with plenty of windows, the children are bathed, clothed, fed, and hugged—especially hugged—for this is what they need most. Clean and happy, they then gather in church and sway side to side as they sing "Amra Korba Joi" in their native Bengali. Then, without missing a beat, they sing out strongly and sweetly in English: "We shall overcome / We shall overcome / Someday."

Mother and child beg for handouts in Calcutta.

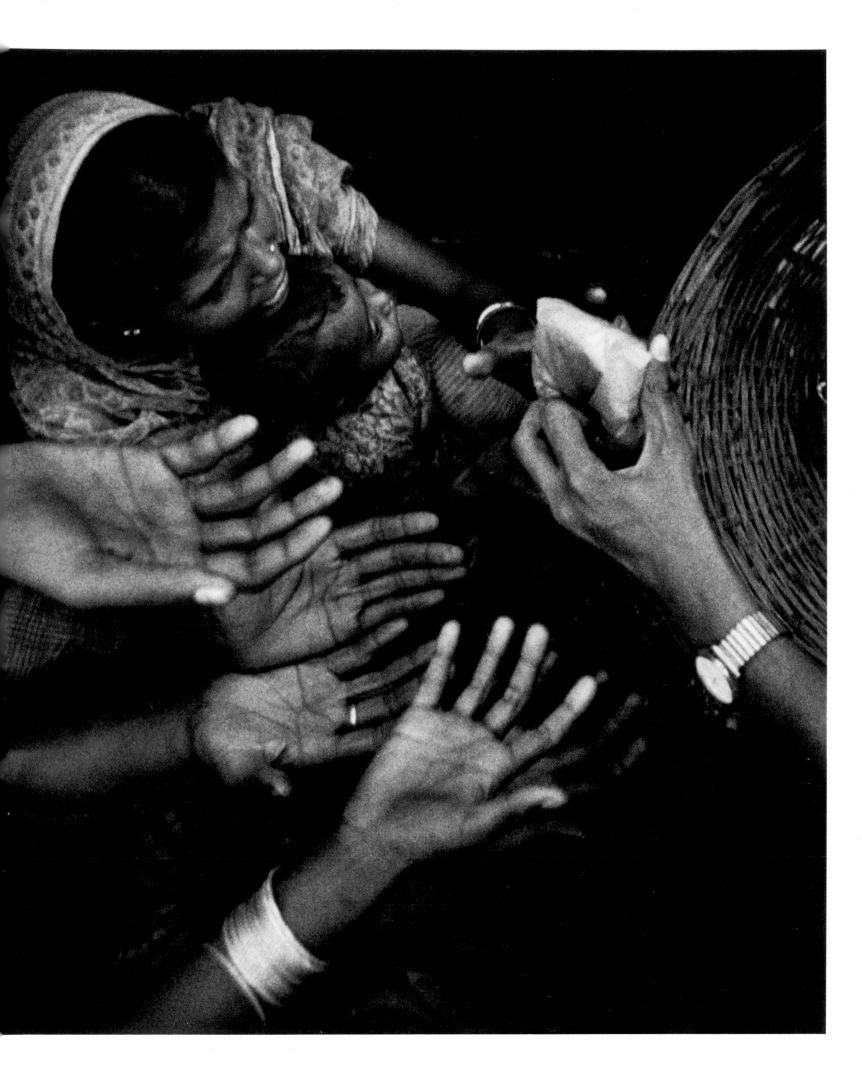

A homeless
child in Calcutta.

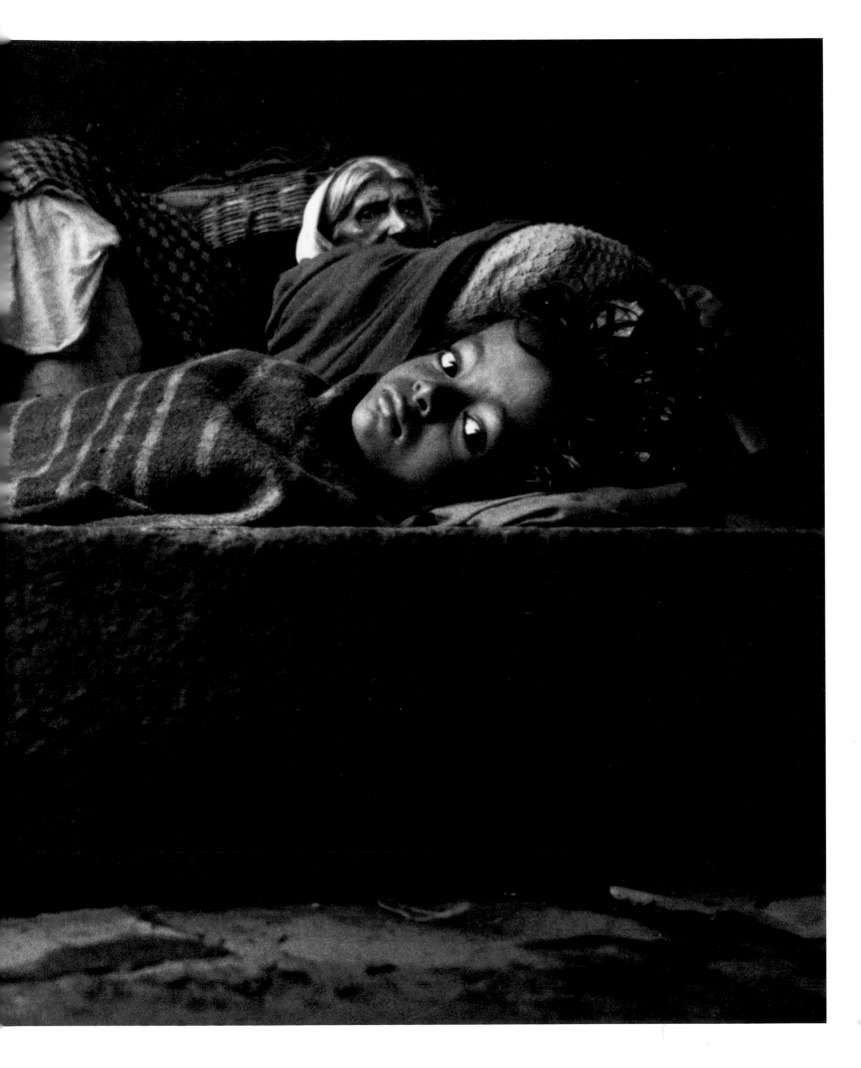

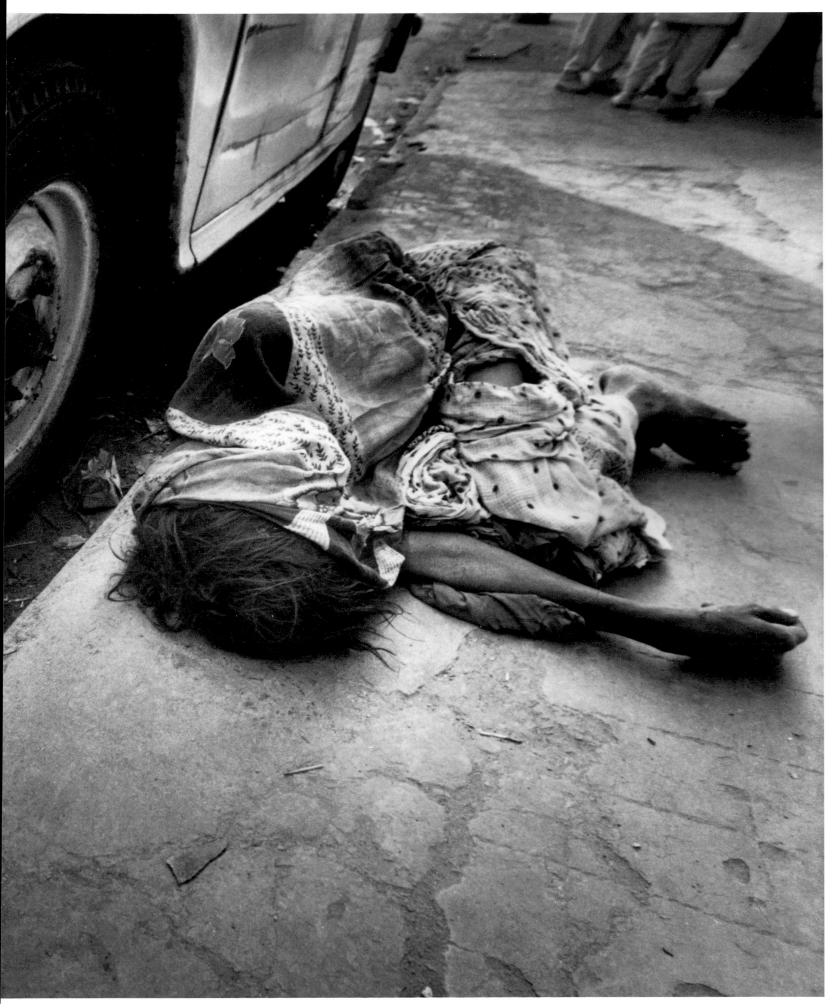

A homeless child and stray dogs sleep in the streets of Calcutta.

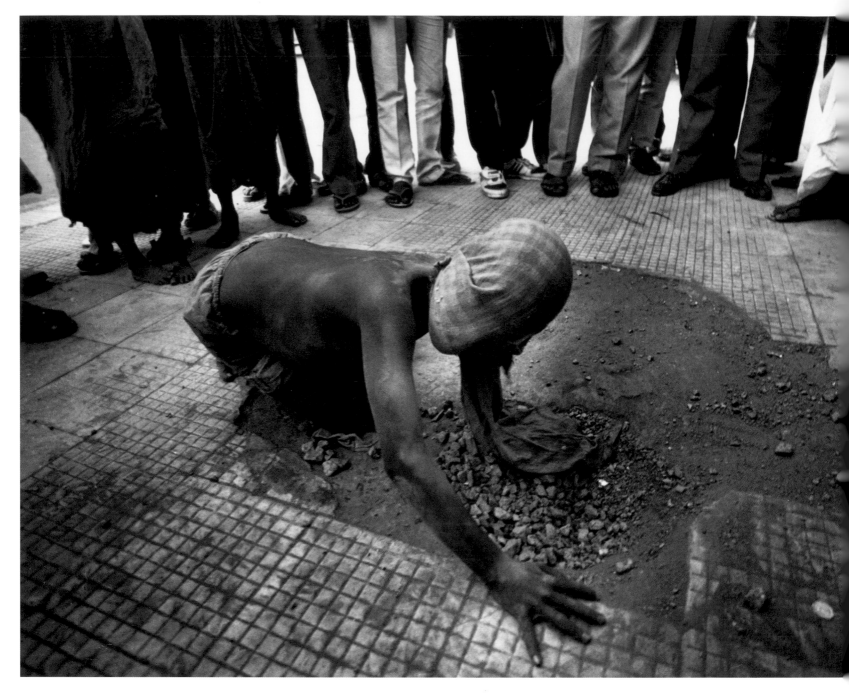

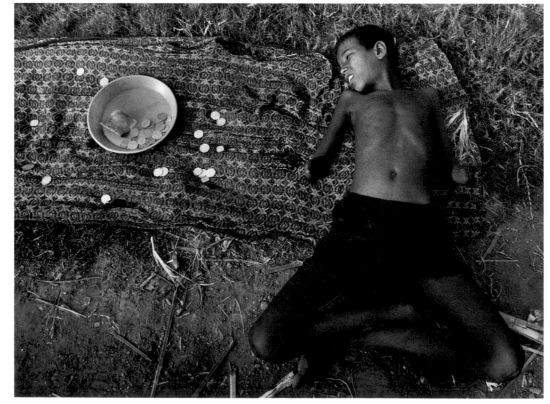

Above and opposite:
An Indian boy buries
his head for coins in
the streets of Calcutta.
Left: A beggar boy in
New Delhi.

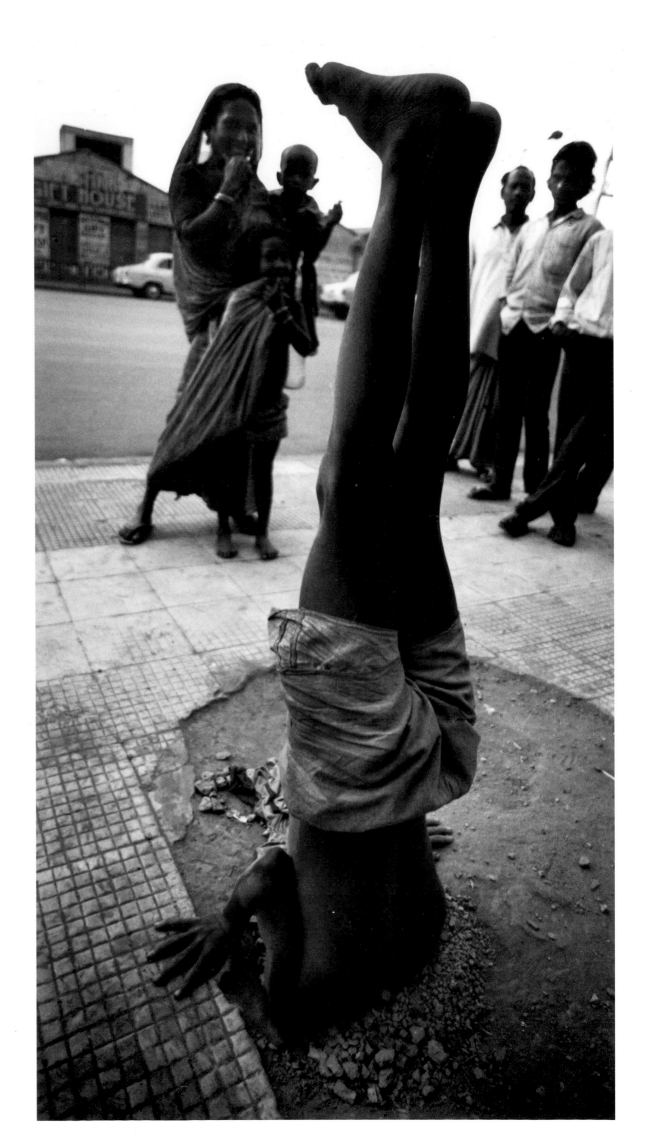

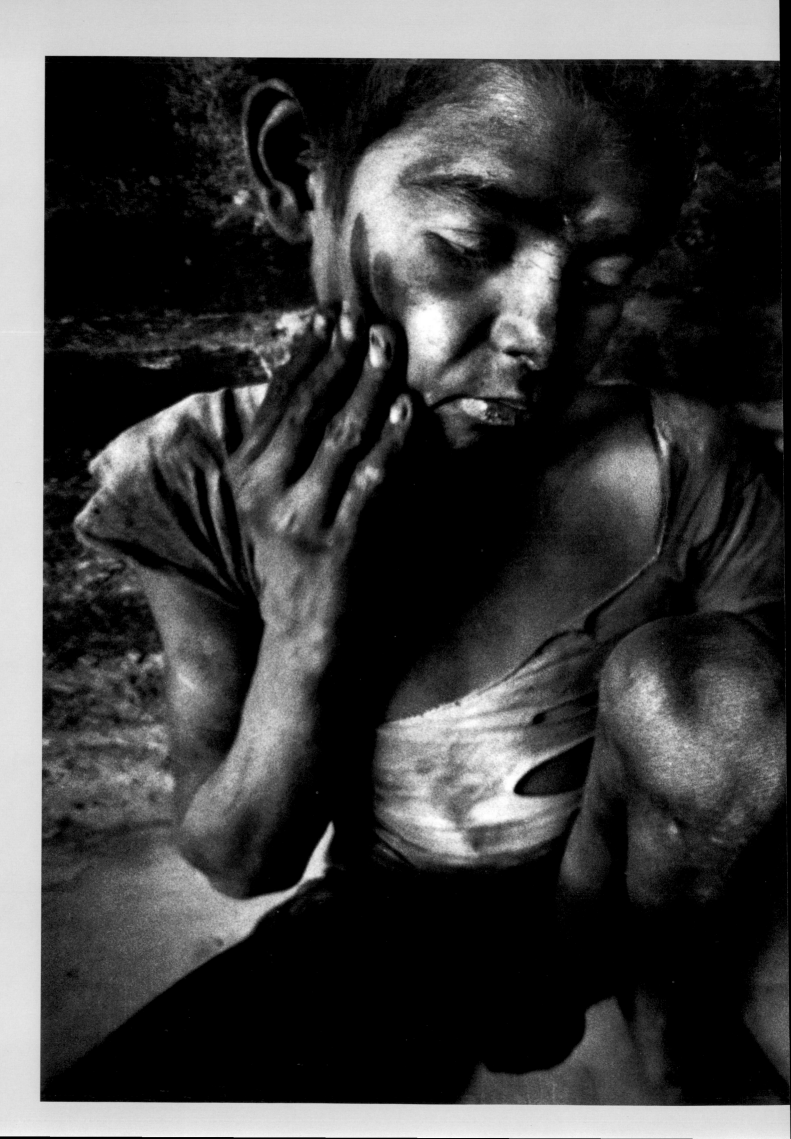

Previous spread: Iqbal Salim, ten, of Moradabad, India, has been working in a factory
since he was four, cleaning brassware with an air pump from 7:00 A.M. to 9:00 P.M.

For the last six years, Mobsin Ikramuddin, twelve, has been working twelve hours a day in a Moradabad factory making brass statues.

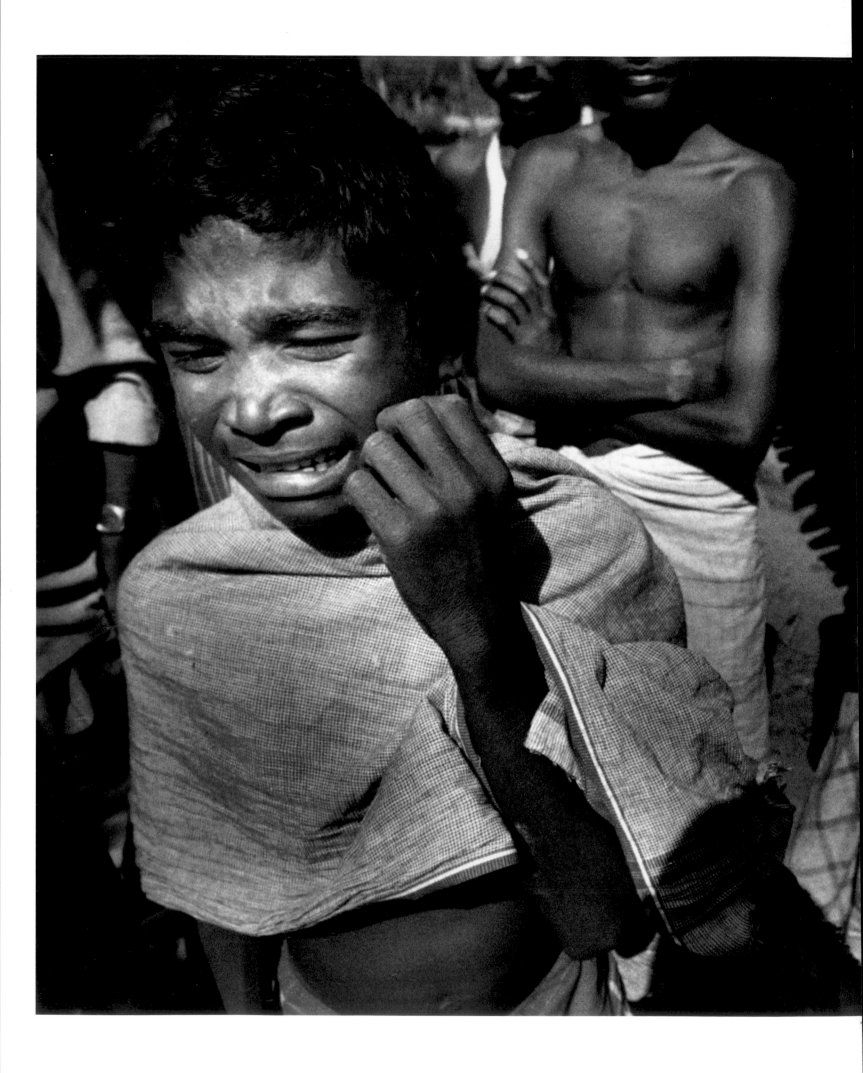

The brass factories are all unmarked, down alleyways framed by streams of urine baking under windows covered by bars. This is the nineteenth century revisited. Furnaces belch molten lava, and acrid smoke attacks the eyes and throat. On the edge of the darkness, a ten-year-old boy, his brown body turned black with soot, is making a brass angel while living in hell.

For this, he is at least paid a pittance every week, thirty rupees, or about a dollar. But for the ten million children who toil throughout India as virtual slaves, there is no compensation.

"I was kidnapped," says eight-year-old Laxmi Sada at Mukti Ashram, a home for freed slaves. "Me and three more boys were playing outside the village and some people came and gave us something to eat and said they had even better things to eat. They took us in a bus. I didn't even know what a carpet factory was. I started crying. Many times I was beaten. It was the master who first hit me with the *punja* [a comb-like tool], and the blood came down . . . then they would put matchstick powder on the wound and light it to stop the bleeding. I never saw the sun rise." Sometimes Laxmi went to the bathroom in his pants. "If you got up, you'd get beaten."

Laxmi's father came to the factory to rescue him, but factory thugs intercepted him. "I saw my father being beaten. He could not recover. My father wanted to take me and put me on his lap. Why did he have to die? I was there one year. Now I say, long live the revolution, stop child slavery. I want to kill the master. Because of him I couldn't see my father."

Fifty thousand children toil six days a week for a few dollars a month in factories throughout Moradabad, four hours east of New Delhi. The children choke on noxious fumes that carry tuberculosis and other respiratory diseases.

"Nobody lives to be forty," says Karan Singh, a human-rights worker. Behind these doors, children make miniature Statues of Liberty and busts of John F. Kennedy. India is doing virtually nothing to enforce a 1986 law that prohibits children younger than fourteen from working.

"It's very frustrating," says Kailash Satyarthi, chairman of the South Asian Coalition on Child Servitude, an umbrella organization responsible for the rescue of twenty-six thousand children. "The law is there but the government doesn't want to implement it. Sometimes the fine is less than two dollars. So you're using a child's life for a two dollar fine. They say the parents need the children to work to get by, but that's not true

(continued on page 100)

A child is freed from slavery after a raid on a carpet factory in Mednikhad, India. The South Asian Coalition on Child Servitude organized the action, anticipating the rescue of eighteen children; only three were freed. Information about the raid had leaked and the employer was successful in driving away the other children moments before the coalition arrived.

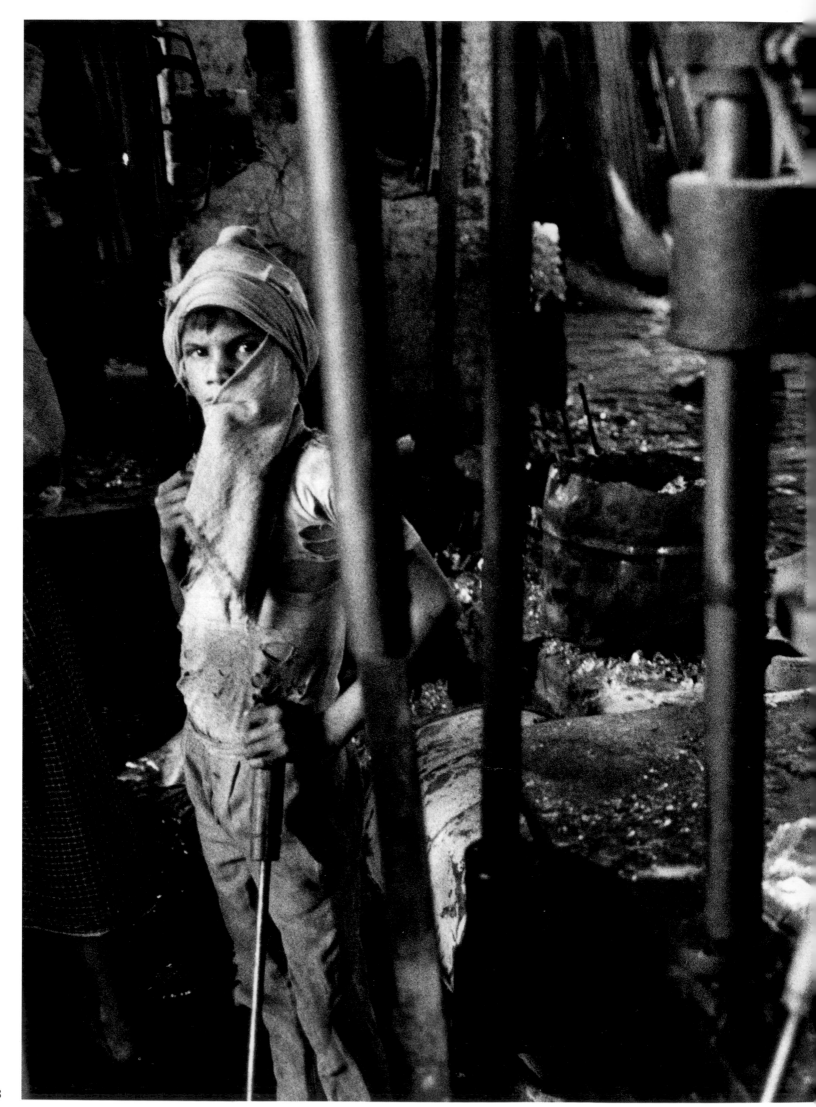

(continued from page 97)

because there are fifty thousand children working here while fifty thousand adults are unemployed. We need to give those jobs to the adults and let the kids go to school," says Ashutosh Chakrapani, a coalition worker.

The International Labor Organization estimates there are some two hundred million child laborers under the age of fifteen worldwide. Many of them are bonded laborers, that is, virtual slaves. They don't get paid wages, they don't get paid on a piecework scale. They are lured away from their parents, who are told their children are going to go to school to be trained for a job. The parents are then given a small loan with high interest that they can't repay. Sometimes they are given nothing.

Udai Ram, nine, of Bihar says, "A middleman came to my village and told my father I would be taken to school to learn things.

"When I went in there the first time there was a thick cloud. I saw this beautiful carpet and I wanted to sit on it and I was beaten. I worked till twelve midnight. The master was teaching and I made many mistakes. The master would hit my finger with a very sharp knife. Once he cut the small tip off."

Udai said he worked with eleven other boys in a factory with three looms. "I always wanted to cry. I'd think about a beautiful forest and a river with my friends making balls of sand.

"My master is free. While I was working, I saw he got a new car and a new truck. It was like being in a cage. Have you seen birds fly? Now I'm out of the cage. I have never seen an adult make a carpet."

"Nimble fingers? That's bullshit," says Satyarthi, rebutting the claim that child weavers make smaller knots and thus produce higher quality rugs.

"Nimble fingers have nothing to do with the knotting. The more knots in the less space, the finer the carpet. Tighter knots are made by strong men."

Satyarthi has supported U.S. Senator Tom Harkin's Child Labor Deterrence Act, which calls for a ban on importing goods produced with child labor (under age fifteen) and provides money for rehabilitation. The United States imported more than $170 million worth of carpets from India in 1993, but importers and retailers say it is impossible to certify that the carpets are made without child labor. And with the passage of GATT, the Iowa senator's bill is technically illegal.

"If people keep buying carpets, they are guilty of perpetrating child slavery," says Satyarthi. "We're telling people that with these shining carpets, most of the shining comes from the blood of the children."

Previous spread: **A child laborer in the Ceeraj glass factory.**
Right: **Protesters against child labor march in New Dehli.**

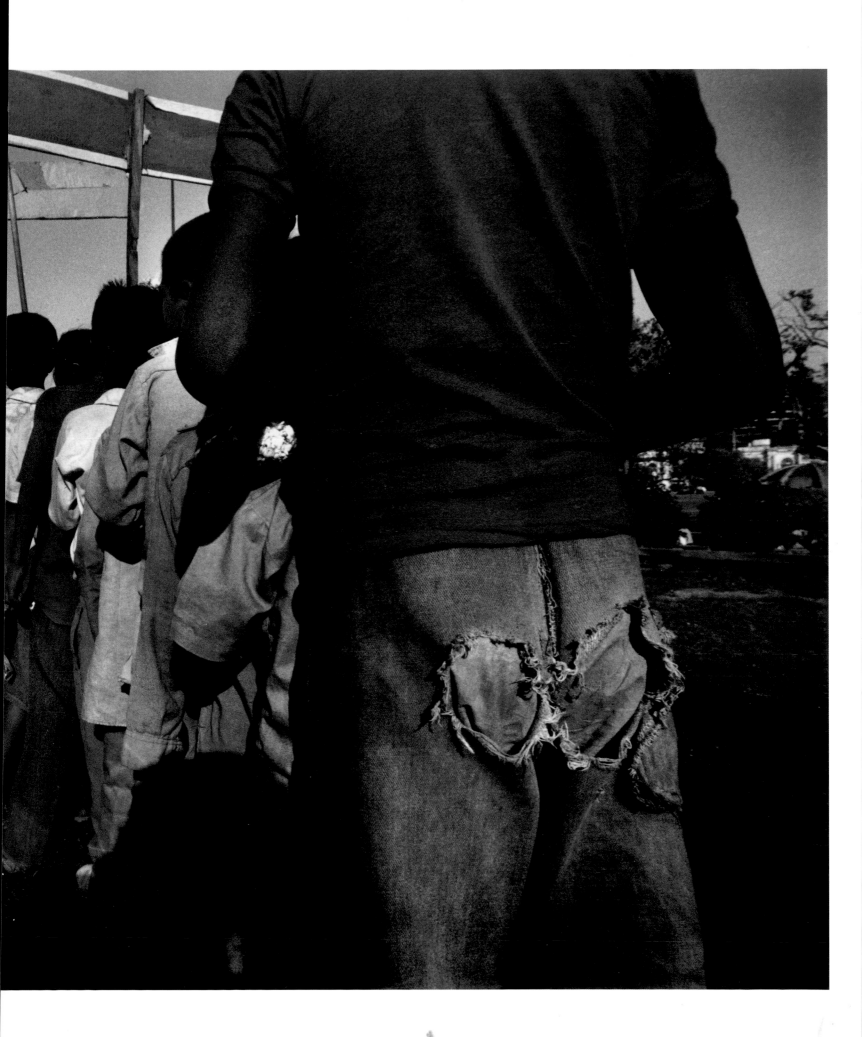

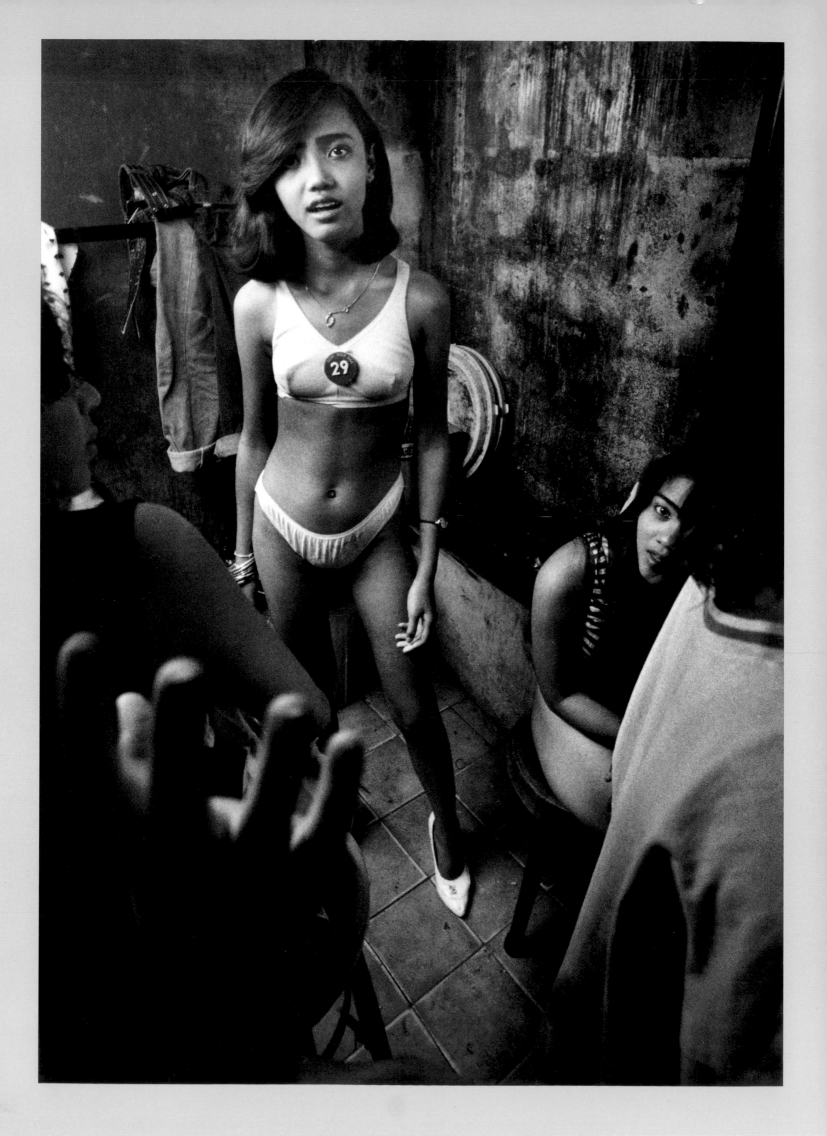

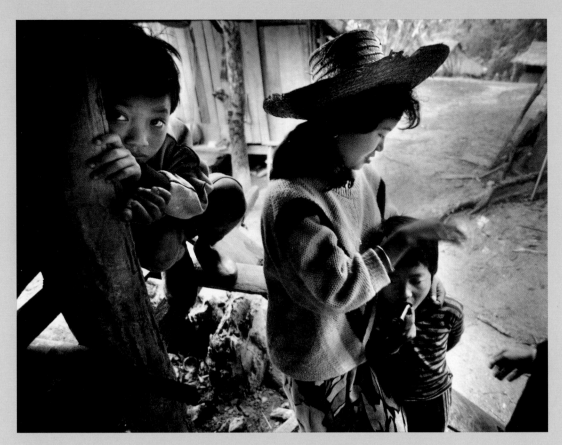

Above: **Prostitute Maew Noi, twenty, comforts her younger brother in Pong Chang, a village in northern Thailand. A prostitute since the age of thirteen, she says, "I have advice for young girls who need money and are lured to the big city: don't go."**
Opposite: **A girl propositions a man at a bar in Bangkok. The prostitute, who says she is fifteen, wears a number so that clients can select her from the group.**

There are secrets here. Secrets about sex.

In the northern Thailand village of Pong Chang, the hill tribes speak their native language of Akha. Unless, of course, they want you to understand them. Then they speak Thai.

"I'd like to kill him," say several villagers, gesturing toward a Thai interpreter who has brought two foreigners to this village nestled in the Golden Triangle, far from the tourist trail. Maew Noi, or "Young Cat," speaks in a hushed voice, and when village elders pass by she falls silent and stares at the ground.

Like most of the young girls of this area, she was lured into prostitution in Bangkok when she was thirteen. Now twenty, she says the experience has ruined her life.

"We didn't know what we were going for," she says. "My whole life I had never been out of this village. At first I liked the colors and the lights of the city, but. . . ." Her voice trails off. She won't discuss the horrors of forced sex, except to say the past plagues the future.

"Now I can never fall in love. I have no interest in sex. It's finished."

Her father, she says, is in jail, framed on an opium charge. She has come back to help her mother work on the land. There are no bright lights here. There is no electricity and there are no cars, just the lush green vegetation and the brown thatched-roof huts. The boys walk around with slingshots in their back pockets to hunt birds. The girls find themselves bouncing from

an eighteenth-century farm life to cruel exploitation in a sort of sexual Disneyland, and then back to the farm.

"What do I do for fun now?" she asks. "Nothing."

There are more than eight hundred thousand child prostitutes in Thailand working in sixty thousand brothels, according to Sanphasit Koompraphant, director of the Center for Protection of Children's Rights. In northern Thailand, famous for its beautiful women, up to 90 percent become prostitutes, he says.

"In the past, agents would go to the villages and didn't tell the truth," says Sanphasit. "Now most girls are sent by their own families, who get between seven thousand and thirty thousand baht [$275 to $1,200], which the girls work off in one or two years. Then they get to keep between 10 and 50 percent of the profits.

"They have to pay for their own clothes and medicine, but they get two meals daily and a place to stay. But now the problem is getting worse, and the children are organizing themselves to beat the broker."

Kesorn Ronsai, fifteen, sits in a Bangkok hotel room with a circular bed and mirrors on the ceiling and thinks about her mother. "I miss her. I came here because we didn't have enough money to finish the house. My mother didn't want me to come; she's afraid of AIDS.

"I'm not afraid of AIDS—I'm afraid of nothing to eat."

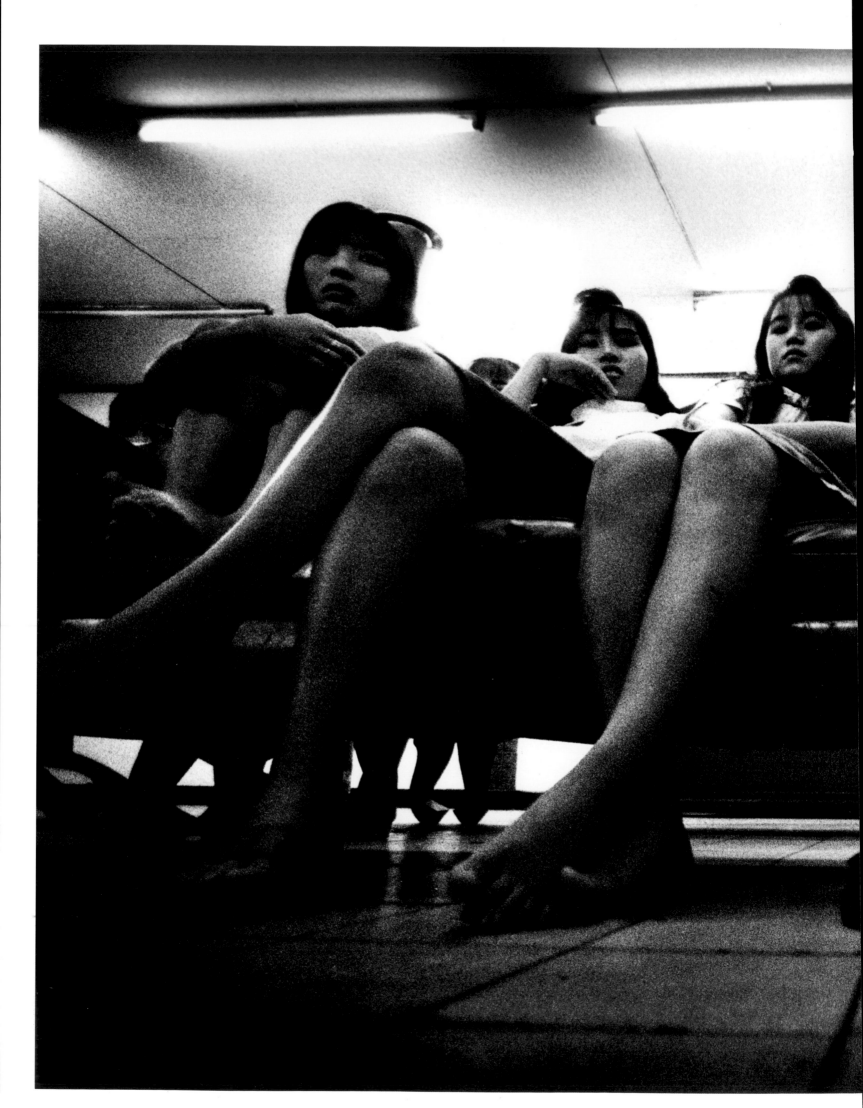

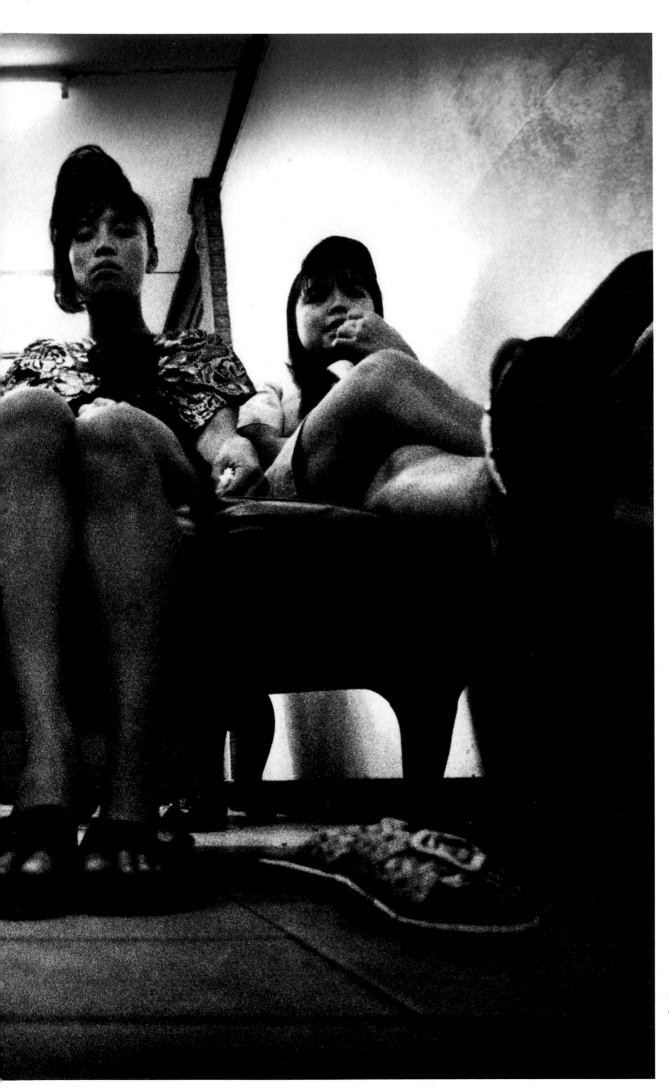

Young prostitutes
wait for clients.

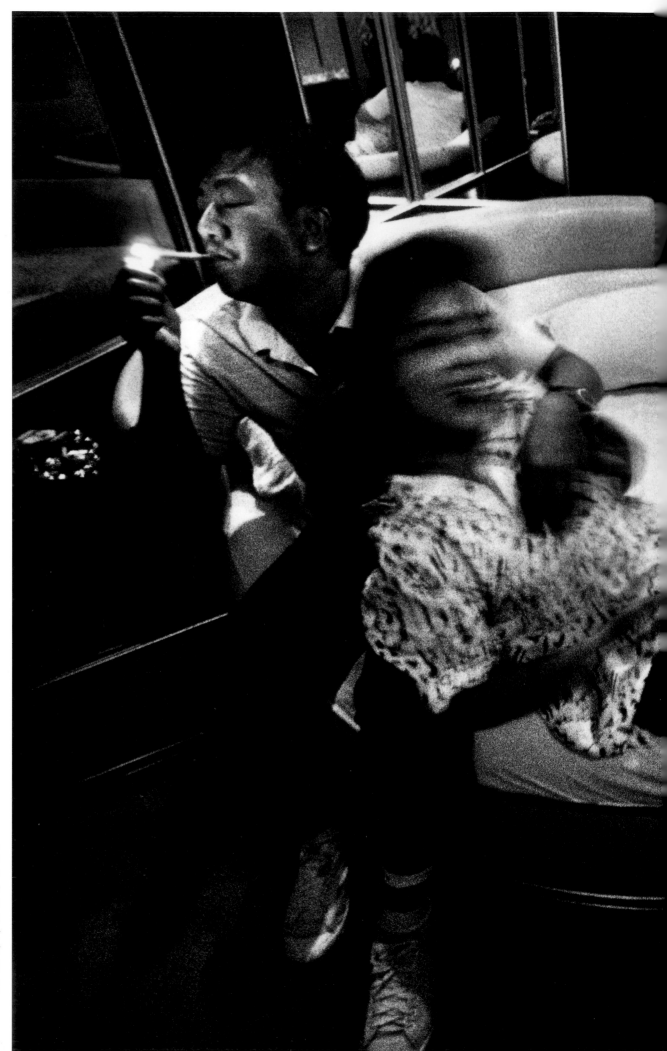

Kesorn Ronsai, fifteen, moves away from a man at a cheap prostitution motel in Bangkok. She says she left northern Thailand to become a prostitute because her family needed money for a new roof. "I'm thinking of my mother," she says. "I miss my mother."

The City of the Dead is a stop that the Egyptian government does not want you to make on the way to the pyramids. Amid the souls of the departed, hundreds of thousands of people are living in Cairo's cemeteries, people whose fate is as immutable as the tombs they inhabit.

A pack of heat-crazed dogs, boney and growling, fights over a scrap of food. When the dust settles, the outer grounds of Cairo's massive cemeteries look deserted. Inside the crypts are the dead, buried according to Islamic law with their heads facing east toward Mecca. And among the resting places for the dead are the living, more than two hundred thousand of them. Tombstones become headboards for beds, monuments become kitchen tables, and shrines to the dead become shelters to enshrine the living poor. Here the best philosophy is taken from an old West African proverb: "The beginning of wisdom is to get you a roof."

There is a refrigerator in one of the tombs, but it is broken and empty. Atop the refrigerator a small black-and-white television beams Olympic wrestling with electricity pirated from power lines near the road. Fatma Amin has just bathed her children in huge cooking pots, with water carried in by hand. She is forty years old and has eleven children, "one every two years." She has a granddaughter older than her youngest, an eight-month-old baby. Laundry dries on a clothesline strung between two tombstones. Amin welcomes her guests.

"I clean where the dead people are," she says, as one of her younger children tries to eat the tongue of the interpreter's running shoe. "We live here because there's not many apartments and we can't afford to pay the rent.

"The people that lie here are just human beings; they were probably better off than us. It's getting more crowded here. We applied to the government for an apartment, but there is a long wait. The families of the dead know we live here, but they only come here during the feast."

Their mail goes to a nearby coffee shop, where Amin's husband, a carpet mender, sits and smokes a water pipe as he waits for work. Another child walks into the tomb, dragging a dead snake. Amin offers beans and bread to her visitors, and when they decline, she becomes upset. "These pots are very clean," she says. "As you can see, we have everything we need here."

Amin is told that by the year 2025, the world population will double. "We never heard about the loop or the Pill and these things," she says. "So, I was watching television, and [information about birth control] came on, and I started using it. If I had heard about it earlier, I would have started using it earlier. All I'm asking from God is to live to see my children grow up and be better than this."

Nearby, Ahmad, so old and feeble that he can no longer move, is a human sphinx. He lies on a blanket in front of the cool marble crypt of Dr. Labib el Sa-id and chain-smokes Cleopatras. The blanket, smelling of urine, is pockmarked with cigarette burns. A laborer all his life and now in his eighties, Ahmad still dreams of going to France for an operation to help him walk again.

(continued on page 113)

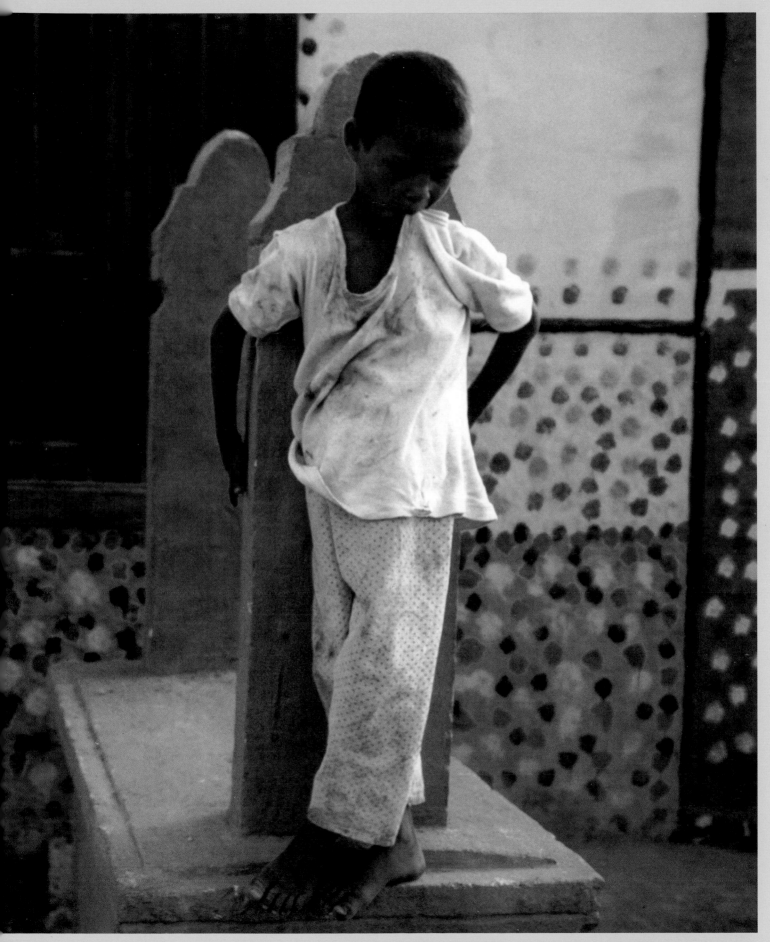

A child chews on his shirt in the City of the Dead, a cemetery which is home to more than two hundred thousand in Cairo.

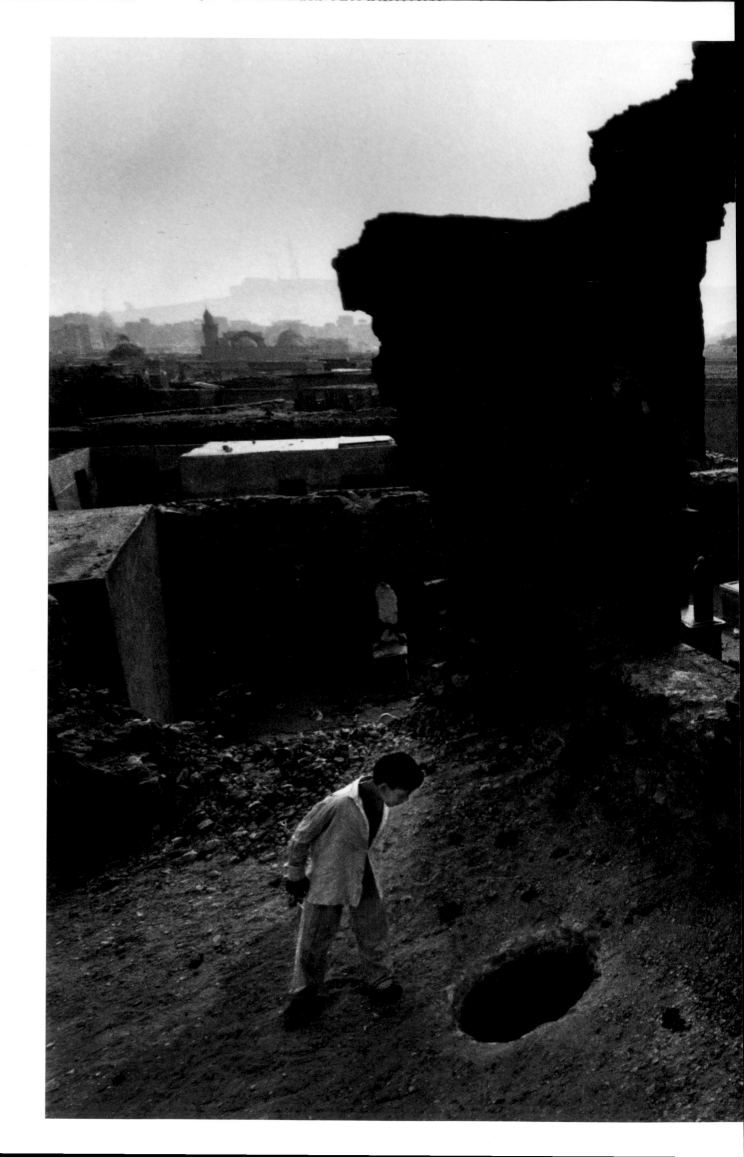

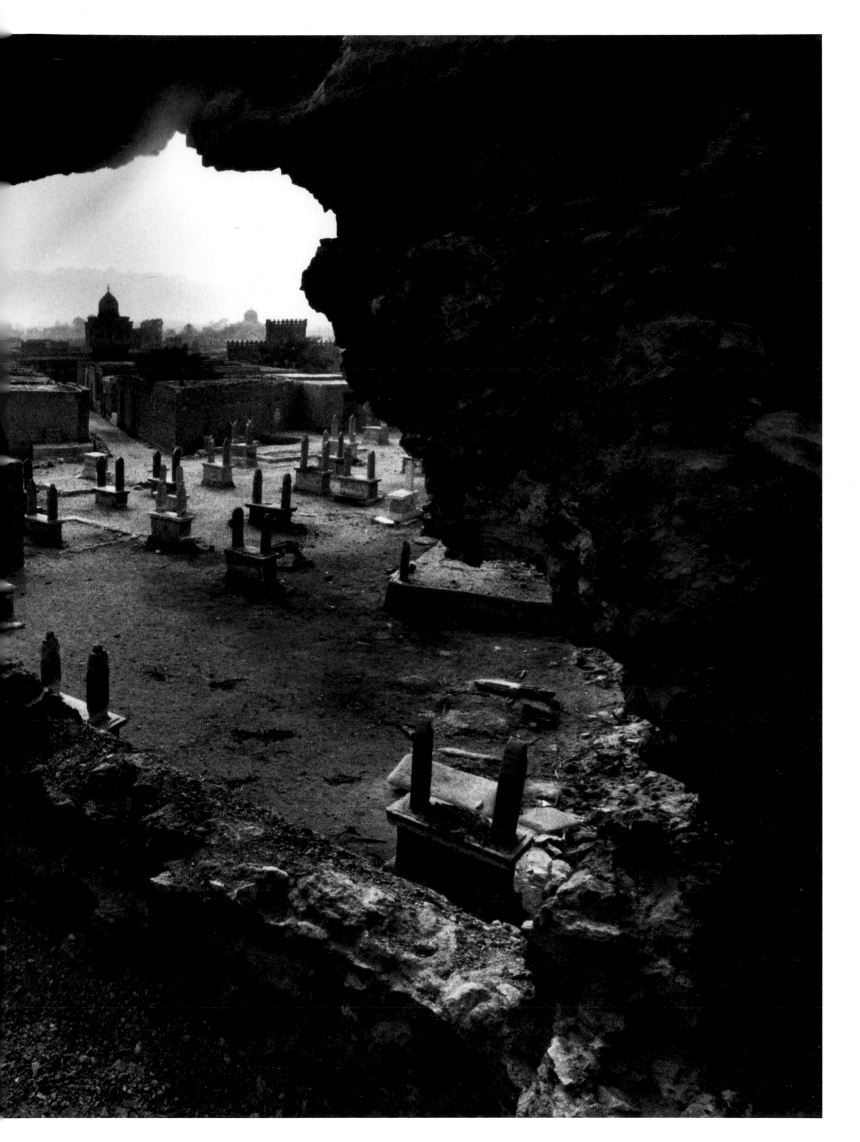

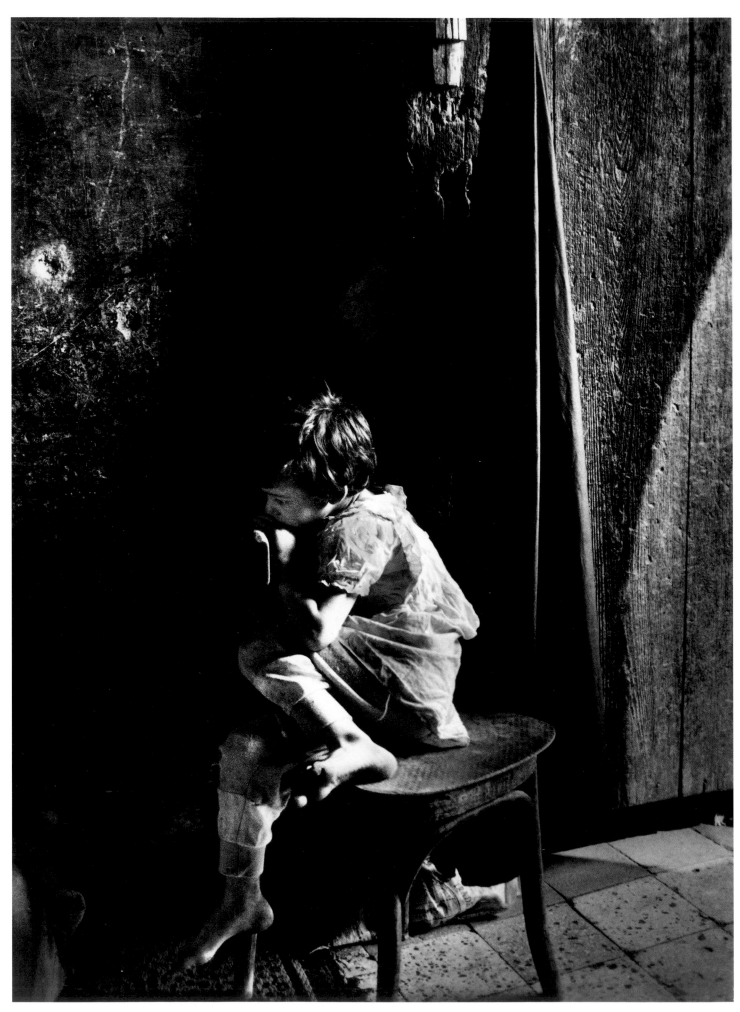

One of the eleven children of Fatma Amin. "All I'm asking from God," she says, "is to live to see my children grow up and be better than this." *Previous spread*: The area in the foreground—not just the pit—serves as a toilet in Cairo's City of the Dead. In this desecrated landscape, tombs of the remembered dead are homes for the forgotten living.

(continued from page 108)

But the only doctor he will ever visit is decaying just below him. The other residents of the two-room tomb—six kittens, two middle-aged sisters, and two children—ignore him.

Sadiya, one of the sisters, prepares coffee and gossips about her neighbors. "Nobody likes anybody here," she says.

Six years ago, attempts were made to toss Ahmad and his family from the tomb. "There was a death, and one woman and two men came with the body," Sadiya continues. "They said get out. I helped them dig, and I helped them clean, and they gave me a few pounds. They called the police before the burial. The undertaker wanted to take us out. He probably had other people who wanted to pay him to stay there. Finally the family said to stay."

Tha'lab, the undertaker, wears pajamas and a vest. Why get dressed if there's no work? He says business was booming twenty-seven years ago when he first moved here, but now there is just the dust. "Business?" says Tha'lab, frowning. "The doctors are doing their work. But I like it here. This is the only work we know."

Many residents of the City of the Dead, fearful of strangers, claim to be undertakers. But they are simply unofficial caretakers who worry about kidnappings or looters who dig up skeletons to sell to medical schools. Some are paid a few pounds by families of the dead to read the Koran for the departed.

Tha'lab insists that he really is an undertaker. "First you have to get a permit," he says. "Take off his clothes, wash his face, take off the cotton on the lips and mouth, and wrap him like a mummy—several layers. Then you attach three bands, and at the waist you do it very loosely because the body expands. Then you dig two meters down.

"Now we don't allow any new families to move in. It's full —it's a kingdom. I don't worry about the dead. They have God to take care of them."

Nearly two miles away but still in the City of the Dead, Hussein Muhammad, also an undertaker, says he wants people to drop dead. "I hope many people die," he says, flashing a smile. "The dead, they're much better than the living. We get our money, and we eat. It's money, money, money. We eat beans, but if somebody dies we eat chicken. The government is building apartments. If we can find a place we will go, but it costs sixty pounds a month. We can't afford even five."

Al-Mazni, another tenant, says he is sixty-five, but his seventeen-year-old wife insists he is seventy. They and their two children are new residents of the City of the Dead. "This is better than the place we came from, where the room had sewer water up to the waist," he says. They have been married for three years. Al-Mazni doesn't want his wife to talk to visitors. The children are hungry, and the crypt needs sweeping. His wife uses the tombstone as a table, and the children compete with the flies for the food. An old woman lives by herself in the next tomb. Both women have sad eyes, the old woman waiting to die and the young woman waiting to live.

Nearby, visible through the slots of an iron-doored tomb, a woman turns away when she sees visitors approaching. In the tomb are sheep and their droppings, children, beds of straw, and dirty sheets. "Leave us alone," the woman says. "Isn't it bad enough that we have to live with the dead."

Left: The refrigerator is broken and empty, but the television, run on pirated electricity, beams an Olympic wrestling event. One of the occupants of this tomb, a forty-year-old woman, has eleven children. "One every two years," she says. "We never heard about the loop or the Pill."

Many tomb-dwellers have forced their way inside. "The families of the dead know we live here," a woman says, "but they only come here during the feast."

Above: Eight-month-old Magdy, her mother, and three others share this two-chamber tomb with six kittens. In the City of the Dead, Magdy's mother says, "Nobody likes anybody."
Opposite: A child plays with dolls in her home.

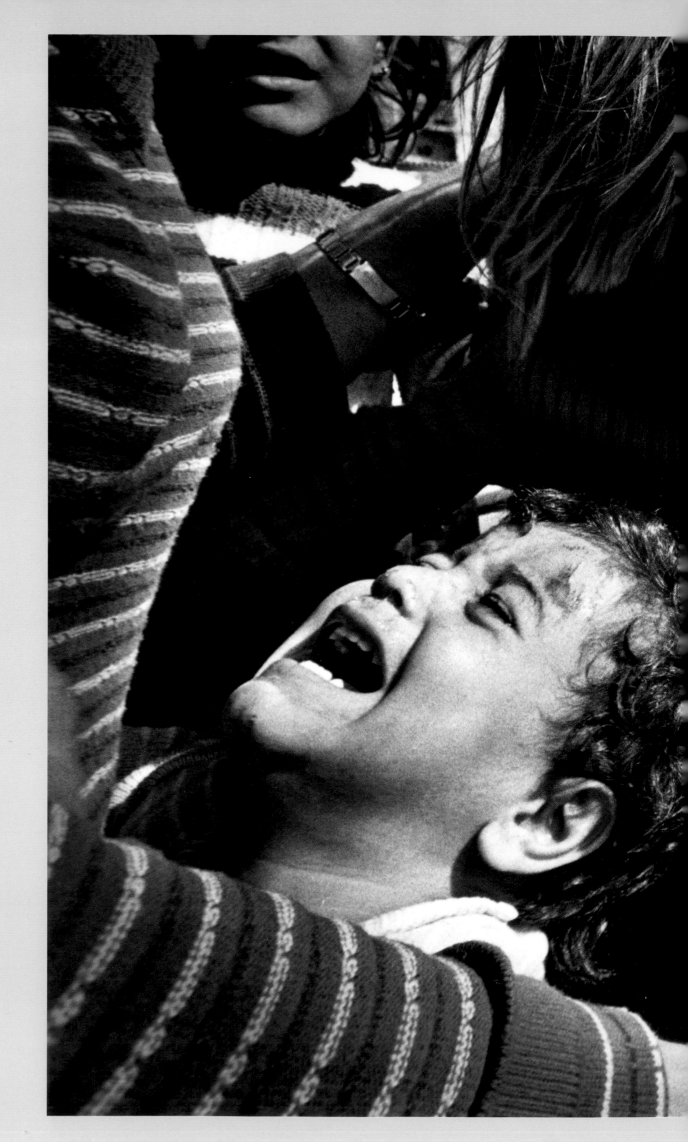

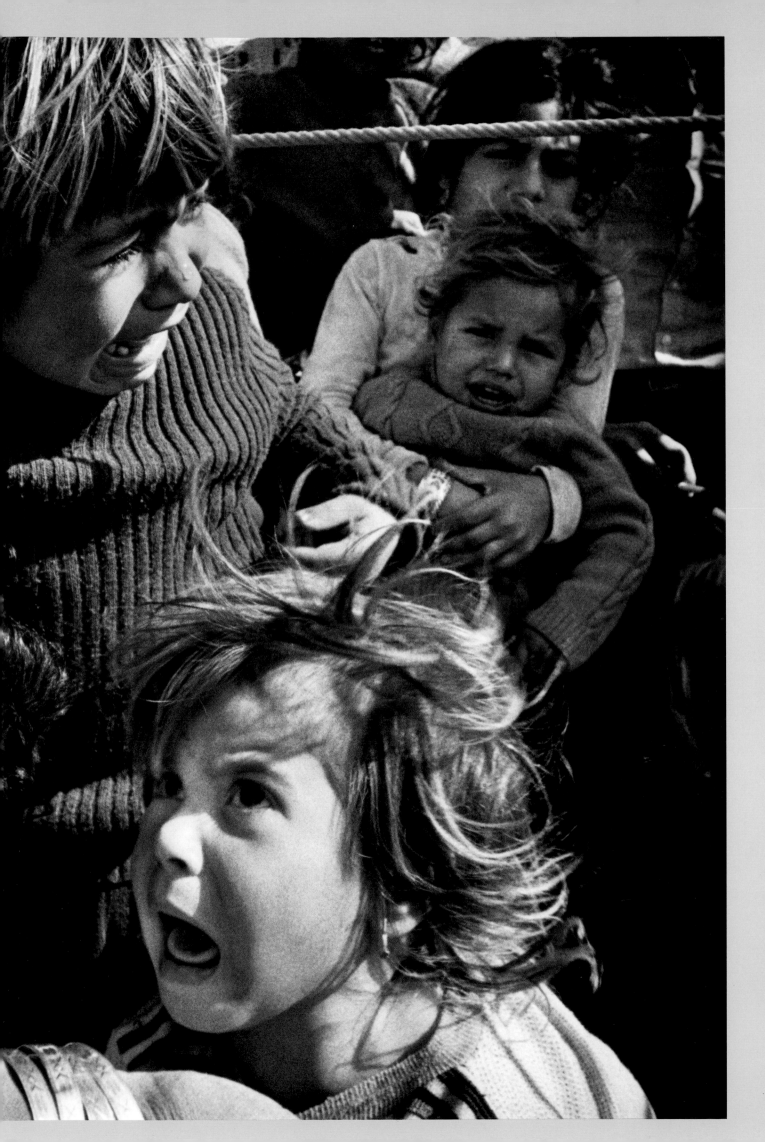

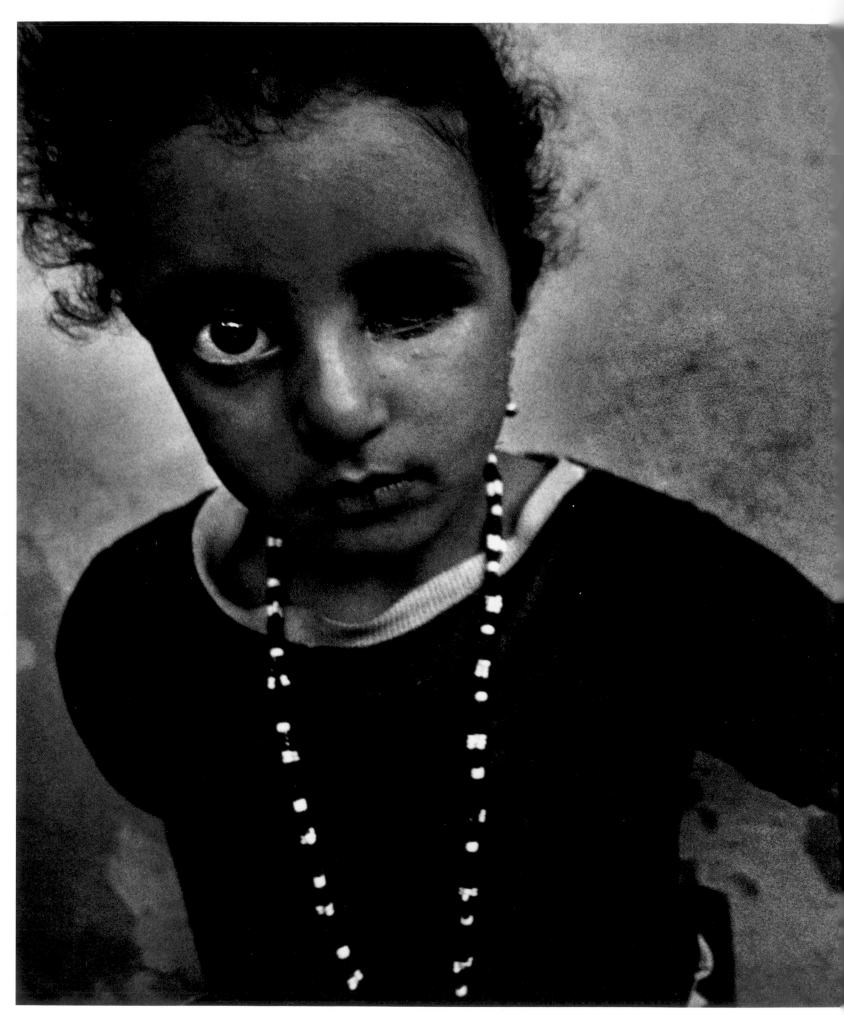

Fida Sherafi, a child of Gaza, holds the glass eye that replaced the one she lost to an Israeli rubber bullet when she was nine months old. She has to take it out every day to clean it. *Previous spread*: Children panic as shells fall on Tripoli, Lebanon.

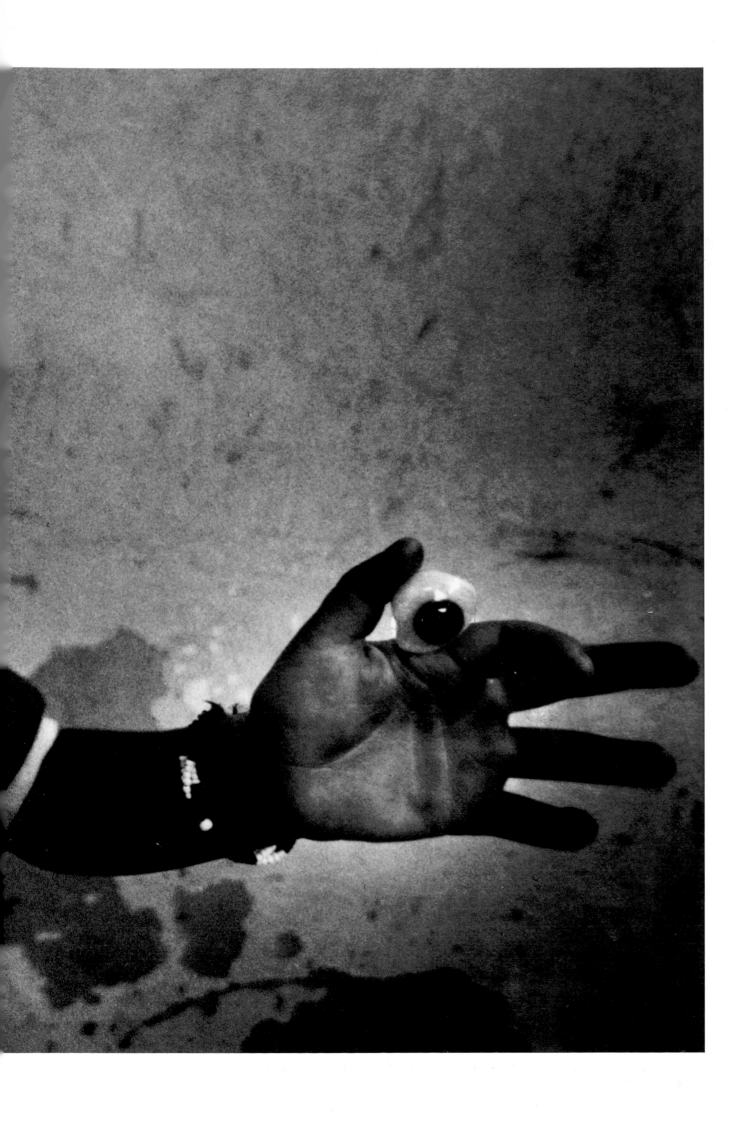

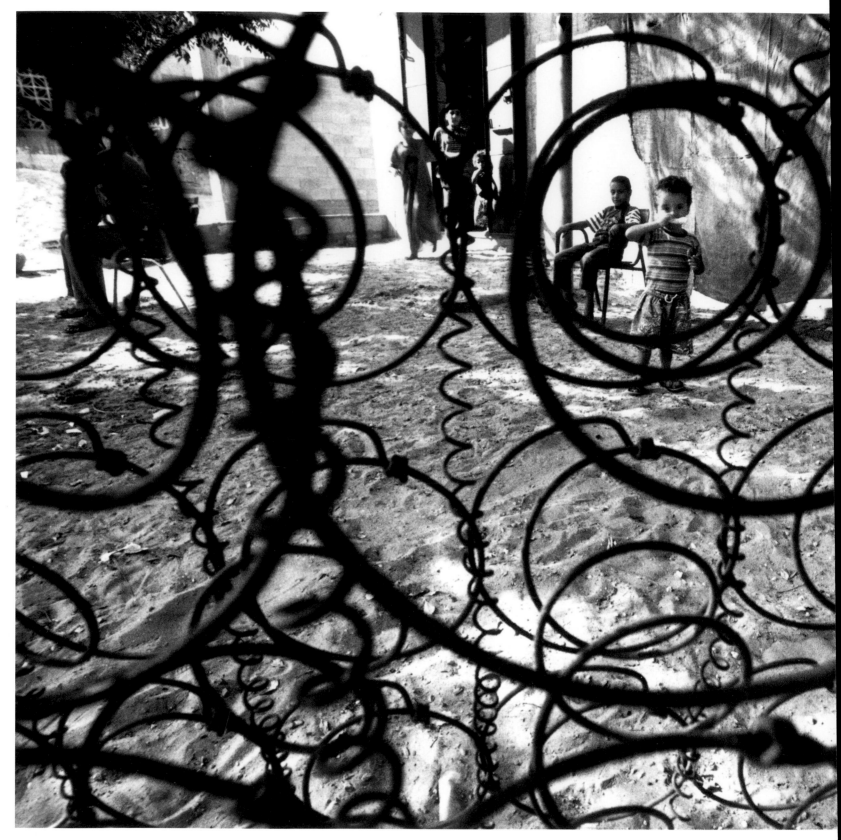

"Better, but not very better," says one Palestinian resident of Gaza.
"Nobody hates peace, and hopefully things will be better for us and the Israelis."

Fida Sherafi looks at the world differently than other children do. She has big brown eyes and one of them follows you around the room; the other is glass.

No one has a normal childhood in Gaza, in Northern Ireland, or anywhere else where people preach hate in the name of God. Fida lost her childhood on June 6, 1988, in a marketplace in Jubalia Refugee Camp. She was nine months old.

Hours after a weeklong curfew had ended, Fida went with her mother to buy vegetables. Israeli soldiers entered the crowded marketplace. Words led to rocks, which ignited a riot. Tear-gas canisters were fired, and, as things got worse, rubber-coated bullets. Mrs. Sherafi ran, clutching Fida against her chest with one arm and carrying groceries with the other. She heard screams, but didn't stop running until she was safely home. Once inside, she saw blood-stains on her shoulder. Then she looked at Fida. "The rubber bullet was stuck in her left eye socket," she says, "and her eyeball was partially dislodged." Hysterical, the mother ran into the street screaming. An Israeli soldier came into the house and ripped the bullet out, gouging her eye.

Mrs. Sherafi pauses as the horror sinks in. She looks at her daughter all dressed up in a pink dress. "Someday," she says, "I'm going to kill him."

Fida says nothing.

"She has to take the glass eye out and clean it every day. She doesn't go to school. We have to get it refitted every six months, and that's a $100 cab ride to Haifa. It hurts her during the night."

Children are the biggest casualties of war. According to "The State of the World's Children 1995," a UNICEF report: "At one time, wars were fought between armies; but in the wars of the last decade far more children than soldiers have been killed and disabled. Over that period, approximately two million children have died in wars, between four and five million have been physically disabled, more than five million have been forced into refugee camps, and more than twelve million have been left homeless."

But it's impossible to measure the psychological scars of children who have lost a parent to religious violence. In Northern Ireland, the recent cease-fire is a sign of hope, but a cease-fire can't bring back the dead.

John Frederick Anthony used to wish that "The Troubles" (the bloody struggle between England, Northern Ireland, and the Irish Republic) would just go away. But because he was a cleaner at the Lurgan police station, and the Irish Republican Army made it clear that anyone who worked for the enemy was the enemy, "The Troubles" found him as he was driving his wife Anne and children to his mother's house.

"When the bomb went off," Anne says, "I heard this awful bang. All of a sudden we were covered with smoke. You couldn't see anything. I went to reach for the wheel, but Fred was slumped over it. The car rolled into the church wall. I looked for Emma and couldn't find her. And then I heard this voice yelling, 'Mommy, Mommy, Mommy.' She was blown out of the back windscreen and was lying in the middle of the road. Her eyes were open and she was a mess."

Fred was pronounced dead on arrival and Emma, three, was in trouble. "Her blood pressure started to drop. They took a CAT-scan and realized her brain was swelling. She slipped into a coma." The IRA claimed responsibilty for the bomb.

One month later, Sadie Anthony clutches her granddaughter, who clutches a pillow. Emma's leg is fractured, her head shaved. She still has scars on her face and shrapnel in her head and legs.

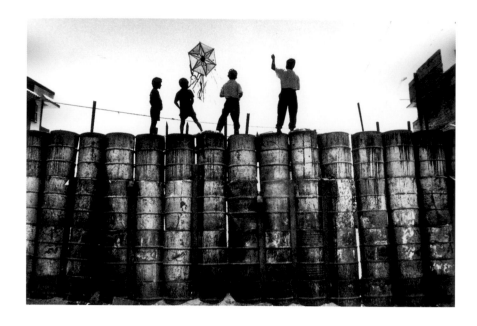

"He always brought 'em, the grandchildren, up here ten to eight every morning. Myself, I could have accepted it, but to deliberately plant a bomb knowing two wee children were gonna be in it . . . ," Sadie says.

"She does cry from her leg. I would love it if this would stop the money coming to them. Revenge? No, we got at least a thousand cards if not more, an awful lot from Roman Catholics. There was not a denomination in this town that wasn't praying for us."

Some forty miles south, in Crossmaglen, a Catholic mother says the same thing. "Revenge?" asks Margaret Caraher. "Well, it wouldn't change anything. I don't want revenge. I don't want any more mothers grieving. I just want justice. Justice and a reason why."

During "The Troubles" in Crossmaglen and in neighboring towns, 176 British soldiers have been killed, as have 137 civilians, including twenty-year-old Fergal Caraher.

About 3:30 P.M. on December 30, 1990, Caraher, his brother Miceal, and several friends left the Lite and Easy Pub in Cullyhanna in two cars. One broke down near a checkpoint, and Fergal offered assistance.

"The Royal Marines had told several people they were going to do somebody," says Caraher. "It was a form of intimidation. They were bragging about it. There was a vehicle checkpoint before the car park. He said, 'Are we all right?' and they waved him through. They nodded, and they walked away and kneeled and fired twenty rounds." Fergal's brother was badly wounded but survived. At 4:20 P.M., Fergal was pronounced dead on arrival at the hospital. High-velocity bullets had pierced an artery in his abdomen, and fifteen-month-old Brendan no longer had a father.

"He was too young to remember his father," says Caraher. "Other children told him about it. Now they put the checkpoints thirty yards from the schools. The kids are human shields. They put the barracks there because it's not going to look good if the IRA bombs the school. Brendan, he wants to know why he can't see his father. I tell him, 'Well, he's off in heaven.' And he says, 'Well, when is he going to come back?' And then he cries."

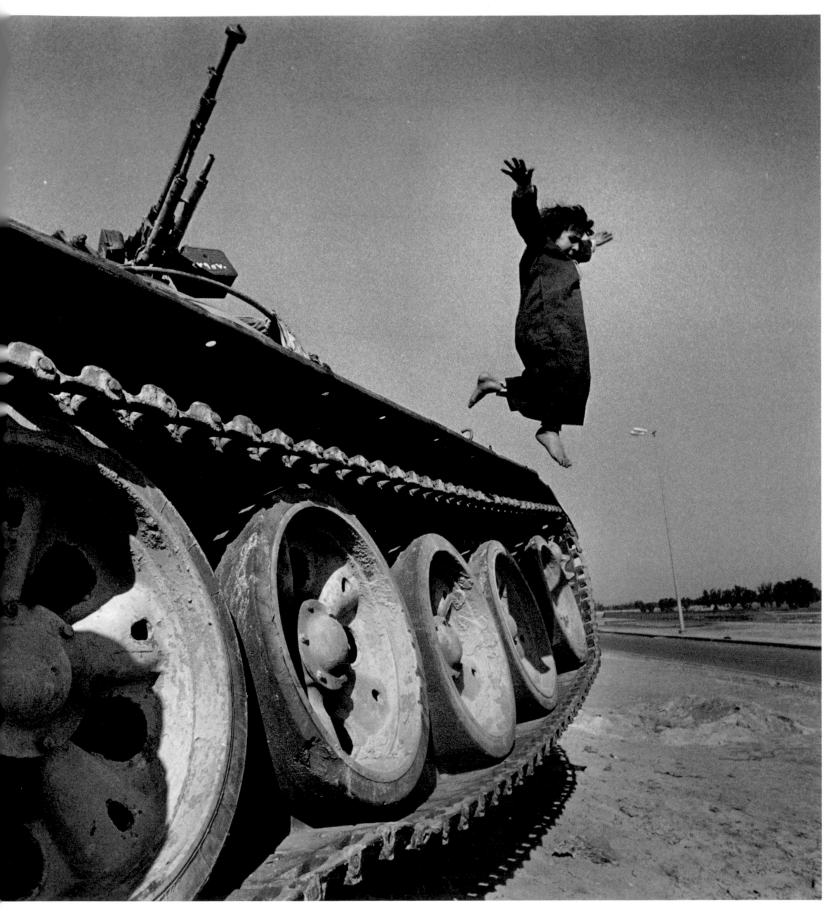

Above: A child gleefully jumps off an abandoned Iraqi tank in Kuwait. *Opposite page*: A barrier of barrels in the Gaza Strip. Says one resident, "Those barrels, most of them are down, but . . . it's like a big jail, fifty kilometers long."

War-orphaned children play with hula hoops at a school in southern Lebanon.

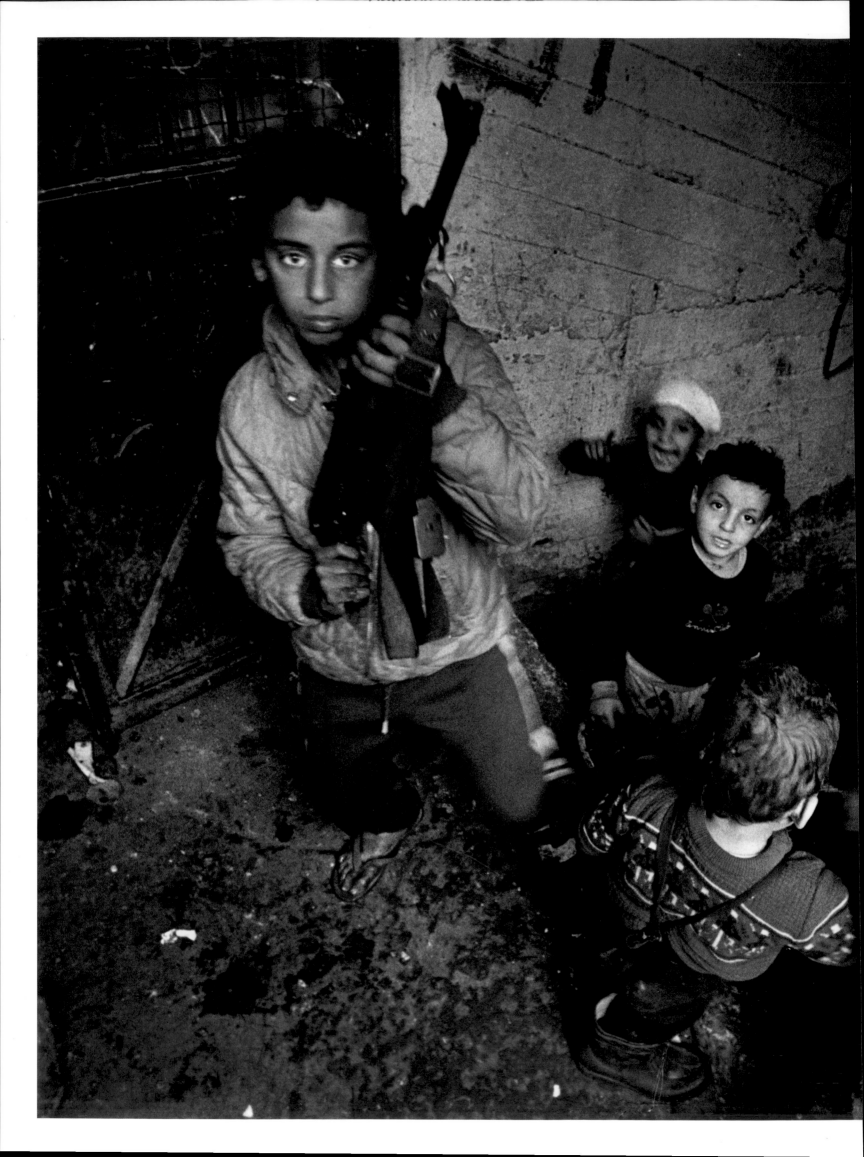

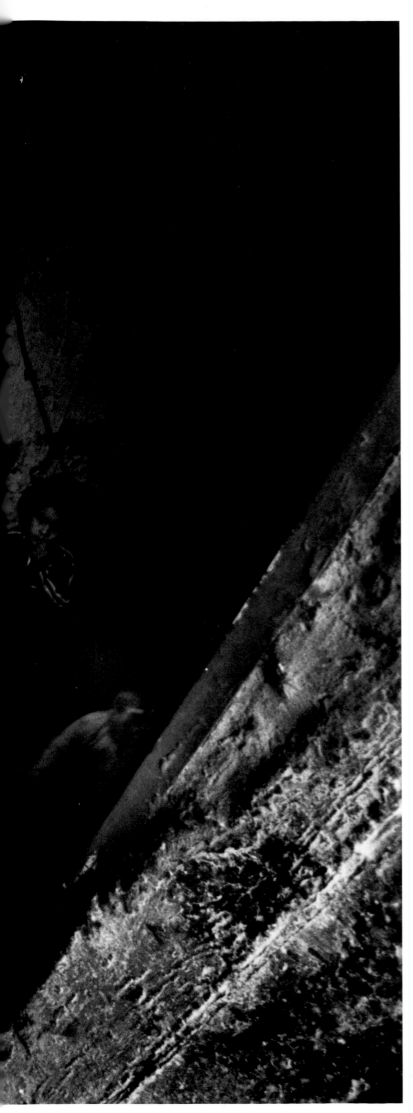

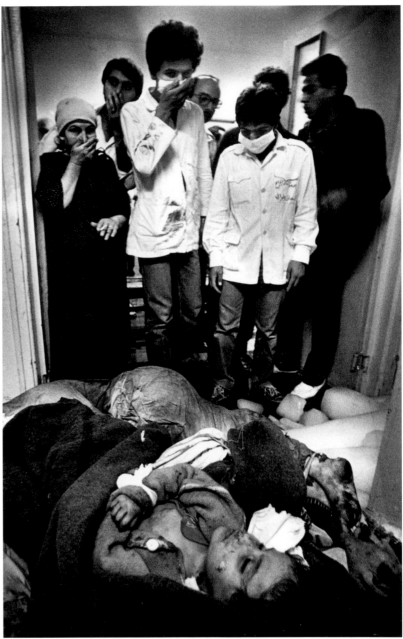

Above: Parents look for their children following heavy shelling in Tripoli, Lebanon.
Left: Kids with guns protect their turf during the civil war near Tripoli, Lebanon.

This four-year-old Iranian girl was born in prison and is not identified because she still has family in Iran. Her parents and siblings were tortured in prison. Her mother was chained to a bed when she gave birth.

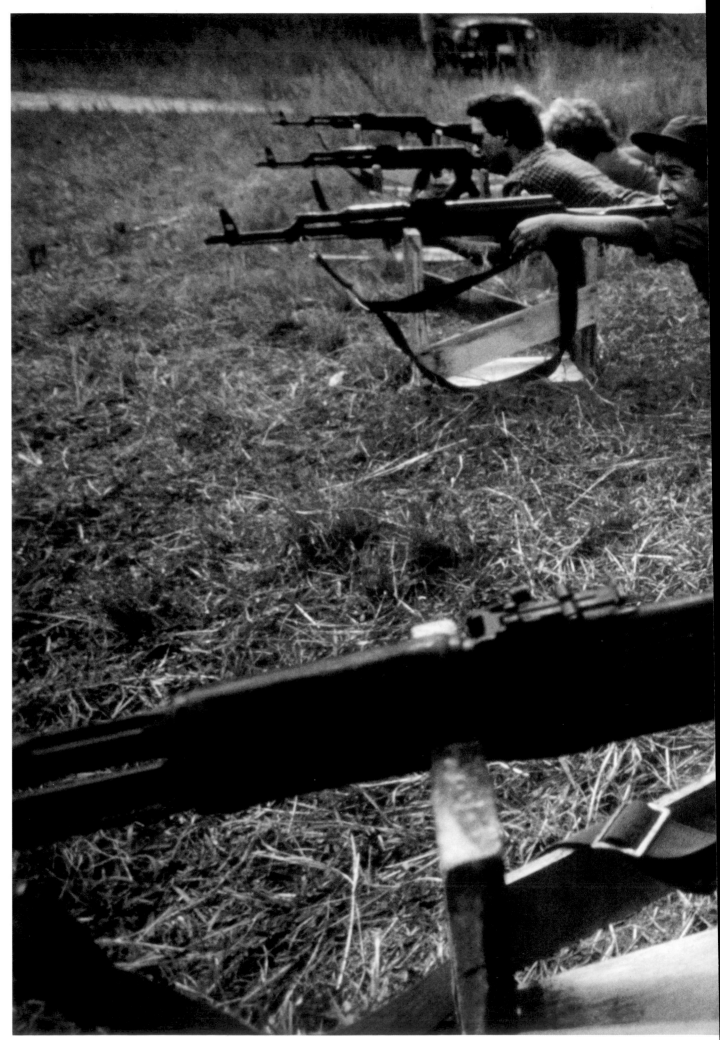

A Cuban youngster learns how to aim a gun during a militia training exercise near the Bay of Pigs.

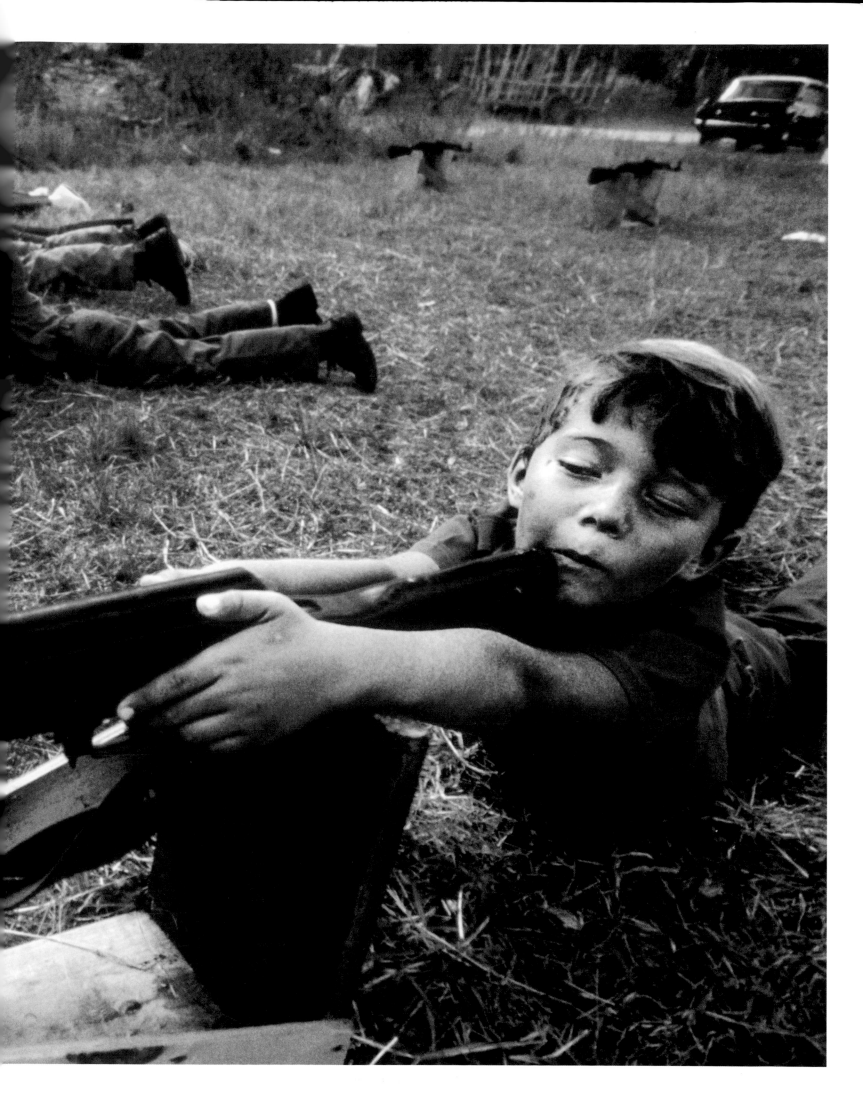

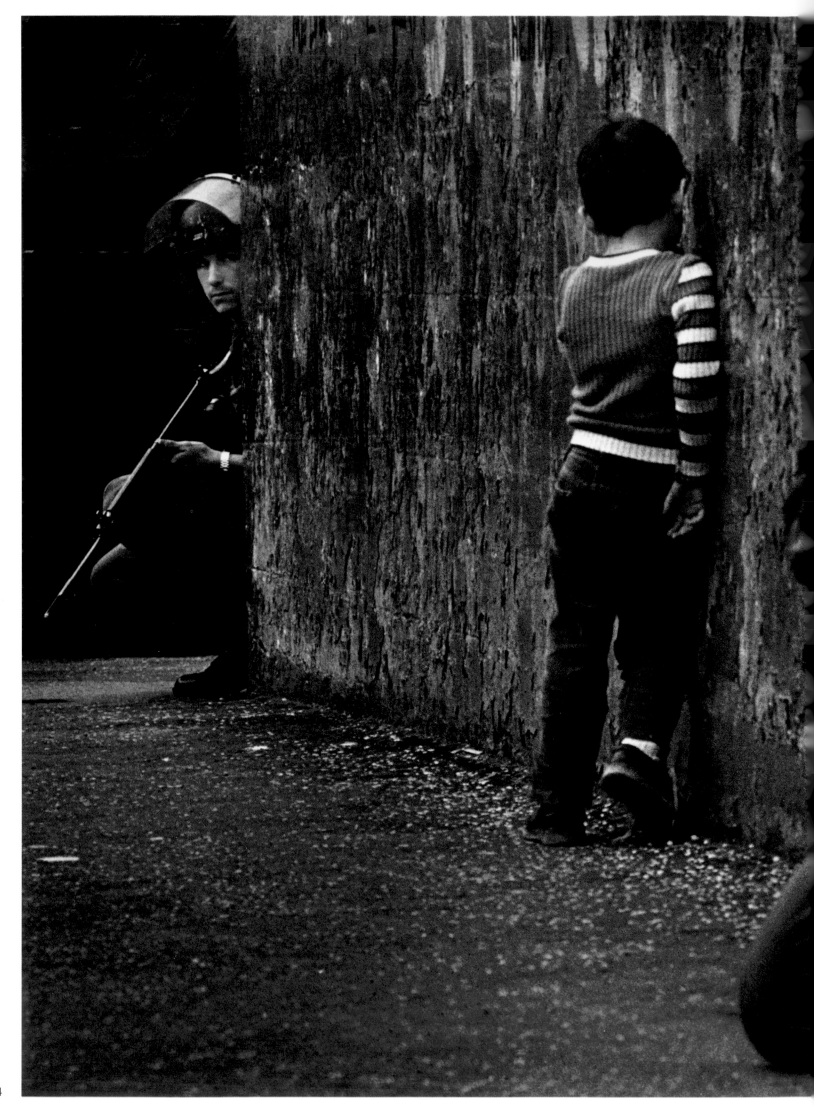

A child plays amongst soldiers in Northern Ireland.

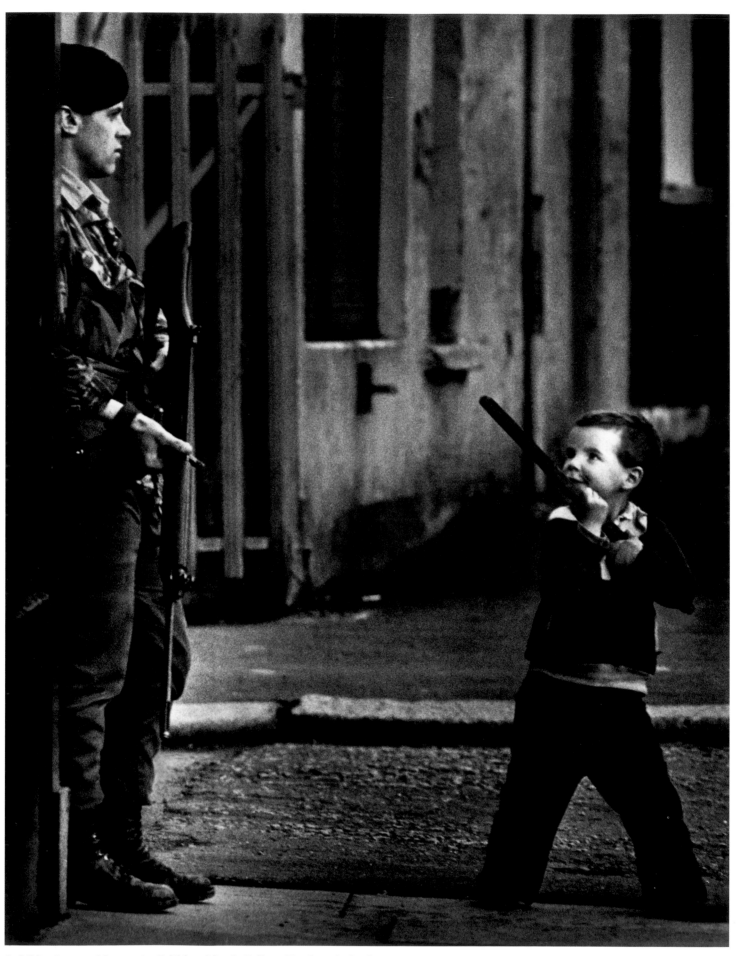

A child points a stick-gun at a British soldier in Belfast, Northern Ireland.

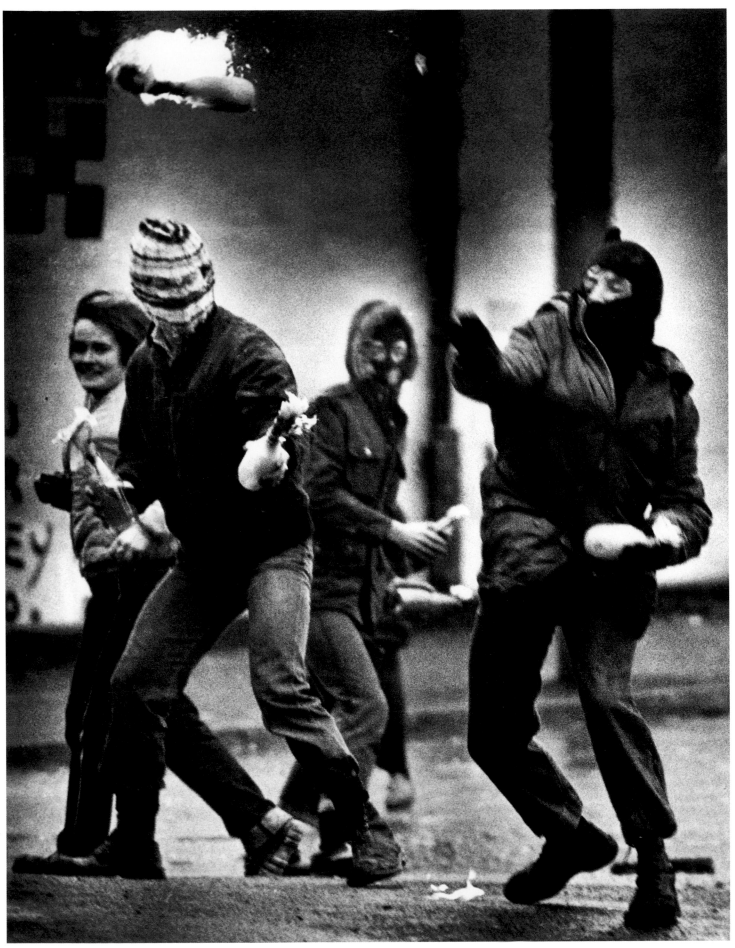

Teenagers toss petrol bombs at British patrols in a Catholic section of Belfast, Northern Ireland.

A mother and baby walk past a hijacked and bombed van on the streets of Belfast, Northern Ireland.

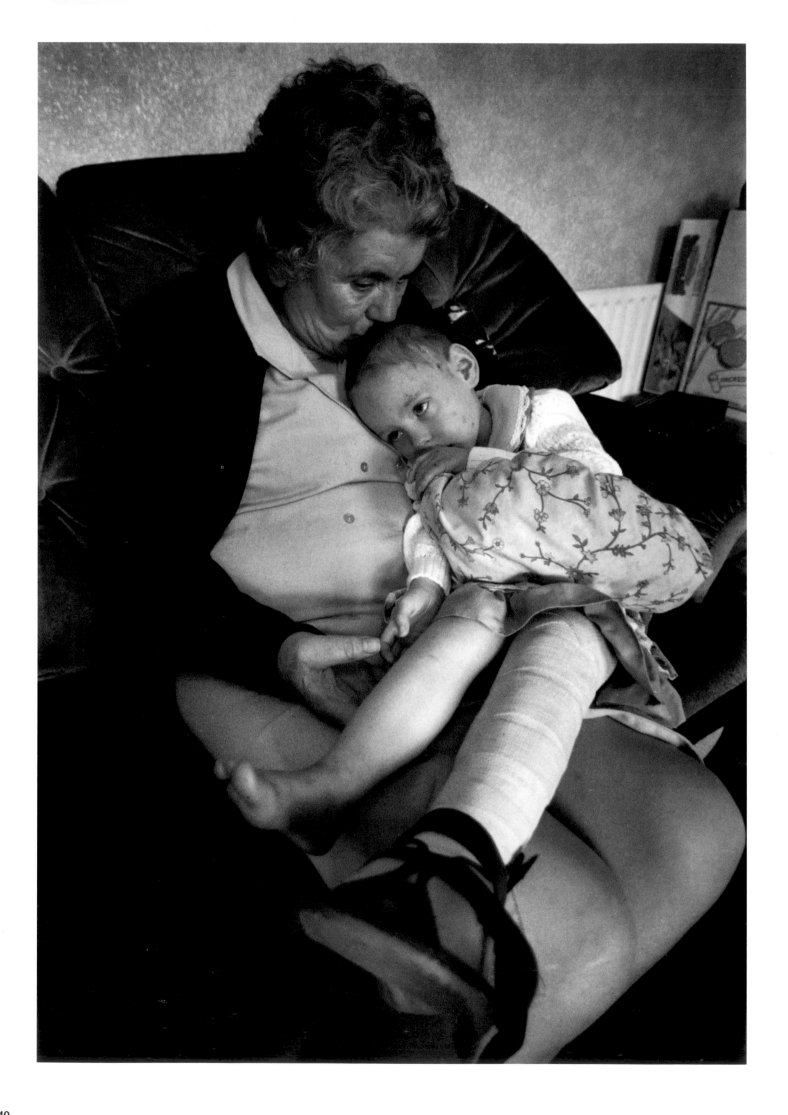

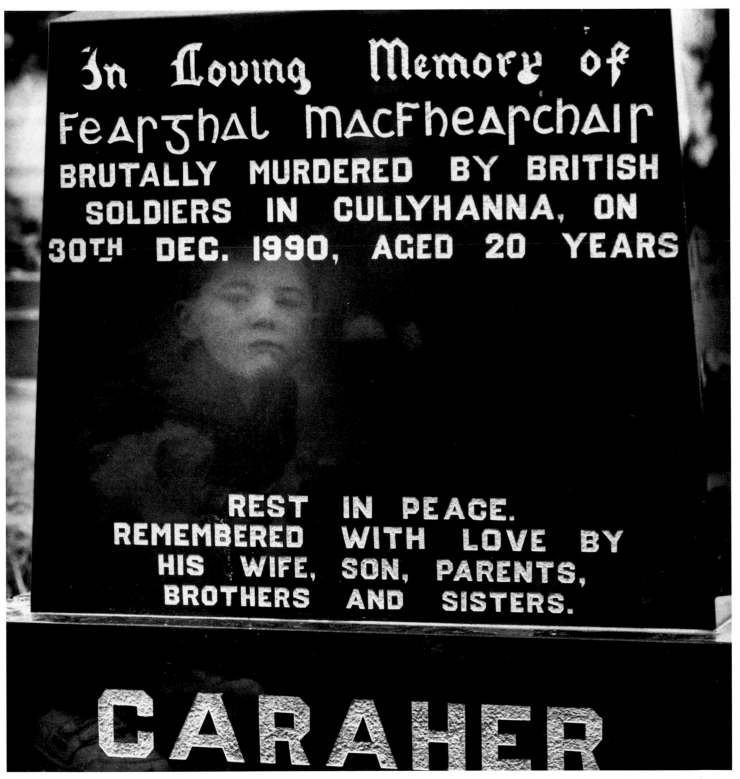

In Loving Memory of
Feargḣal MacFhearchair
BRUTALLY MURDERED BY BRITISH
SOLDIERS IN CULLYHANNA, ON
30TH DEC. 1990, AGED 20 YEARS

REST IN PEACE.
REMEMBERED WITH LOVE BY
HIS WIFE, SON, PARENTS,
BROTHERS AND SISTERS.

CARAHER

Above: Brendan Caraher, four, visits his father's grave in Crossmaglen, Northern Ireland. When his mother tells him his father is "off in heaven," he asks, "When is he going to come back?" Then he cries.
Opposite: Emma Anthony, three, and her grandmother, Sadie, relax in their home in Lurgan, Northern Ireland. Emma's father was killed by an IRA bomb planted in the family's car. One of her legs was broken in the blast, and shrapnel remains embedded in her legs and head.

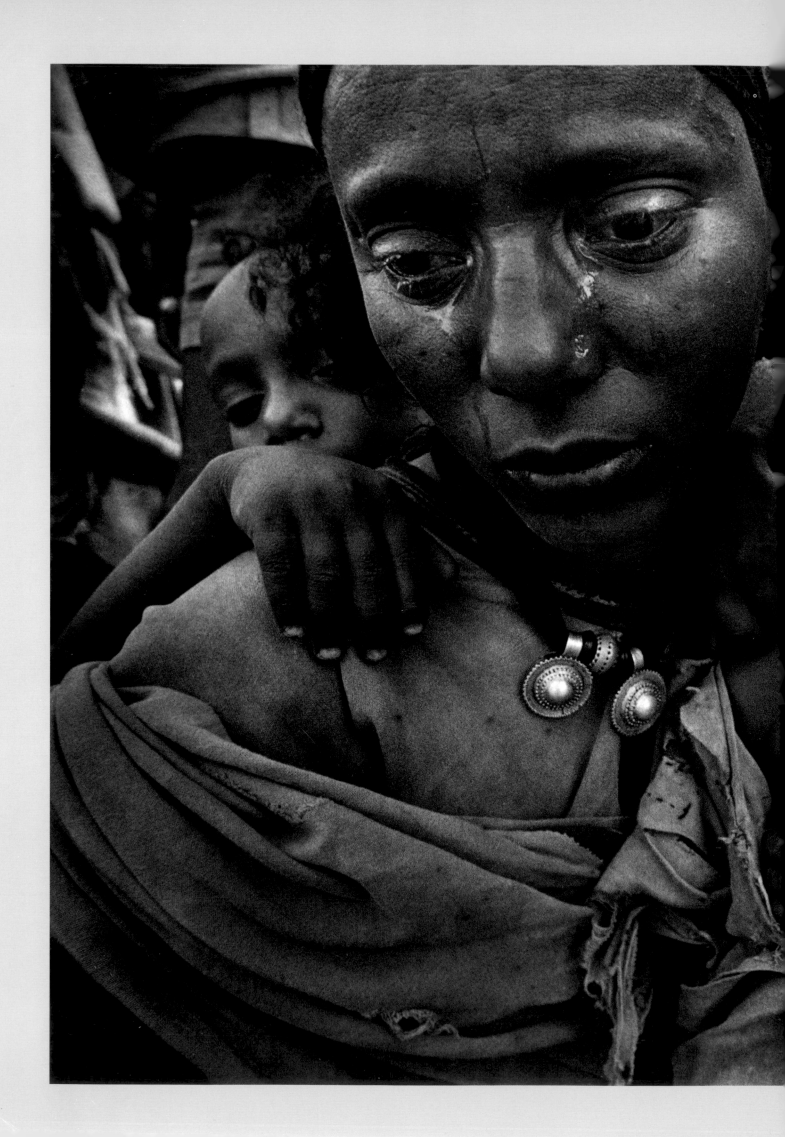

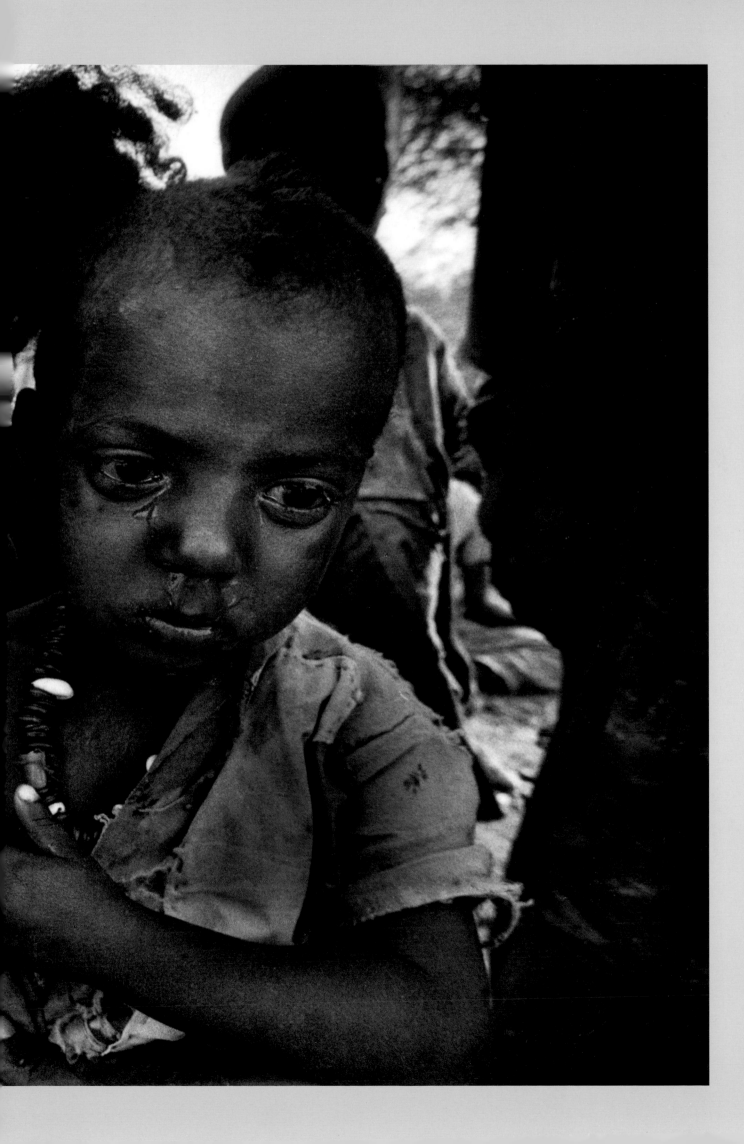

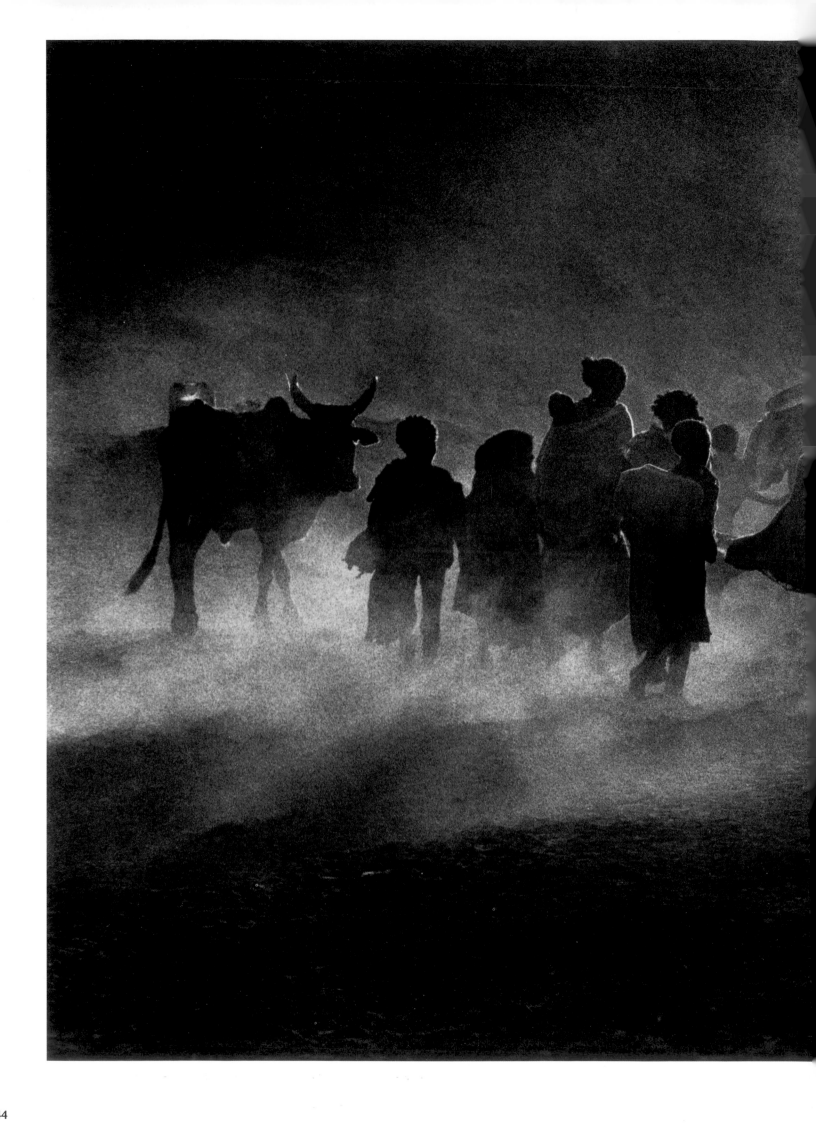

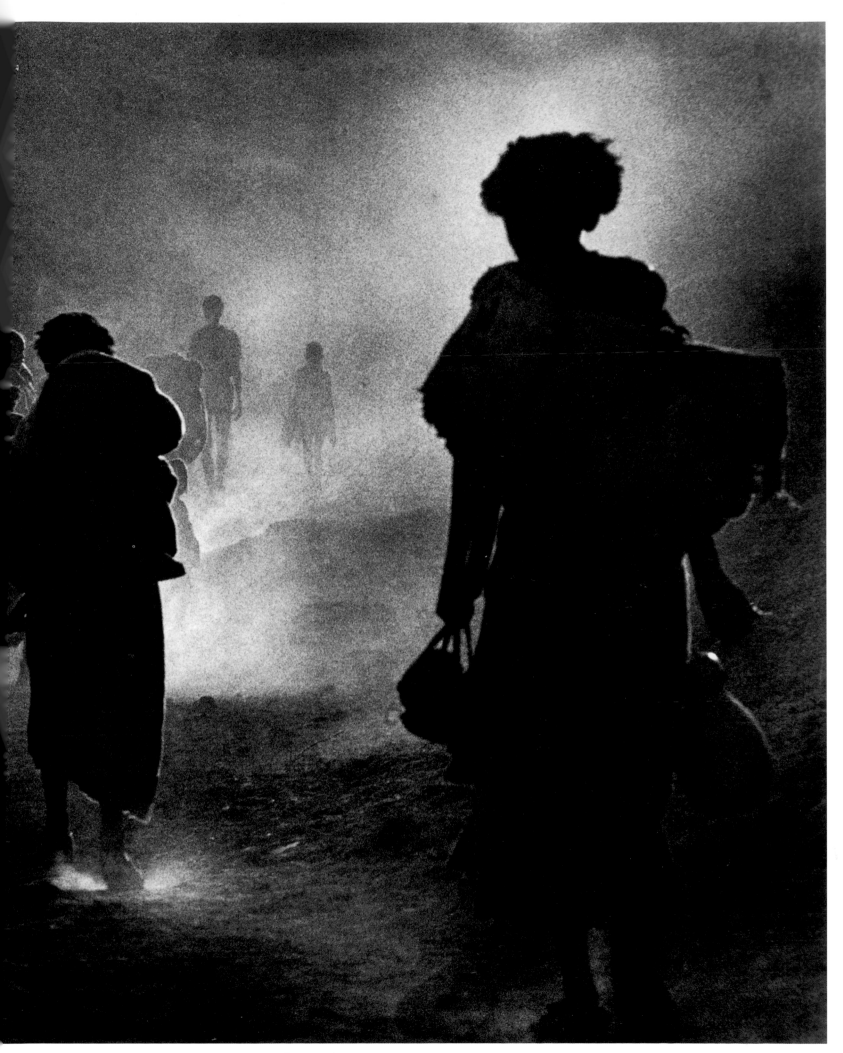

Ethiopians line up at sundown in Tigre Province for the long overnight march toward the Sudanese border.
Previous spread: Near the Gash River in Tigre Province, a woman and her son are told there is no room for them on the convoy heading to Sudan.

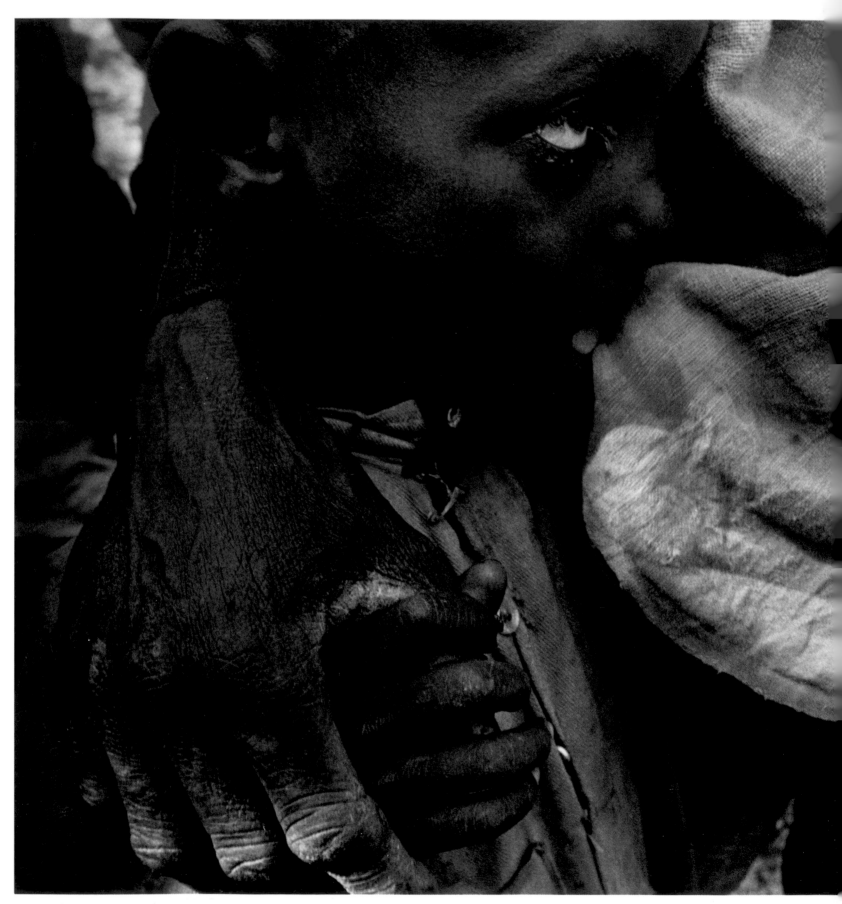

A hungry youngster licks flour from an empty burlap bag as he waits in line for food in Tigre Province.

Put yourself in this Ethiopian child's bare feet. He doesn't know why there is a civil war, he just sees his friends and family die. He's walked over one hundred miles from home along a dried-out riverbed, but he has more than that left to go to the Sudanese border. He has drunk water from wells that starving cattle have defecated in, but that's all there is. Sleep is a luxury he can't afford. In the daytime he has to hide because Ethiopian MIGs flying overhead drop bombs. He walks all night in the dusty paths of others. If he veers off the path to relieve himself, he must worry about land mines. He's always hungry but all that is left of the food is a trace of flour trapped on a burlap bag.

This was the scene in Tigre Province, Ethiopia, during the civil war of 1984. Africa accounts for roughly one-third of the world's refugees, and the situation is growing worse worldwide. The number of uprooted persons has nearly doubled in the last ten years, according to the United States Committee for Refugees (USCR), a nongovernmental agency. Now for every young innocent victim of unrest there are two.

Whether it is Ethiopians fleeing civil war in 1984 or Liberians fleeing civil war in 1996, the most innocent victim is always the same—the child.

"Every year brings yet another unpredicted refugee emergency of massive proportions," according to a USCR report. "In 1994, it was the unprecedented flight of nearly two million people from Rwanda. In 1993, it was the sudden exodus of nearly seven hundred thousand refugees from Burundi. In 1992, it was the outflow of 1.6 million persons from the former Yugoslavia. In 1991, it was the Persian Gulf War, resulting in 1.7 million refugees. In 1989 to 1990, it was the disintegration of the Soviet Union."

Tell the boy in the bare feet, licking the burlap bag that he's old news. That now he's running the wrong way. Today there is peace where he came from in Ethiopia, but war where he is headed in Sudan. Today thirty-five thousand children will die from causes such as malnutrition, dehydration, and infectious childhood diseases, according to UNICEF. Today nearly half the countries in the world are either producing or receiving significant numbers of refugees according to USCR figures, but maybe you won't have to tell him. Maybe one of the millions of land mines scattered around the world's war zones already left him a message.

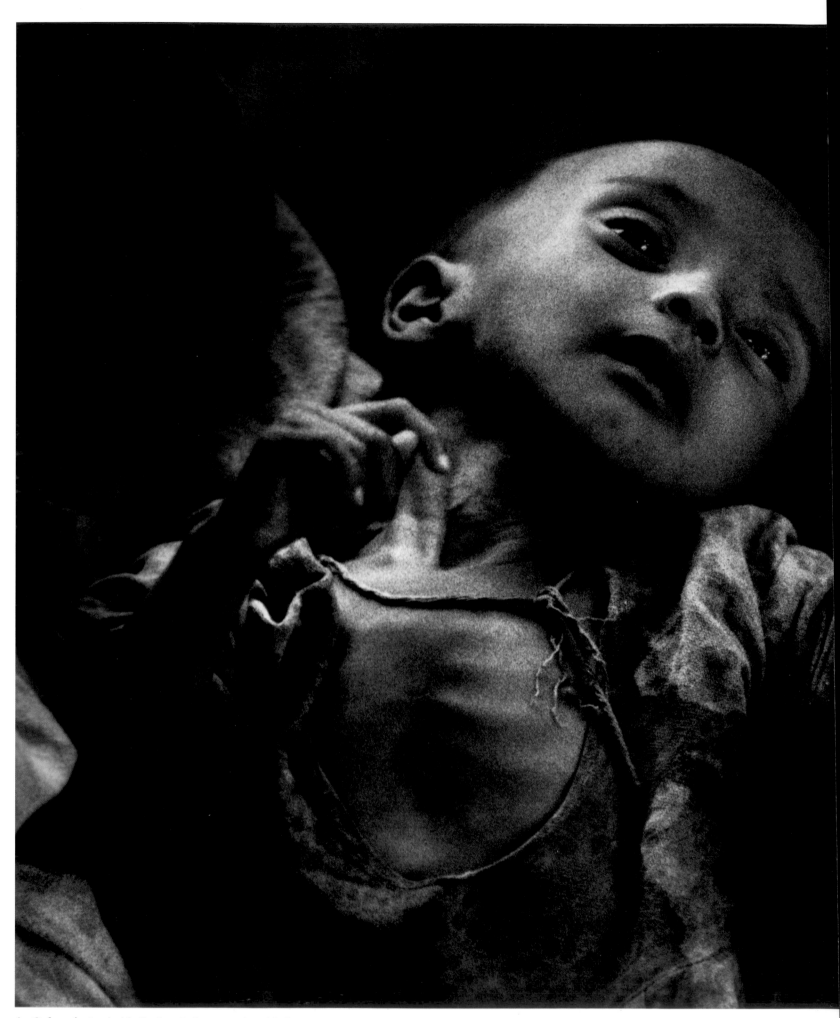

An Oxfam doctor holds the hand of an emaciated baby.

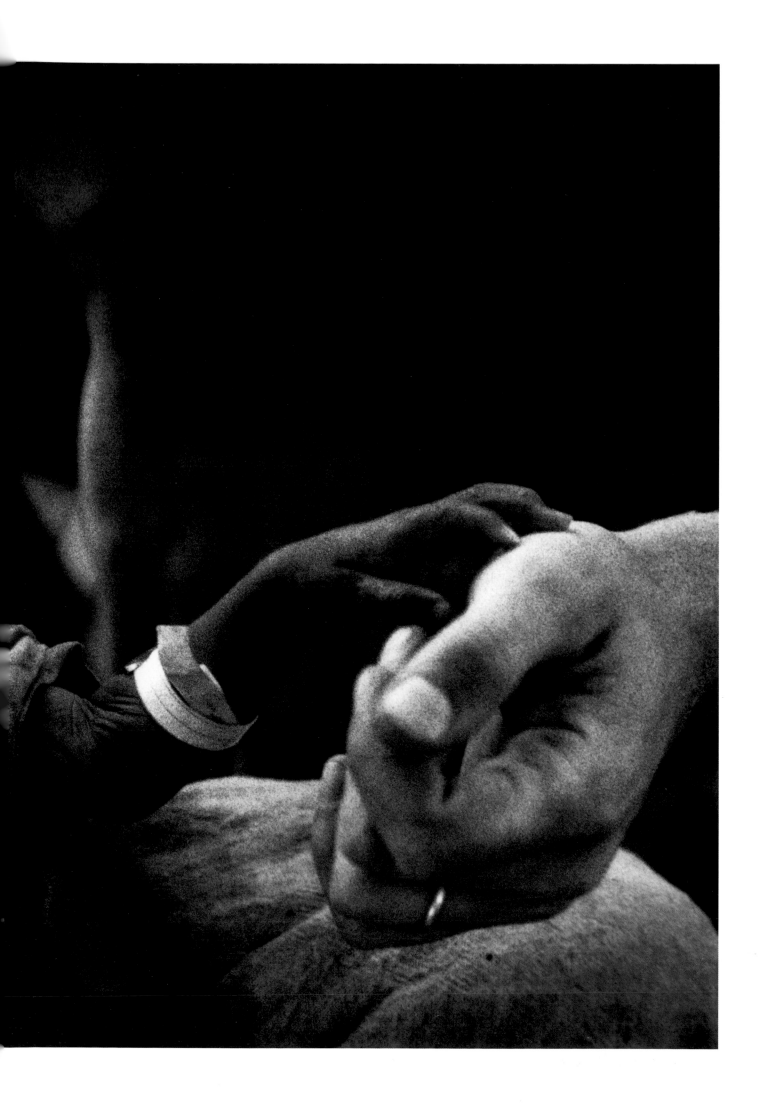

The Americans are invading Vietnam again. But this time it is tourists, armed with cash. In Hanoi, a Vietnamese official excitedly meets the plane. "You must stay in Halong Bay Hotel, room 208, he says. "That's where Catherine Deneuve slept making the movie *Indochine*."

Visitors love to say they slept in the same bed as the French actress, and they marvel as they tour Halong Bay in the Gulf of Tonkin, where three thousand islands rise like tombstones from the sea. In the gauzy fog, the rickety sailboats look like ghosts.

It is a postcard-perfect scene, until the bats fly out of the caves and the children surface. Cu Bom, nine, is cradled in his sister's arms. He is lifeless and his eyes are dull. His sister says that the child has a blood disease and they have no money. They survive by begging.

This is not news in Vietnam, "Whoever said we won the war but lost the peace is right," says Dr. Duong Quynh Hoa, a former Viet Cong doctor who set up field hospitals in the jungles. Today, with the government's attention on tourism and the economy, social programs have been cut. "There's no safety net," says Maurice Apted of UNICEF. Vietnam's per capita income is only $200 a year, roughly half of Haiti's. And although Vietnam has the highest child survival rate among poor nations, UNICEF says, 50 percent of the children under age five are "significantly malnourished."

In the big cities there are so many homeless children they have a name for them: Children of the Dust. These fifty thousand children lead lives of misery and shame. The police round them up by the truckload and place them in detention centers that they call schools. Sometimes blood is spilled.

In Saigon—nobody calls it by its postwar name, Ho Chi Minh City—the cart of capitalism is now moving faster than the horse, and the government is trying desperately to put on some brakes. Government officials say they don't want Saigon to become another Bangkok—choked with traffic, overpopulated, and overrun with sexploitation.

In Vietnam, Miss Saigon is not a play. She, or he, is a prostitute. With AIDS skyrocketing in Thailand, there are whispers that Vietnam is the next stop for sex tourism. In Saigon, those whispers are roars. "It's like standing on the shore and watching a hurricane shoot up the coast," says Michael Hegenauer of World Vision International, an aid organization.

Outside the Saigon Hotel, pedophiles pick up young boys born long after the war. These kids get their news from watching Asian MTV. "Hey," says one thirteen-year-old boy, rubbing a man's leg. "Boom, boom. Twenty dollars. You, you. Michael Jackson."

Some bars are named Apocalypse Now and Hard Rock Cafe. They are for tourists. Other bars are unmarked, and they are for trouble. In one, a dour woman glances at a clipboard and calls a name. Out comes a teenage girl wearing a dress with "I love you" printed on it, but her sad face says, "I don't want to sell my body." As she waits for a customer, she nervously squashes ants that crawl between the tiles of the bar.

"There is no AIDS in Vietnam," declares the madame. Not so. Officially, there were 1,171 cases detected before 1993, but health authorities suspect the true figure is ten times higher.

Environmentalists call parts of the south "environmental disaster zones." Even today, mortality rates are higher in areas of southern Vietnam sprayed with eleven million gallons of Agent Orange. The herbicide contains dioxin, one of the most toxic substances known. Vietnamese doctors say that the herbicide was transmitted by breast-feeding to millions of babies.

As head of U.S. Naval forces in Southeast Asia from 1968 to 1970, retired Admiral Elmo Zumwalt Jr. issued the direct orders to spray the chemical defoliant Agent Orange over Vietnam. He believed he was saving young American lives, and he still does.

But his son, a patrol-boat commander in the Mekong Delta in 1969 and 1970, died in 1988 of a form of cancer that has been linked to Agent Orange. Today, his grandson has learning disabilities. "We did what was right to do at the time. It saved a thousand lives. You live with the consequences.

"I deeply believe birth defects are caused by dioxin from Agent Orange. There is tragic anecdotal evidence that will over time be proven scientifically—AO causes birth defects," says Zumwalt.

The United States dumped eleven million gallons of Agent Orange in Vietnam, yet it has refused to acknowledge that it caused any health problems there.

"We know that dioxin affects the immune system and causes deformities," says Dr. Dinh Quang Minn, a Hanoi physician who serves on a Vietnamese committee studying the effects of AO. "Until now there was no official cooperation. I am a veteran, but like the American proverb says, 'Let bygones be bygones.' We need your scientists to come here and study."

"The big problem is the children are victims of the adult," says Dr. Duong Quynh Hoa. "I was in the war and sprayed with Agent Orange. I have seen many birth defects in defoliated country. I saw one woman at delivery give birth to Siamese twins— two bodies and one head—it was horrible, fortunately it died. I had a son that died at eight months and then I had two abortions, after that I refused to have any more. You must bring here your knowledge and goodwill."

Zumwalt agrees. "They're the ideal lab. That population has been exposed to it for a quarter century. There's no doubt some of their children are affected. They're lumping in all of their children and I don't think that's accurate. But our government has made a career in denying the effects of AO.

"The truth lies somewhere in between."

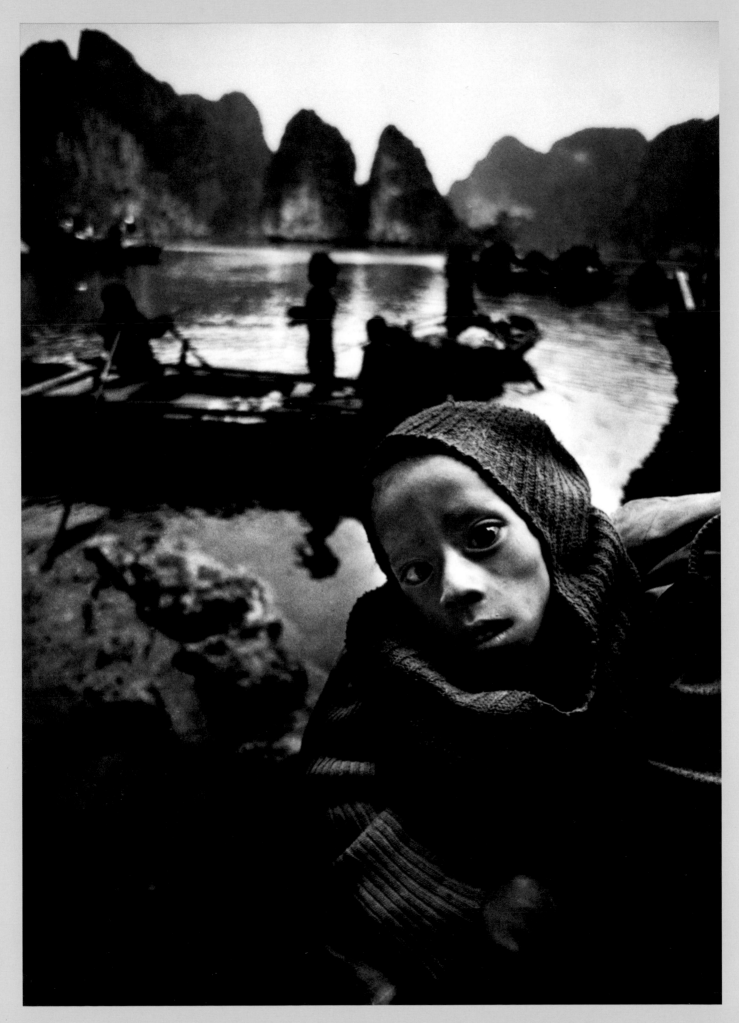

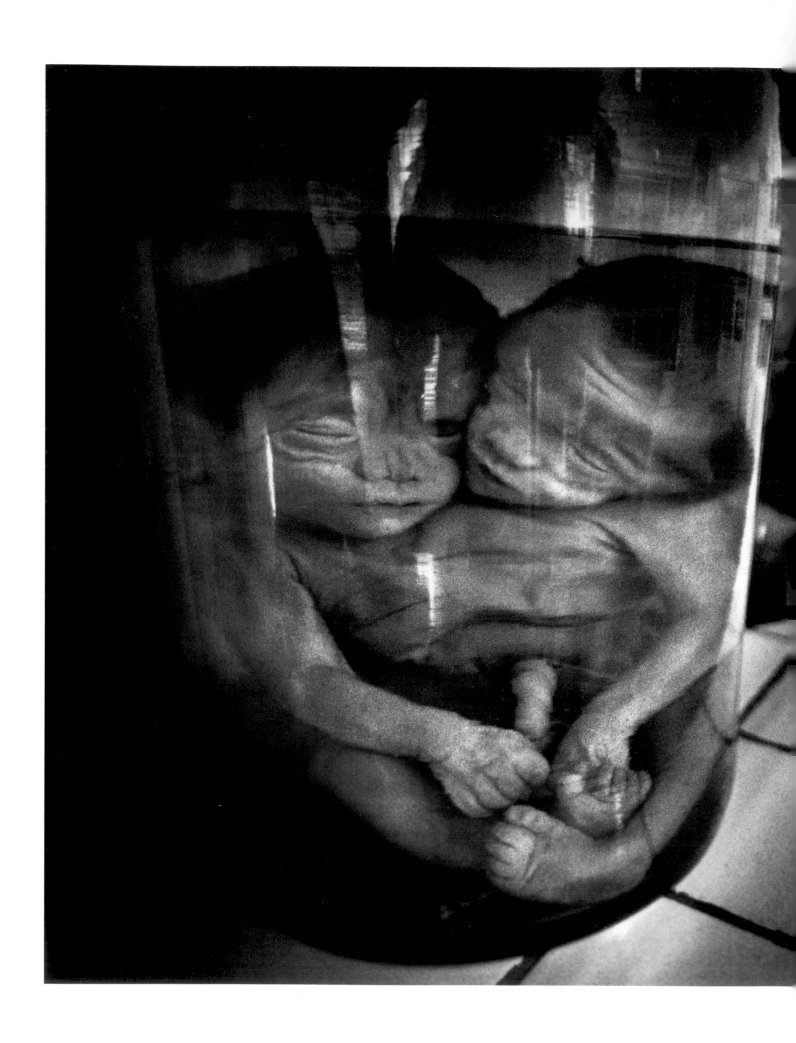

Jars hold deformed fetuses and infant corpses that doctors in Ho Chi Minh City claim are the result of Agent Orange. *Previous spread*: This child, who suffers from a blood disease, is used by his family as a beggar in Vietnam's picturesque Halong Bay.

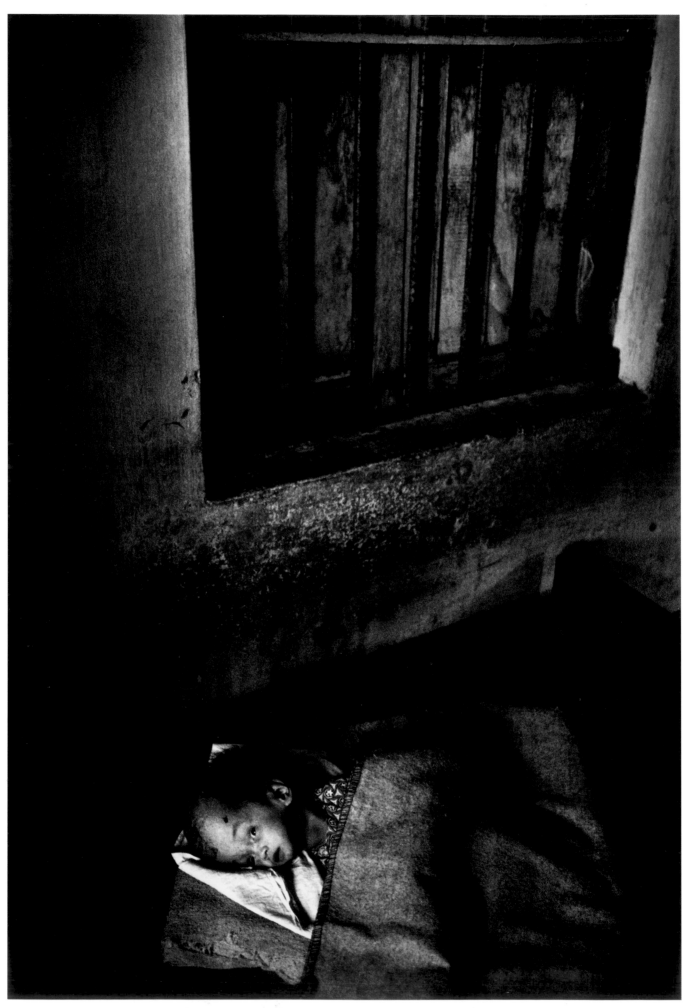

Above: Abandoned by his mother in Dac Lac province, Nguyen Van Roi, seven months old,
is another suspected victim of Agent Orange.
Opposite: Cu Di, four, of Vietnam, is thought to be a victim of Agent Orange.

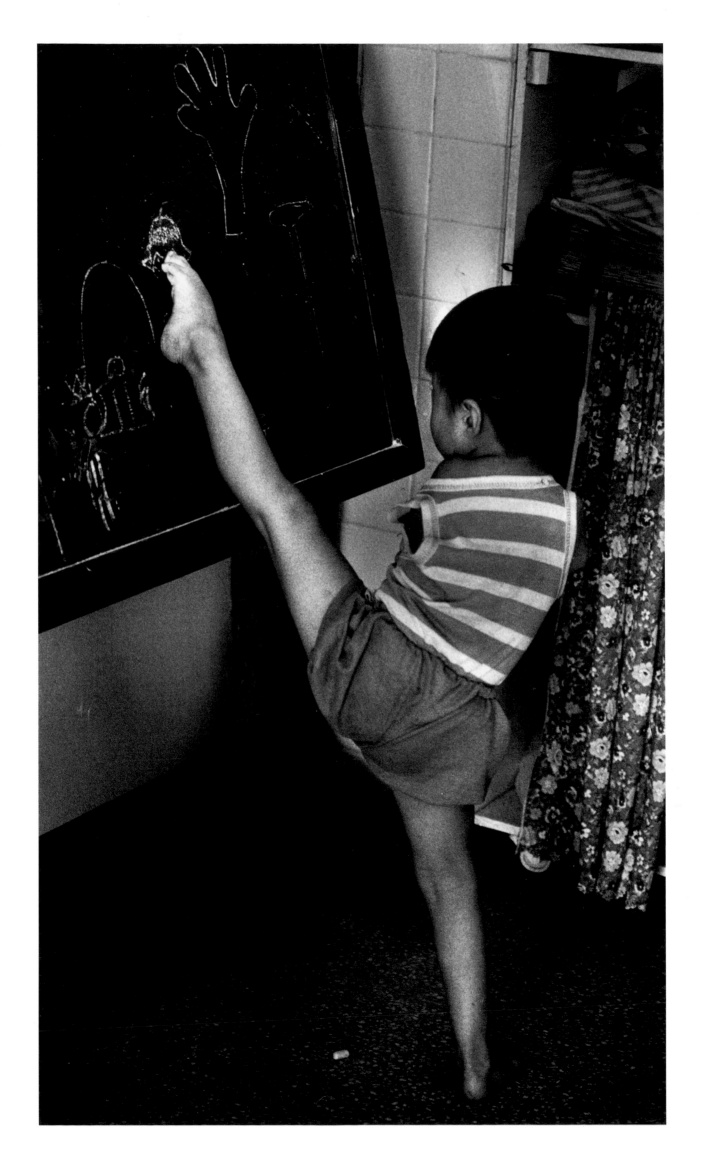

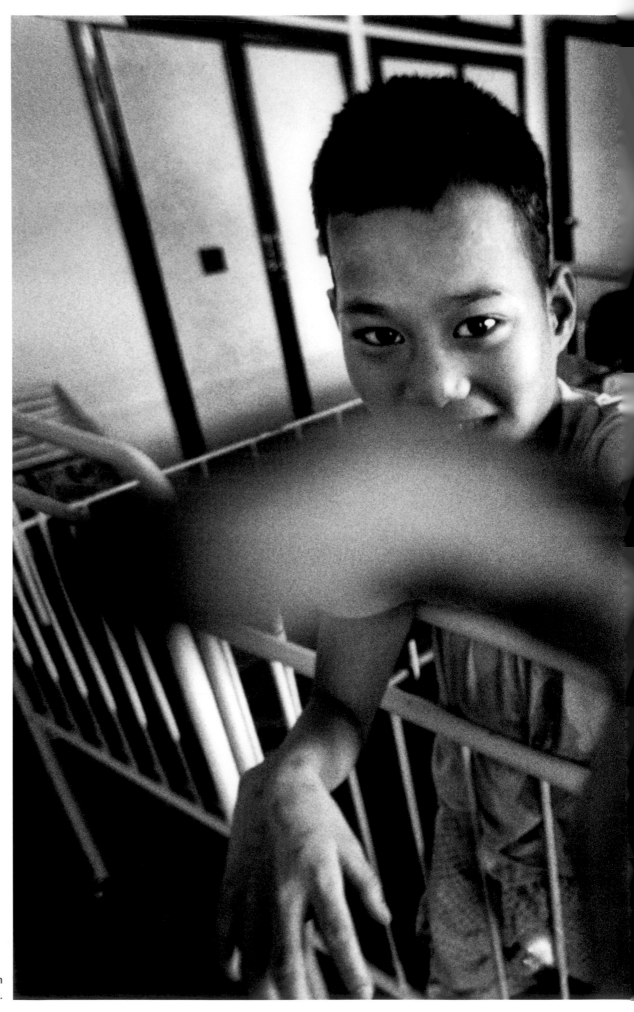

A possible victim
of Agent Orange.

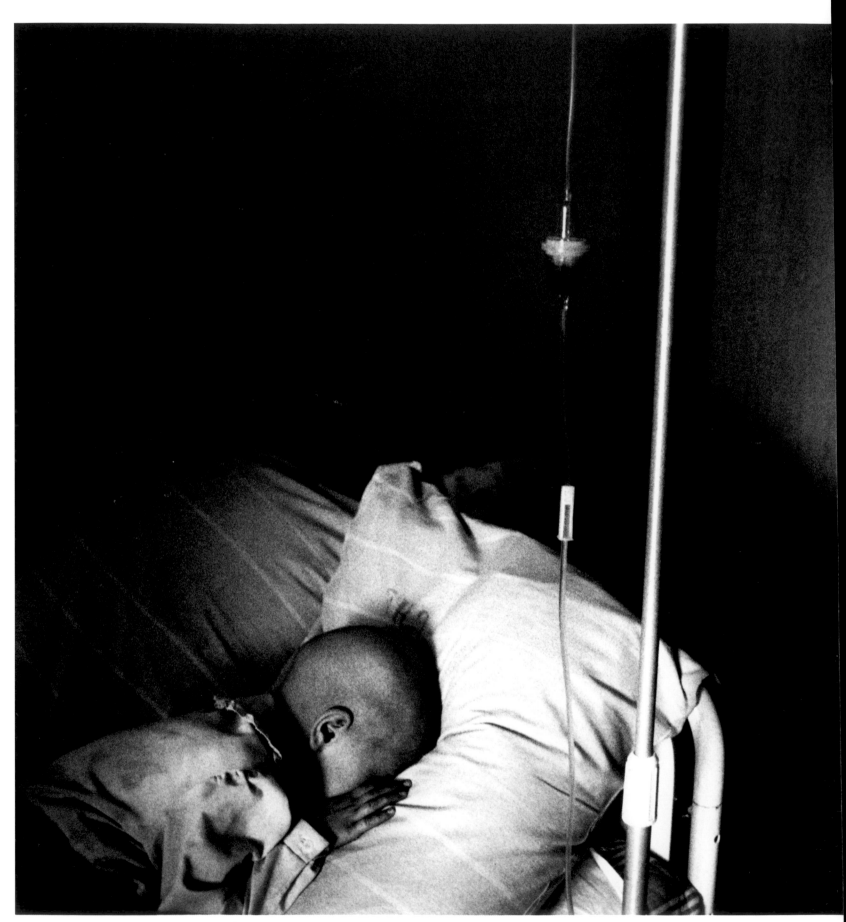

A leukemia patient and her mother at a Minsk hospital, downwind from Chernobyl.

In 1945, long before Chernobyl's poisons blew across the world, Josef Stalin ordered seventy thousand labor camp inmates to build the Mayak Chemical Complex in the Ural Mountains to produce plutonium.

By 1949, they were testing bombs in Kazakhstan. Although Mayak (also known as Chelyabinsk-40) appeared on no maps, it formed the backbone of the Soviet nuclear weapons complex. At Mayak, waste was dumped directly into the Techa River, in lakes and into tanks that still leak. A person standing on the shores of Lake Karachy would receive a lethal dose of radiation in one hour.

Three major accidents have occurred at Russia's largest plutonium production center, collectively exposing a half-million people to radiation. Now they are dismantling nuclear warheads and storing the waste improperly.

"We have over-militarized," admits Alexei Yablokov, President Boris Yeltsin's counselor on ecology and public health. "The situation here is really dangerous. Fifteen percent of my country is an ecologically unfit disaster zone from military and industrial pollution."

In Semipalatinsk, Kazakhstan, medical personnel collect deformed infants and fetuses, including one with only one eye and another with two heads.

Cancer studies show nearly 40 percent more cancers among downwinders. Life expectancy is down. Birth defects are up. For the dead there is peace, for the living the harsh winds blow radiation.

Berik Syzdykov, fourteen, has large flaps where his eyes should be. Doctors admit this is "most probably" from Soviet testing. Berik is blind and he doesn't understand about bombs. The bumps and scars on his face are getting worse. He is shy, and has the mental capacity of a six year old.

He is offered a candy bar and shares it with his sister. His answers are simple: "Sun is good, cold is bad. Dog is furry. Cow is cold." But when asked what he dreams of, he flashes a smile that wins out over the scars and bubbles on his face. "In my dreams, I drive a tractor," he says, gripping an imaginary steering wheel. "I don't know how to drive. I put the key in and it drives itself. I go to visit my sister at work."

Outside in the warm Kazakh sun, Berik hears a camera click. "Am I allowed to smile?" he asks.

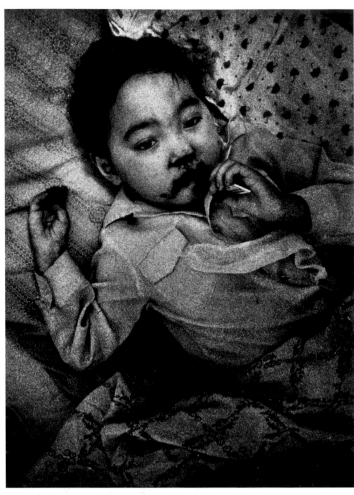

Above: A Kazakh downwinder in the final stages of leukemia.
Right: In the House for Abandoned Children, in Semipalatinsk, Kazakstan, Dr. Natalya Borisovna Averbach cuddles a child born with small-brain syndrome. The baby writhes like an insect. "What future do these children have?" she asks. "Death by infection. She will live like an animal and usually die like an animal."

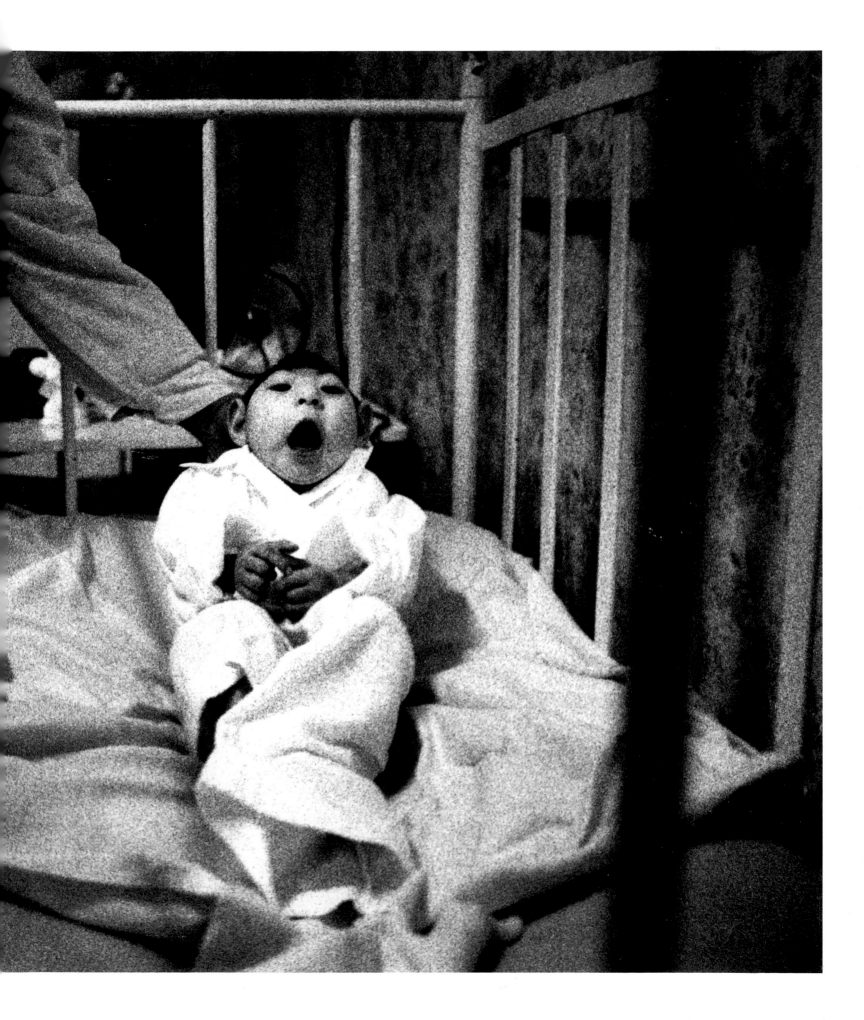

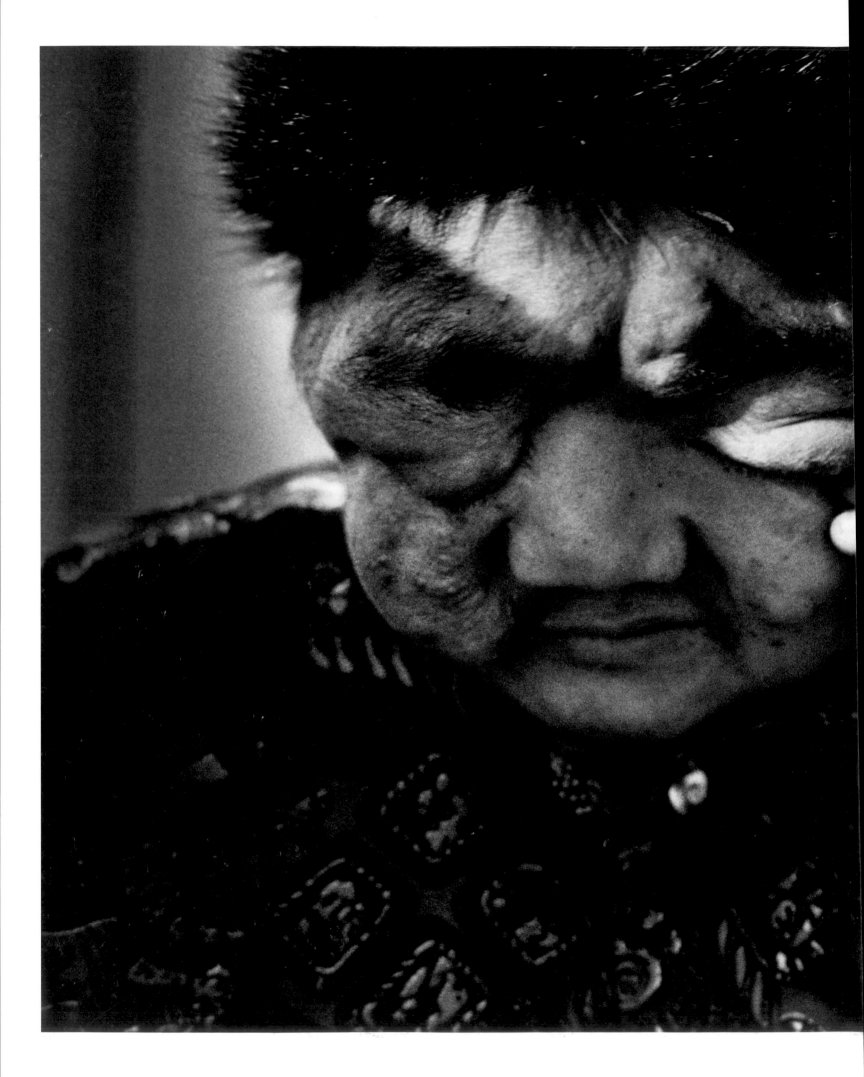

Berik Syzdykov, fourteen, lives downwind of the Semipalatinsk test site in Kazakhstan. "The nuclear test is to blame," says his mother. "He is one of ten kids and all are frequently sick."

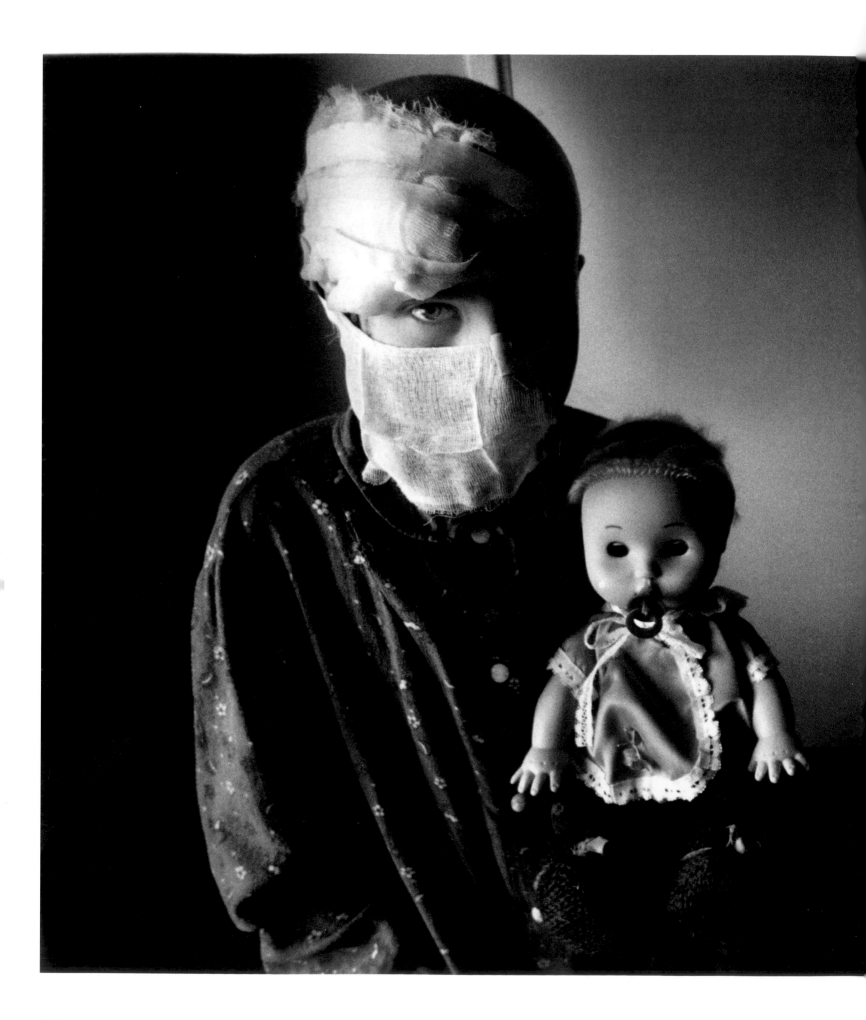

Above: A suspected victim of Chernobyl. The 1986 explosion affected at least eight hundred thousand children in neighboring Belarus alone.
Left: A Soviet cancer patient. The former Soviet Union has approximately ten thousand incidents of pediatric cancer yearly.

The little boy chewed on the fence. Blond, blue-eyed, with perfect white gleaming baby teeth. He didn't cry, he just ground his teeth on the rusty iron fence of the special kindergarten in Constanta, Romania.

The child's future is his past. He was abandoned by his parents, who had infected him with the AIDS virus. Even if he lives a few more years, he may never get a chance to go to school with other children. "It is my country and I love it," says Mihai Goldner, of the Association Romania Anti SIDA (AIDS). "But these children are not received in schools."

Romania has the worst juvenile AIDS problem in Europe. Half of all children with AIDS in Europe are in Romania. At least 90 percent of its nearly three thousand patients are under twelve years old. The majority were infected by contaminated blood or poor medical hygiene.

The chief causes are the lack of disposable syringes and the fact that before 1990 Romania didn't screen its blood.

In Constanta, Dr. Rodica Matusa, a specialist in infectious diseases, has declared a public health emergency. "Ninety percent of the kids are abandoned, they don't know their parents. We are their parents," she says.

"Our children have lasted five years. I don't have AZT. I need Tylenol, disposable syringes, antibiotics. The whole world spotlight was on us a few years ago, but now there is nothing. We give them good care, nutrition, and lots of love. How long will they live? I don't know. I hope until the medicine gives an answer and rids us of this terrible disease."

After the fall of the communist dictator Ceausescu in 1990, the whole world was shocked by the horrific images of abandoned babies lying in thier own feces in Romanian orphanages. Ten thousand children were adopted, some reportedly sold from the backseats of cars. The Romanian government, embarrassed by the worldwide uproar, stopped the baby market. Then the spotlight moved on, and with it, much-needed aid. Today, the consequences are painfully clear. Eighty-five percent of Romania's AIDS population is age four and under.

"It breaks my heart," says Matusa. "There's no social help. We tell them there's so much love there and there's chocolate and light and it's okay to die, it's up to Jesus. At least now the child is not dying alone, but in the breast of someone. It's a shame their parents never cared about them."

A child at a kindergarten for AIDS patients in Romania. Half of all children with AIDS in Europe are in Romania.

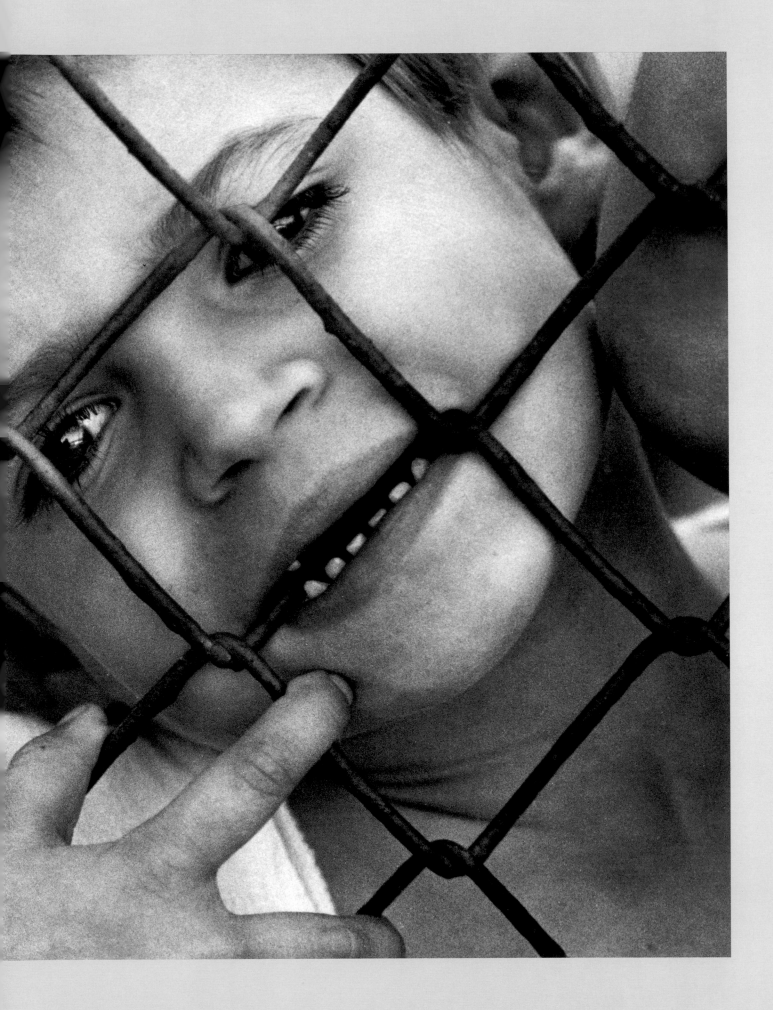

Above: A girl and her friend at a kindergarten for AIDS children in Romania.
Opposite: A child receives a helping hand at a special kindergarten for AIDS patients in Constanta, Romania.

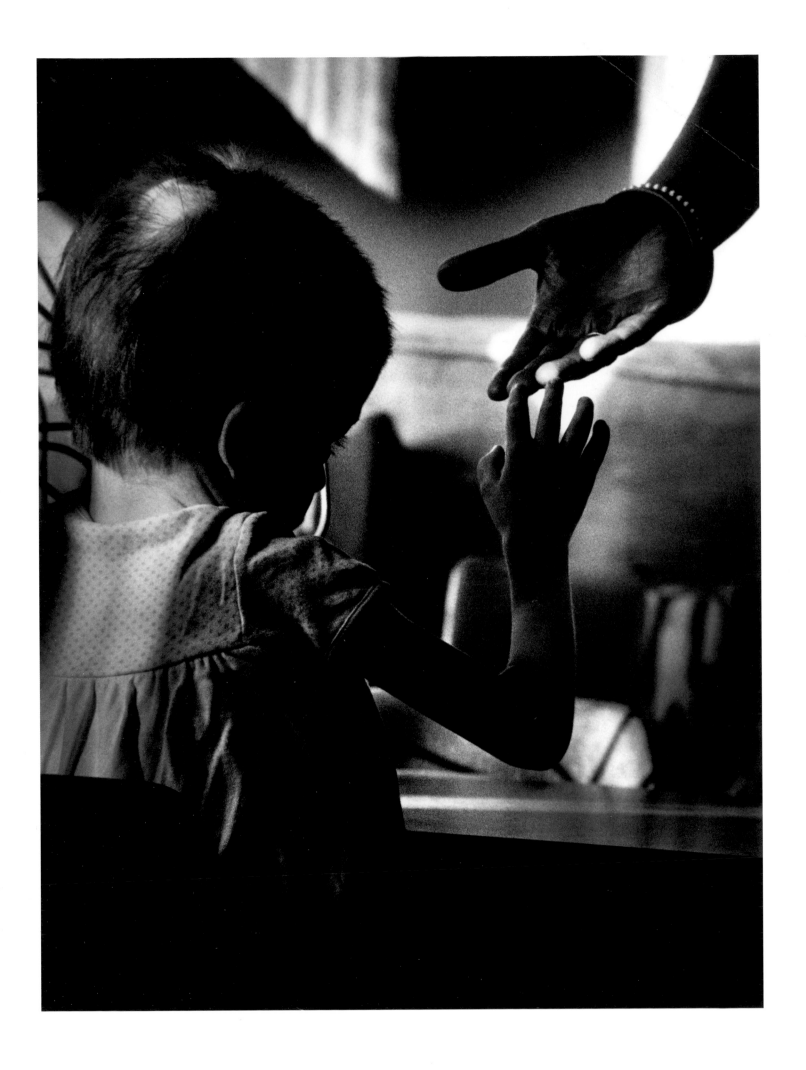

A stricken child in
Romania, where
children aged four
and under account
for 85 percent of
all AIDS patients.

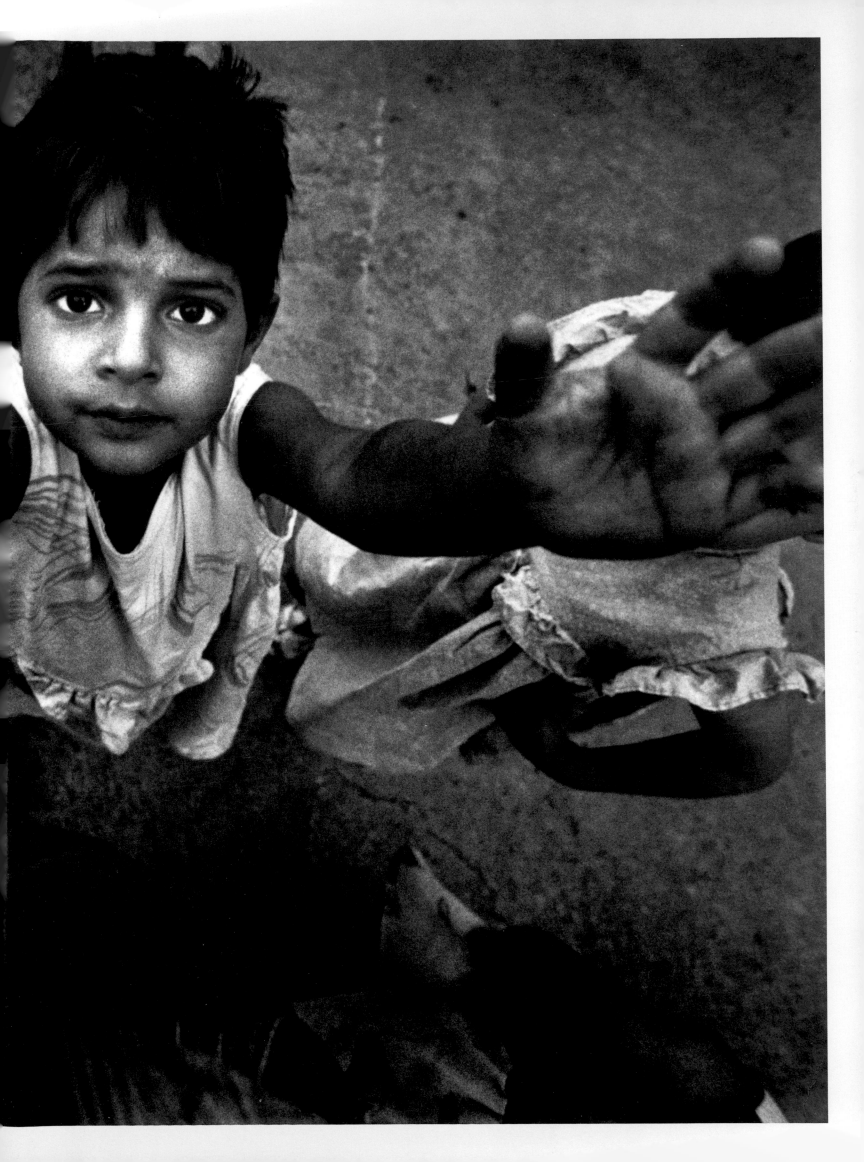

HOPE FOR THE FUTURE

Stand for
Children rally,
Washington,
D.C., 1996

LOVE IS ALL

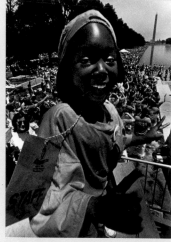

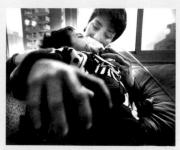

In Rio de Janeiro, death squads of off-duty police aren't the only ones looking for kids; rights workers are out there too. "We give them shelter, food, and love," says Roberto José dos Santos, director of **ASSOCIACAO BENEFICENT SAO MARINHO**. "Through education we can save them. We have a shelter. We have twelve educators who circulate and try to get to the children. Sometimes we're better than a home, because there's so much violence in their homes." **COVENANT HOUSE** works with street children in Mexico, Honduras, and Guatemala, as well as in the U.S. Call 212-727-4000. To volunteer call 212-727-4917. Crisis hotline in the U.S. 800-999-9999.

"We should be hugging each other instead of being violent and doing drugs," says Kristin Nichol Hamilton, ten. Hamilton was one of 200,000 participants in a Stand For Children rally at the Lincoln Memorial sponsored by the **CHILDREN'S DEFENSE FUND**. By becoming a mentor to a child, you could make a difference.

For more information, or to volunteer, call **CHILDREN'S DEFENSE FUND** at 800-CDF-1200, or, **STAND FOR CHILDREN** at 800-663-4032. E-Mail at CDF@childrensdefense.org. Also, the **ONE TO ONE PARTNERSHIP, INC.** at 2801 M. Street, N.W., Washington, D.C. 2007; 202-223-9186.

Most of it "comes down to attention, and do you really care for me?" says Bob Monahan of the **BOYS AND GIRLS CLUBS** of Boston. "Kids start crying out really early. It's a question of who's listening. . . . There's a line that some kids cross; they buy into it, and we can't reach them all. We have a program. If they're truants, we go and get them."

To find the **BOYS AND GIRLS CLUB** program nearest you, call 800-854-CLUB, or write to 1230 West Peachtree St., NW, Atlanta, GA 30309.

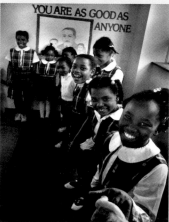

THE NATIONAL BLACK CHILD DEVELOPMENT INSTITUTE is a national nonprofit charitable organization dedicated to improving the quality of life for African-American children and youth on the national and local levels. **NBCDI** focuses on health, child welfare, education, and child care / early childhood education.

Contact: **NBCDI**, 1023 15th St., N.W., Suite 600, Washington, D.C., 20005; 202-387-1281, fax 202-234-1738.

Ricky Smith sucks on a plastic tube of medication twice a day because his mother sucked on a glass tube filled with crack while she was pregnant. He was born cocaine-addicted. He's blind, can't walk or talk. But now he has a home. "This is not a story without hope," says Terry Smith, who adopted him. "The first time I saw him I was a volunteer at the hospital and he was screaming his bloody lungs out. He was eleven months old. The doctors said, 'You know, he's basically a vegetable.' They've been so wrong." Now, she says, he has a personality and is attending special classes, including music. "He likes *Peter and the Wolf.*"

SHARE OUR STRENGTH conducts anti-hunger campaigns in the United States. Since 1984 it has distributed more than $30 million in grants in the USA and around the world. See its homepage at http://www.strength.org

•Volunteer to work at a food bank, community garden, or soup kitchen. Call **SECOND HARVEST**, the national network of 185 food banks at 1-800-344-8070.

•Donate perishable foods. Call **FOOD CHAIN** at 1-800-845-3008.

•Support restaurants that display the **SHARE OUR STRENGTH** logo.

THE NATIONAL GANG NETWORK helps communities establish responses to gang violence. Call 617-969-0788.

New York's **RESOLVING CONFLICTS CREATIVELY PROGRAM (RCCP)**, a collaboration between the NYC Board of Education and Educators for Social Responsibility—Metro, teaches students and teachers how to resolve conflicts without aggression. Similar programs are now implemented in schools across the country. Call 212-260-6290 or 212-870-3318.

The following organizations work on children's issues worldwide: **CARE** 800-521-CARE. **SAVE THE CHILDREN** 800-243-5075

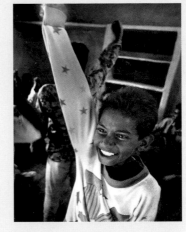

Amanda Loos, fourteen, does a victory dance at the Broad Meadows School in Quincy, MA. "A bullet doesn't kill a dream," she wrote on the Internet in an appeal to end child slavery.

The students became human-rights advocates after a 1993 visit by Iqbal Masih, a former slave in Pakistan's carpet industry. After Masih was gunned down in his native village, the students vowed to raise $5,000 to build a mud-brick school in Pakistan. They have currently raised over $100,000.

They can be reached at HTTP://WWW.DIGITALRAG:COM/IQBAL-HTML.

Raj Bansh, seven, does a victory dance at Mukti Ashram, a home for freed slaves near New Delhi where children get schooling, vocational training, and human-rights instruction. He worked eighteen months as a slave in a carpet factory. The children asked that a message be delivered to America: "You should not buy carpets. There are many people spoiling their life from them. You must tell all the people. No one should sit on that carpet."

THE SOUTH ASIAN COALITION ON CHILD SERVITUDE raids factories in India that use child labor illegally: Call 011-91-11-621-0807.

Look for the "Rugmark Logo" indicating that a carpet is made without child labor.

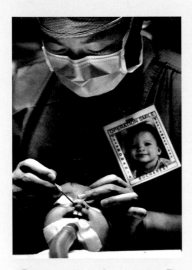

OPERATION SMILE surgeon Dr. Han Kai repairs a cleft lip in a Bucharest hospital. Operation Smile is a group of unpaid doctors, nurses, dentists, and physical therapists who do free reconstructive surgery across the U.S. and abroad. In Romania, some 600 patients were examined, including a thirteen-year-old girl who had a tumor the size of a golf ball on her lip. Her case was given low priority, the operation deemed impossible "this year." Later, Raluca Zaharia was heard encouraging another child in the hall. "For me it's not important to be beautiful," she said, "it's more important what's in your heart." The next day, when the surgery list was posted, her name was on it. "They are very very good and their hearts are real big," she says. "When I looked in the mirror afterwards, I thought, "Thank you, God."

Operation Smile has helped more than 30,000 children worldwide. OPERATION SMILE, 220 Boush Street, Norfolk, VA 23510. Call 757-625-0375. Website: http://www.operationsmile.org

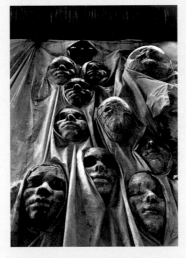

AMNESTY INTERNATIONAL has over 1,1000,000 members and supporters in over 150 countries. They participate in a variety of different programs to stop human-rights abuses and to raise the awareness of human-rights issues. Since it was founded in 1961, Amnesty International has worked on behalf of more than 43,000 prisoner cases, of which 40,000 are now closed. These aren't just numbers. Amnesty members give direct and effective assistance to people who become more than a number and more than a name. Write to: AMNESTY INTERNATIONAL USA, 322 Eighth Avenue, New York, NY 10001. Phone: 800-266-3789. AMNESTY INTERNATIONAL LONDON, 44-171-413-5800.

Good news from UNICEF:
•Most countries have sustained an 80 percent immunization rate for infants.
•Oral rehydration therapy saves one million children a year from diarrhea, once the No. 1 killer of children.

Since World War II:
•The under-five death rate in the developing world has been cut by two-thirds.
•Immunization has eradicated polio from the Western Hemisphere.
•Average real incomes in the developing world have more than doubled.
•The proportion of the developing world's children who are starting school has risen from less than half to more than three-quarters.
•The percentage of rural families with safe water has risen from less than 10 percent to almost 60 percent.

UNICEF— 800-for-kids; website: www.Unicef.USA.org

"If we are going to have peace, people have to be willing to give something up," said Martin O'Brien, coordinator of the COMMITTEE ON THE ADMINISTRATION OF JUSTICE in Northern Ireland.

At peace camps, he brings together people of different religions and classes. "People start off very nervous or aggressive.

They are not getting along but after awhile you see real friendships develop." At a farm project amidst rolling hills on the north Antrim coast, there is a harvest of hope. "There's something about cleaning out the goat shed and working the land that makes people realize there's not a problem that can't be sorted out."

The COMMITTEE ON THE ADMINISTRATION OF JUSTICE works with people on all sides of the conflict in Northern Ireland. 45/47 Donegall Street, Belfast BT1 2FG, Northern Ireland. Phone:44-1232-232-394. Fax: 44-1232-333-522.

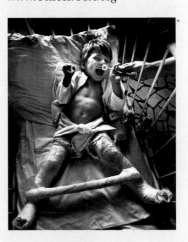

THE PUBLICATION OF THIS BOOK IS SUPPORTED BY A GENEROUS CONTRIBUTION FROM THE *BOSTON GLOBE*

AUTHOR'S ACKNOWLEDGMENTS

There's a human-rights activist behind almost every photograph in this book who helped make it possible. These caring and wonderful souls deserve a lot more credit than I do. I jet into a country, shoot and scoot. They stay, sometimes working under horrendous conditions and risk of bodily harm to get the truth out. Most of the time they must go unnamed so that they can continue their work without retribution. These guardian angels of children's rights have our sincerest thanks and prayers.

My wife, Stacey Kabat, who has an Academy Award in documentary film, but deserves an Academy Award for best heart, has helped me survive the post-traumatic stress of what lies on these pages. Her agency, Peace at Home, has done so much to battle domestic violence in the United States. Her love and devotion help give us the spirit to endure.

I'd like to thank my sister Sandy, the sharpest yet most compassionate lawyer in the world, and my mother, Mildred, who as a teacher in the South Bronx taught hope and love by example. She is truly a hero.

This book would not have been possible without the sponsorship of the *Boston Globe*. Bill Taylor has proven to be as compassionate and caring a publisher as there is in the business. *Globe* president Ben Taylor cheerfully agreed to sponsor this book after he unknowingly sat next to me in the *Globe* cafeteria. That turned out to be the most expensive tuna-fish sandwich he ever ate. I'd like to especially thank former editor Tom Winship who always encouraged me to poke around where there's injustice, and managing editor Tom Mulvoy for his enduring good sense. David Nyhan and Wil Haygood have been writing mentors but, more important, great friends over the years. *Globe* editor Matt Storin has shown faith and given me the freedom to pursue much of the work that is on these pages. His concern for this project has been tremendous. *Globe* Associate Editor Ande Zellman and Design Director Lucy Bartholomey's talent, teamwork and vision originally breathed life into this project. The *Boston Globe* library has always offered support, particularly Jimmy Cawley.

Globe readers have offered tremendous support and energy throughout the years, thank you so much for all the cards and letters. I am blessed to work with the talented staff of the *Globe* photography department and director of photography Peter Southwick. They have given me the kind of support you wouldn't believe.

Brian Kaplan has helped this book become a reality with his top-notch research skills and photographic assistance. With the possible exception of his support of Steinbrenner's Yankees, he knows how to do the right thing. Rey Banogon and Margaret Farmakis, both of Boston University's College of Communication assisted admirably in the production of the photographic prints and ensured that there were good tunes in the darkroom.

At Aperture, I was impressed by the passion of director Michael E. Hoffman, the good sense of editor Michael Lorenzini, the sensitivity of designer Wendy Byrne, and the enthusiasm of Lois Brown, Ron Schick, Stevan Baron, Helen Marra, and Jeanne Courtmanche.

UNICEF takes pennies and saves lives. At the U.S. Committee of UNICEF, Cate Jarett and Dr. Eddy Bayardelle have shown great enthusiasm for this project. I would like to thank especially Ed Mitchell, of UNICEF New England, for his continuing support and friendship.

A special thanks is due to Muhammad and Lonnie Ali, and Mother Teresa.

I would also like to thank Vice President Al Gore, Callie Shell, Vince Musi, Mike McHugh, Lynne Smith, Howard Bingham, Thomas Hauser, Melissa Ludtke, Mike Barnicle, Linda Hunt, Bill Brett, Kerry Brett, Sally Stapleton, Ellen Powers, Kathleen Curran, Tim Dwyer, Dan Shaughnessy, Steve Sheppard, Sean Mullen, Ben Bradlee Jr., Tom Herde, Bill Greene, Michelle McDonald, Suzanne Kreiter, Joanne Rathe, John Tlumacki, Mark Wilson, Dan Sheehan, Bob Dean, Colin Nickerson, Curtis Wilkie, Steve Morse, Jean Mulvaney, Howard Manly, Ron Borges, Joseph Meyer, Katie Aldrich, Jennifer Blake, Amanda Sastow, Rose Devine, Barbara McDonough, David Godine, Sherman Teichman, Bill Kovach, Steve Pena, Joe Ryan, Paul Drake, John Ioven, Jimmy Bulman, C.J. Gunther, Paul MacDonald, Paul Minezzi, Sandy Hawes, and Al Larkin.

The Nieman Foundation, Casey Journalism Center for Children and Families, Tufts University EPIIC Project, National Center for Children in Poverty at Columbia University, Boston University College of Communication, and OXFAM America all were more than generous with their vast resources.

Library of Congress Catalog Card Number: 96-78750
Hardcover ISBN: 0-89381-696-5
Paperback ISBN: 0-89381-720-1

Book and jacket design by Wendy Byrne
Printed and bound by
Federico Motta, Milan, Italy

The Staff at Aperture for *LOST FUTURES* is:
Michael E. Hoffman, *Executive Director*
Michael Lorenzini, *Editor*
Lois Brown, *Executive Editor*
Stevan A. Baron, *Production Director*
Helen Marra, *Production Manager*
Cindy Williamson, Amy Schroeder, Craig Cohen, *Editorial Work-Scholars*
Katie Warwick, *Production Work-Scholar*

Aperture Foundation publishes a periodical, books, and portfolios of fine photography to communicate with serious photographers and creative people everywhere. A complete catalog is available upon request. Address: 20 East 23rd Street, New York, New York 10010.
Phone: (212) 598-4205.
Fax: (212) 598-4015.

Aperture Foundation books are distributed internationally through:
CANADA: General Publishing, 30 Lesmill Road, Don Mills, Ontario, M3B 2T6.
Fax: (416) 445-5991.

UNITED KINGDOM: Robert Hale, Ltd., Clerkenwell House, 45-47 Clerkenwell Green, London EC1R OHT.
Fax: 171-490-4958.

CONTINENTAL EUROPE: Nilsson & Lamm, BV, Pampuslaan 212-214, PO Box 195, 1382 JS Weesp. Fax: 31-294-415054.

For international magazine subscription orders for the periodical *Aperture*, contact Aperture International Subscription Service, PO Box 14, Harold Hill, Romford, RM3 8EQ, England.
Fax: 1-708-372-046.
One year: £30.00. Price subject to change.
To subscribe to the periodical *Aperture* in the US write Aperture, P.O. Box 3000, Denville, NJ 07834. Tel: 1-800-783-4903.
One year: $44.00.

First edition
10 9 8 7 6 5 4 3 2 1